World War II Quilts

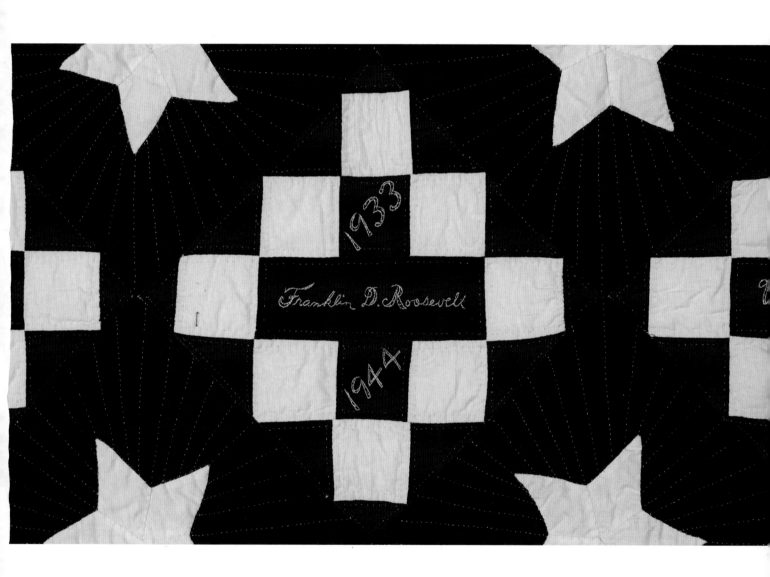

Sue Reich

Schiffer Publishing Ltd

4880 Lower Valley Road, Atglen, Pennsylvania 19310

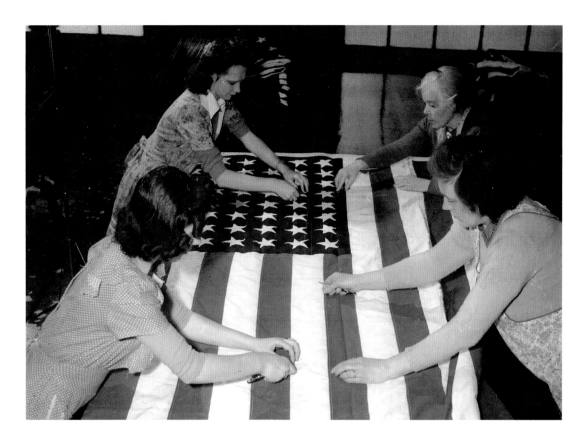

Schiffer Books are available at special discounts for bulk purchases for sales promotions or premiums. Special editions, including personalized covers, corporate imprints, and excerpts can be created in large quantities for special needs. For more information contact the publisher:

Published by Schiffer Publishing Ltd.
4880 Lower Valley Road
Atglen, PA 19310
Phone: (610) 593-1777; Fax: (610) 593-2002
E-mail: Info@schifferbooks.com

For the largest selection of fine reference books on this and related subjects, please visit our web site at

www.schifferbooks.com

We are always looking for people to write books on new and related subjects. If you have an idea for a book please contact us at the above address.

This book may be purchased from the publisher. Include $5.00 for shipping. Please try your bookstore first. You may write for a free catalog.

In Europe, Schiffer books are distributed by
Bushwood Books
6 Marksbury Ave.
Kew Gardens
Surrey TW9 4JF England
Phone: 44 (0) 20 8392 8585; Fax: 44 (0) 20 8392 9876
E-mail: info@bushwoodbooks.co.uk
Website: www.bushwoodbooks.co.uk

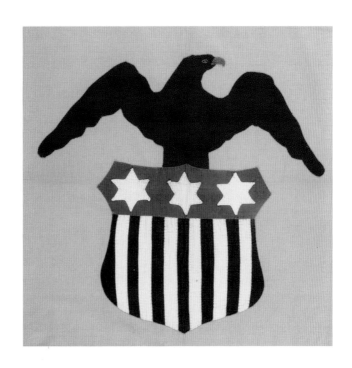

Dedicated to the men and women of the Armed Forces
who honorably serve our country
to protect our freedom and prosperity

Acknowledgments

American Study Group for giving me my first opportunity in 2004 to present my research on World War II quilts.

Cuesta Benberry for her initial research on World War II quilts, the unselfish sharing of her information, and the encouragement to expand upon her research.

Xenia Cord for providing World War II ephemera from her personal collection.

Sally Ward for her knowledge of the quilts sent to England during the War via the Red Cross and Bundles for Britain.

Sally Ambrose for sharing the World War II quilts from her appraising travels.

Patricia Almy Randolph for access to her index of Nimble Needle Treasures.

Elaine Hunter, my sister and the photographer of many of the World War II Memorial Dedication pictures.

Rose Lea Alboum for generous access to her indices of the quilt patterns and welcoming me into her Vermont country home.

Maureen Gregoire, Susan Fiondella, and Sharon Waddell for their diligence and patience as readers of this manuscript.

Barbara Garrett, Mary Kerr, and Maureen Gregoire for their invaluable help with the photography sessions.

The owners of the World War II quilts featured throughout this book for sharing their treasurers.

The staff at Schiffer Publishing, Ltd. for their fortitude and guidance in the preparation of the book.

My family for their patience and understanding of my passion for quilt history.

Contents

Preface

In 2004, my family and I attended the dedication of the World War II Memorial in Washington, D.C. We went to honor our father, Joseph Winklmann, who fought in the Pacific Theater and served on the USS Saratoga. He never talked much about his war service. The only memorabilia from those years are his uniform, his discharge instructions, and an album of pictures from the Hawaiian Islands and throughout the Pacific. Naively, our family believed we would meet men who served with our Dad. Sadly, we found most of the men on his ship had already passed away. Other seamen veterans we met that day recalled that the USS Saratoga took a lot of enemy fire.

The experience of attending the dedication of the World War II Memorial was truly unforgettable. Men and women who served their country in a war sixty years earlier came supported by walkers, pushed in wheelchairs by family members, leaning on canes, and standing upright nearly at attention. Some even wore their dress uniforms. Proud of their service to our country, they were moved to tears when interviewed about their years of service by the staff of the Smithsonian and the Library of Congress. Members of the baby boomer generation grasped their hands in open gratitude and small children eagerly sought their autographs, giving them long-overdue recognition for their sacrifice during the war.

Joseph Frank Winklmann, U.S. Navy Aviation Machinist (H) 2C. Served on the U.S.S. Saratoga in Guam and the Pacific Theater. Honorably discharged from the Navy on December 24, 1945.

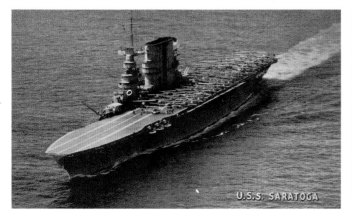

An official photograph of the U. S. Navy.

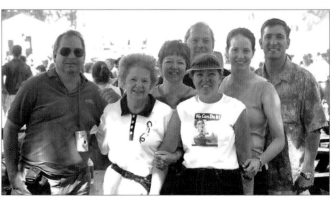

The family of Joseph Winklmann at the Dedication of the World War II Memorial, May 2004.

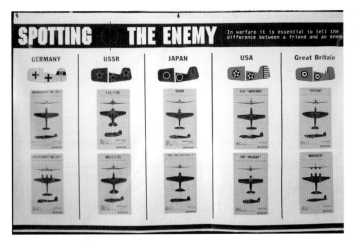

This poster was photographed at the Dedication of the World War II Memorial. The aircraft designs resemble the many airplane quilts made during the mid-twentieth century.

everywhere. I was struck by the similarity between these designs and quilts from the mid-twentieth century. I began to realize that quilt historians had overlooked the era of World War II quilts. Quilts of the 1940s were usually placed in the same category with quilts of the 1920s and 1930s in state documentation projects. "How many World War II quilts are really out there?" became a reoccurring question of mine.

Most women remember knitting and crocheting during the war. This knitted patchwork has seventy blocks with appliquéd World War II military insignia representing divisions and units in the US Army.

On January 8, 1942, in the *Soda Springs Sun*, of Soda Springs, Idaho, the following article, titled "Relief Society Announces Work Meeting," was reported. "The Relief Society will hold a work meeting next Tuesday, Jan. 13, at the home of Esther Wallace, with Agnes Wood, Evelyn Thirkill, and Stella Egg as assisting hostesses. The time will be devoted to knitting and sewing for the Red Cross. Those

Across the Mall and between the museums of the Smithsonian Institution, reunion tents were filled with photos, posters, magazine covers and other memorabilia from the War years. American flags, images of Blue Stars, airplanes, Vs for victory, Morse code, ships, anchors and other popular World War II ephemera could be seen

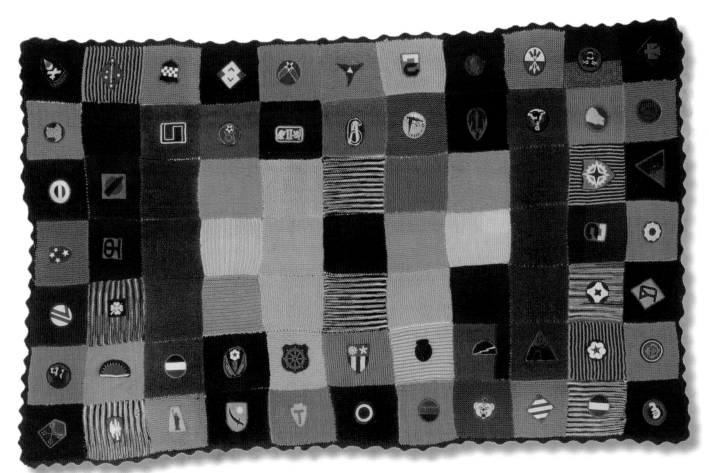

Knitted Quilt appliquéd with World War II Army Insignia, 43.5 inches x 75 inches.

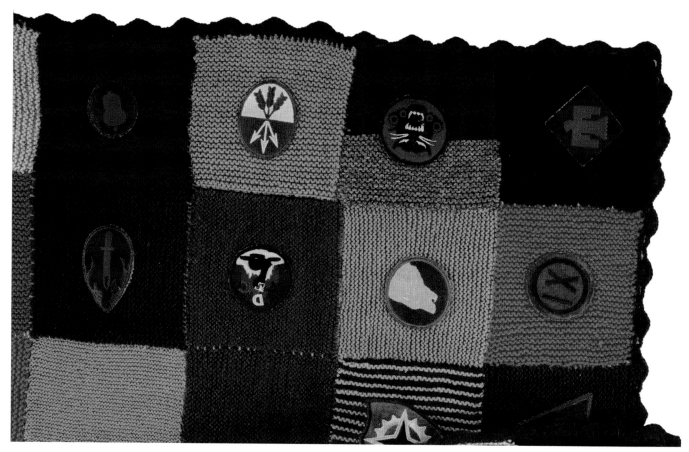

Detail of the Knitted Quilt.

A close look at this World War II hospital bed shows it was covered with a knitted quilt. School groups and women were encouraged to bring their knitting needles and sewing machines to community centers to sew and stitch for the War effort.

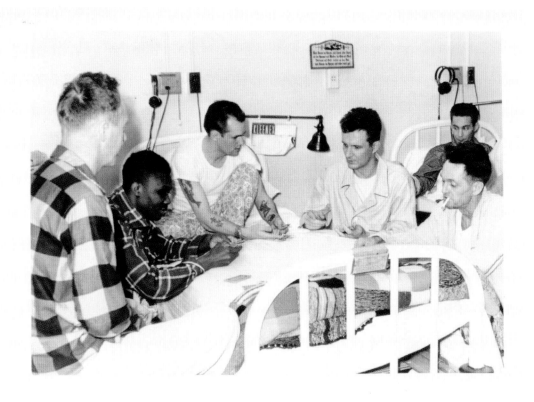

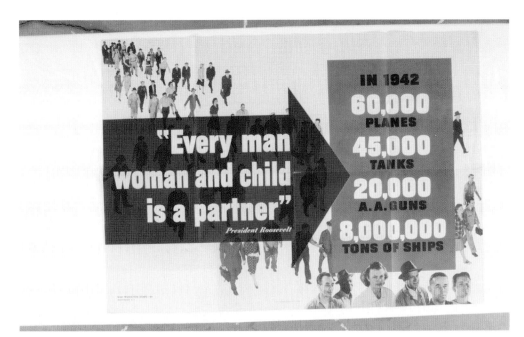

War Production Board, Washington D.C., United States Government Printing Office 1942 – 453836

who wish to knit must bring their own needles. There will also be quilt blocks to work on."[1]

Through extensive research of newspapers from 1940 to 1945, there are hundreds, if not thousands, of articles recording quiltmaking in the United States, Canada, Britain, Australia and New Zealand. Most of those quilts are still in trunks and attics, placed there 65 years ago by "The Greatest Generation,"[2] as they moved on with their lives after the war ended. Today, the men of that generation are leaving us at the rate of about one thousand a day, and the women, now in their 80s and 90s, are also starting to pass from this life. Their children, the baby boomer generation, are emptying those trunks and the quilts of World War II are beginning to enter the market place.

Over the past five years, I have dedicated much of my free time to the study of World War II era quilts. I lecture across our great country and share my own collection of World War II quilts with museums, historical societies, quilt shows, quilt study days, and magazine publications. Through access to newspapers and magazines of that era, I have been able to authenticate the patterns and designs available to quiltmakers, anchoring the quilts historically in time. There were very specific types of quilts made during the war: the obvious red, white and blue patriotic quilts, quilts with military symbols and insignia, quilts made for donation to the Red Cross and organizations such as Bundles for Britain,[3] quilts made to raise money for the war effort, and quilts that look exactly like any other quilt made between 1920 and 1950. This book concentrates on these five styles of quilts, and when possible the original patterns and designs that inspired the quilts are included.

Hopefully, the publication of this book will give information to enable quilt historians and researchers, military historians, baby boomers, and the general public to gain a greater appreciation of WWII quilts and their historical significance.

Throughout his lifetime, my own father honored the same code of silence about his military service and the war that are required of soldiers to this day. Perhaps this publication will serve to open a dialog between the World War II generation and their families before those oral histories are lost forever. Remember that this was "the People's War, and everyone was in it." Those who stayed home and fought the war on the home front were essential to winning the wars abroad, and it has become extremely important to document their stories.

This book presents information primarily from two collections: one of quilts and the other of newspaper accounts of quiltmaking from the World War II years. The quilts belong to museums and private collections in the United States, Canada, Great Britain and Australia. Unless otherwise noted, the quilts and ephemera belong to the author. The newspaper articles and information gleaned from them represent a small part of my continuing research of World War II quiltmaking.

Sue Reich
Washington Depot, Connecticut

WOMEN WHO STEPPED UP WERE MEASURED AS CITIZENS OF THE NATION, NOT AS WOMEN... THIS WAS A PEOPLE'S WAR, AND EVERYONE WAS IN IT.

COLONEL OVETA CULP HOBBY

Engraving at the World War II Memorial, Washington D.C.

In a Time of War

Women on the Home Front

*"Yesterday, Dec. 7, 1941 - a date which will live in infamy -
the United States of America was suddenly and deliberately attacked
by naval and air forces of the Empire of Japan."*[4]

With their husbands, sons, and fathers at war after the bombing of Pearl Harbor, American women were faced with much more than maintaining their homes and families. Most men between the ages of 18 and 40 were serving in the military. Help was needed in industry and business to keep our country functioning. Every American citizen was called to service on the foreign battlefronts and the home front in World War II.

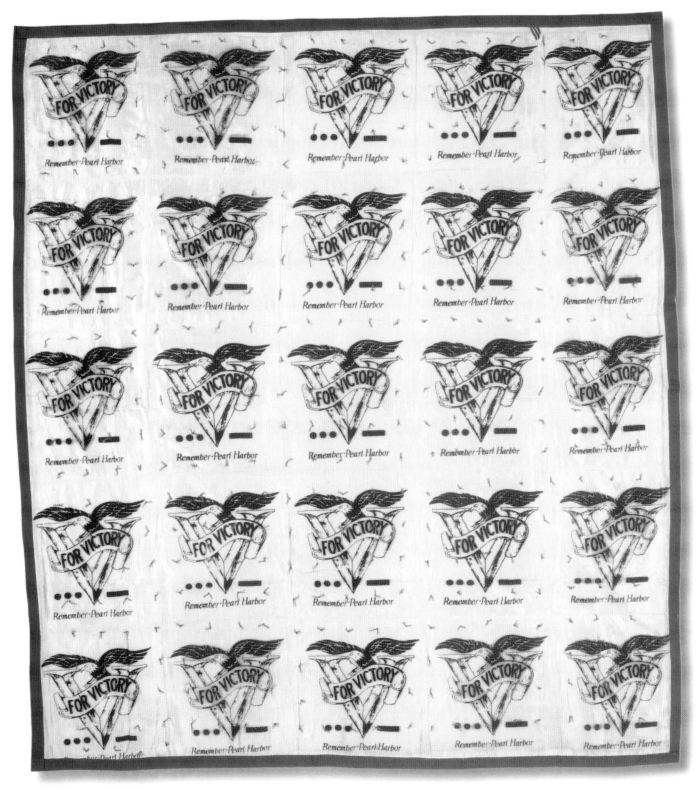

Remember Pearl Harbor Victory Quilt. Quiltmaker unknown. Machine pieced, hand tied, flocked silk, 74.5 inches x 85 inches, silk. The maker of this quilt pieced twenty-five red and white, flocked silks printed to urge Victory during World War II. To complete the patriotic design, she tied her quilt with blue yarn. These silks feature some of the most inspiring symbols of America-at-war; an eagle, the Victory "V", the Morse Code for Victory and the battle cry "Remember Pearl Harbor."

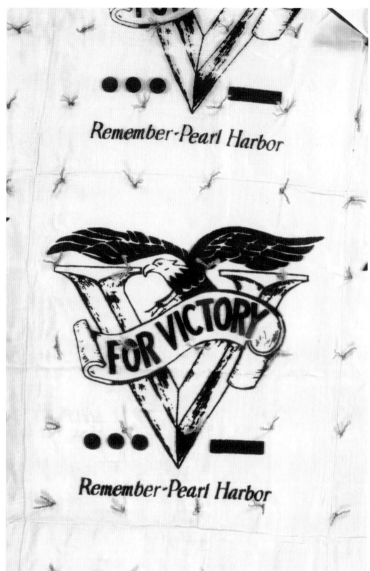

With all the young men at war, there were only boys and girls, women and old men left to march in the Memorial Day ceremonies in Ashland, Aroostook County, Maine, in 1943. The parade marched through nearly deserted streets. *Courtesy of the Library of Congress*

For women who were reticent about their new and unwelcome responsibilities, articles printed in local newspapers across the nation gave them direction and support. A column titled "WE, THE WOMEN," in The *Edwardsville Intelligencer*, Edwardsville, Illinois, on November 12, 1941, instructed, "No matter what kind of job you are trying to get, here is one rule to remember. If you want the job, ACT like you want it. That rule sounds almost too obvious to mention."[5] Without the aid of homefront women warriors, maintaining the needs of the country and the military during the war would have been impossible.

On June 6, 1942, the *Denton Journal*, of Denton, Maryland, reported this speech by Governor Herbert O'Conor. "Throughout the country it is estimated that 1,000,000 more women will have to go into industry during 1942. Undoubtedly, many thousands of women, who never expected to see the day when they would be called upon to forego their bridge and the accepted conveniences of life in the American household, will now find themselves called upon for work of various sorts in connection with defense activities and for even the heavier types of effort in machine shops, armament factories and so forth." He continued, "… Let us never forget for a moment that the military effort goes hand-in-hand with the civilian one. No battle in any part of the world can take place without involving us. Here at home we must drive toward victory. Here at home we must take and maintain an unrelenting offensive. Here at home we must hew the wood and carry the water for the rebuilding of a triumphant peace."[6]

The Rosie the Riveter doll was a wartime playmate for some young girl emulating the dedication and work of women during the World War II years.

Women who directly worked in support of the war were affectionately referred to as "Rosie, the Riveter," patterned after the real-life Rose Will Monroe, a riveter in an aircraft factory in Ypsilanti, Michigan.[7] The women found themselves called to work in the defense industry and other industries that kept the country productive. Most women already possessed many of the essential skills required for employment in manufacturing. The trials of everyday life and frugal life-styles developed during the Depression years gave them the foundation they needed to adapt quickly to the needs of war production and sacrifice. They acquired new skills with ease, and began to modify their dress for the practicality and safety conditions required for working with industrial machines.

This poem was written by Irene Carlisle, a welder at Moore Shipyard in Oklahoma, while her husband was in the Navy during the war. It was published in the *Saturday Evening Post* on February 3, 1945. The word association closely resembles a woman's common household activity: sewing.

> Slowly upon the ways the gray ships rise,
> The hammers ring on forepeak, hold and keel.
> Under our gloved hands and hooded eyes
> The blue arc stitches up the patterned steel.
> Over the hulls, between the clanging cranes,
> We climb and kneel and seam the ships together,
> Women are always sewing for their men,
> It tides the heart through a bitter weather.
> The chattering rivets button up the shell,
> The waiting bay is laced with windy foam,
> The molten stitches glow beneath my hand,
> This is the ship on which he may come home.

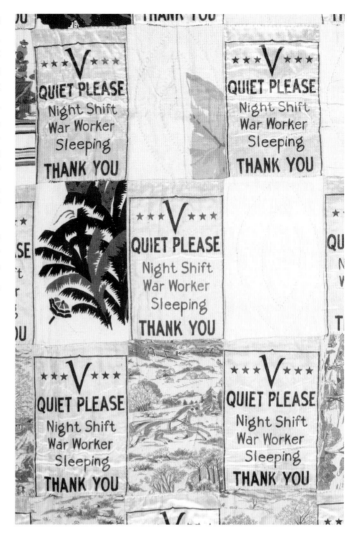

Women were encouraged in pamphlets, rather than to buy new clothes, to mend, alter, and accessorize their own clothes and those of their husbands to meet the fashion needs of the time. They were urged to rekindle the American tradition of quiltmaking to reinforce the clothing they already owned for added warmth. The American Red Cross and women's organizations across the country offered sewing classes to prepare women to adjust to the shortages of available textiles.[8] On September 29, 1942, in Ironwood, Michigan, the *Ironwood Daily Globe* described quilting as a new and favorite trend in fashion born out of scarcity and need. The article, entitled "Fashion Favors Quilting," points out that "Quilting is fashion's favorite this fall. And patriotically speaking, this fashion has been revived to create warmth without wool for civilian use. Almost any article of clothing takes smartly to quilting, and home sewers are urged to put their Yankee ingenuity to work for the sake of aiding the war effort."[9]

In *The Lowell Sun*, Lowell, Massachusetts, the regular column "On The Family Front" featured hints of wartime efficiency for women from the area. On September 24, 1942, this good advice was shared regarding ways to reuse old quilts.

> Now that it's time to bring those quilts out for an airing
> and winter duty, you'll probably find some of them pretty
> well worn. But you can't throw them away this year. One
> woman sewed two together, one atop the other and so placed

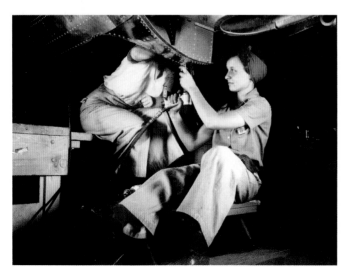

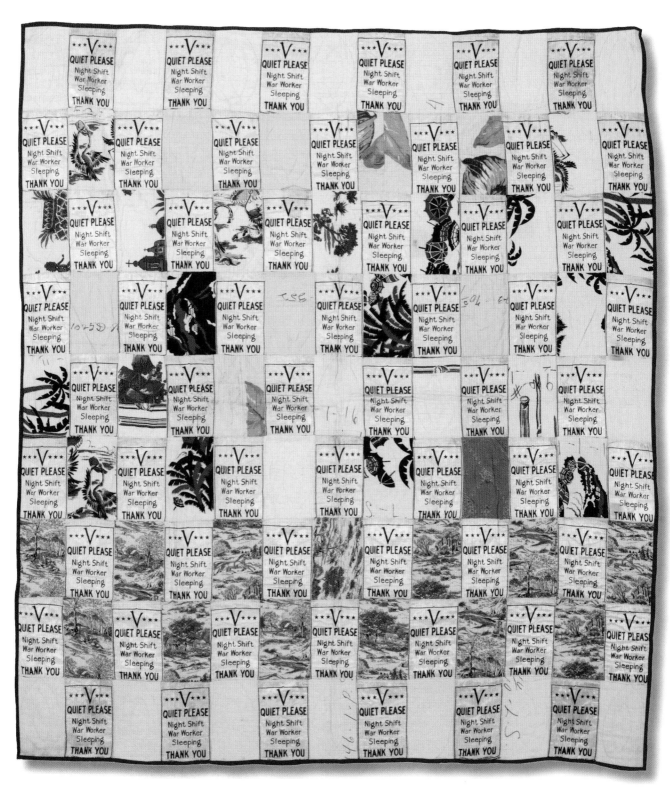

Victory Night Shift Worker Quilt. Quiltmaker unknown. Machine pieced, hand quilted, silk, feedsacks, home furnishing fabrics, and parachute, 68 inches x 78.5 inches. World War II saw warriors on the battlefront and on the home front. Men and women worked tirelessly, 24-hours a day, in the defense and other industries to keep the home fires burning and to supply the military around the world. This amazing quilt incorporates the printed silks hung on doors and windows to insure a good day's sleep for night-shift workers. The Victory "V" is featured front and center on the silks.

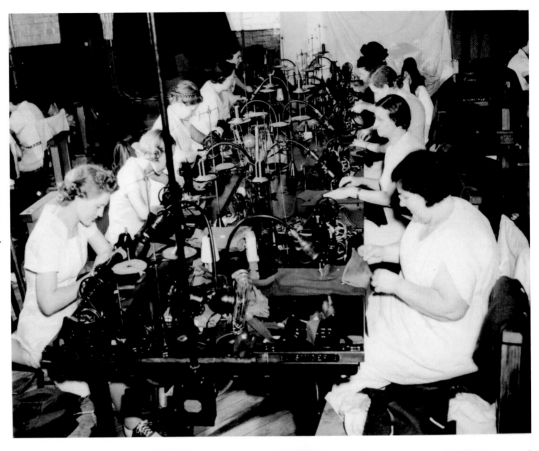

Women sewing Army blouses at the Goodall Manufactory company, Knoxville, Tennessee, c. 1942. *Courtesy of the Library of Congress*

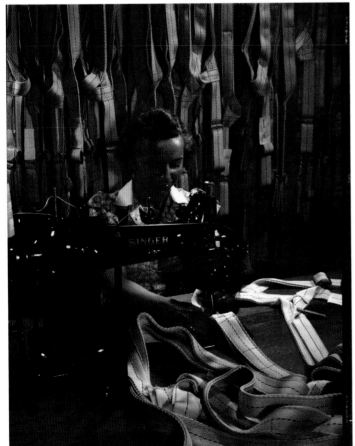

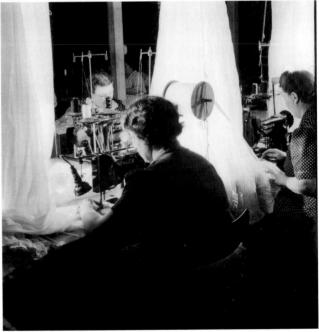

These women sew yards of silk together into flare parachutes. Pioneer Parachute Company, Manchester, Connecticut, August, 1942. *Courtesy of the Library of Congress*

Making harnesses. Mary Saverick stitching, Pioneer Parachute Company Mills, Manchester, Connecticut. *Courtesy of the Library of Congress*

Go through your wardrobe

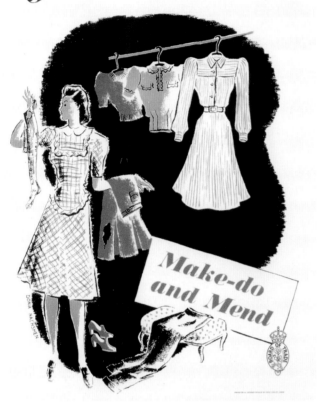

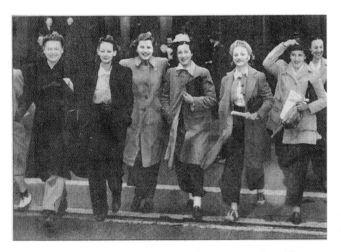

A group of women workers, wearing pants, leaves Scovil's Waterbury plant at the end of a shift. In his diary for March 1, 1942, John Monagen, president of Waterbury's Board of Alderman, noted, "Another result of the war is the slacks-for-women epidemic—I'm not sure of the reason—but a lot of women are wearing them." *Courtesy of Mattatuck Museum Arts & History Center*

that the worn parts on each didn't meet. Then she covered each pair with figured percale and tacked them every few inches so they would not get bunchy or lose their shape. Result: Three good quilts instead of six bad ones.

(And because the evenings are getting a bit—brr—cool). Here's another quilt item: Don't throw away old wool. One woman made herself a brand new quilt for 30 cents by piecing it out of orange-colored feed sacks and unbleached flour sacks. For lining she used unbleached flour sacks. And how about patch quilts—from those old dresses?[10]

In October, 1943, in Troy, New York and Dothan, Alabama, this article was published about quilted clothing during wartime.

New York – The quilting bees of grandmother's day are returning to popularity as Mrs. Patriotic Housewife busies herself turning cotton and rayon fabrics into cozy, cold-weather clothes.... Quilting, 1943 style, however, isn't exactly what it was for grandma. Sewing machine attachments now make it possible to turn out, in blitzkrieg time, even intricate-appearing trapunto effects, with curving lines that call for transfer patterns, while plastic-like dress

forms that duplicate the feminine figure, eliminate the necessity for the expert fitting skill that grandma needed to quilt anything wearable.

Reversible dirndl skirts, sleeveless hug-me-tights, slacks, coat linings and other new, quilted, fashions are made without the bulkiness that was grandmother's bug-bear. Plain or straight line quilted designs, such as the horizontal, the cross-bar, the double cross-bar, the diagonal, the diamond and the double diamond effect are all made easier by the quilter attachment.

Housewives who have never before done any quilting can easily master the art at one of the many local sewing centers throughout the country that are giving instructions on wartime budget lessons in sewing shortcuts, dressmaker tricks and remodeling....Those who have always been home dressmakers will find that eye-filling patterns sewn in attractive thread

Save and Sell for Victory

SAVE burlap and cotton bags. They're scarce. Patch them, keep them dry, use them as many times as you can.

SELL your old newspapers and magazines. Also, old rags and rubber articles. The Salvage for Victory program needs them.

Nashua Reporter, **Nashua, Iowa, June 10, 1942, page 4.**

are an aid to dressing with individuality in wartime, despite restrictions on fabric colors and prints.[11, 12]

The Dothan Eagle, of Dothan, Alabama, carried the following article, written by Rosellen Callahan, to encourage the attributes of sewing.

Sitting at home and sewing has once again become the popular pastime of women the nation over. It not only fills these extra hours which seem so empty since their menfolk left for service, but they find a budget-booming profit in making over old outfits or creating new ones from piece goods. Incidentally, women bought over three and a half billion yards of piece goods in the first four months of this year. Last year 30,000 of them enrolled in the National Sewing Contest sponsored by the National Needlecraft Bureau and this year home sewers upped that figure considerably. This month these amateur seamstresses, ranging from teen-agers to women in their seventies, and from school girls to war workers, submitted their handiwork in the second annual contest. It was ingenious handiwork such as a red and white striped street dress, fashioned from three 15-cent chicken feed bags, a smart four-piece youngster's ensemble made from her daddy's worn out suit and frayed broadcloth shirt, a lounging robe from a quilt and a blouse made out of a 1908 trousseau's chemise. All these were made from original designs or inexpensive patterns, obtained in many cases, through local newspapers.[13]

Newspaper articles across the United States promoting quilting were printed in support of the old-time craft for women. Immensely popular during the 1930s, the art of piecing, appliquéing and quilting for necessity and pleasure continued to flourish right through the war years.[14]

The patriotic urge to make use of every scrap of material has revived the fine art of quilting. With odds and ends of washable fabrics from the rag bag any woman with patience and skillful fingers can put together a warm and lovely bed covering. Novices are advised to choose for their first attempt a simple pattern consisting of combined triangles and squares. After the pieces have been washed and pressed they should be sewn into blocks, then assembled to form a large rectangle for the top of the quilt. Any sturdy washable fabric will do for the backing. A good interlining can be made from cotton batting, flannelette or, best of all an

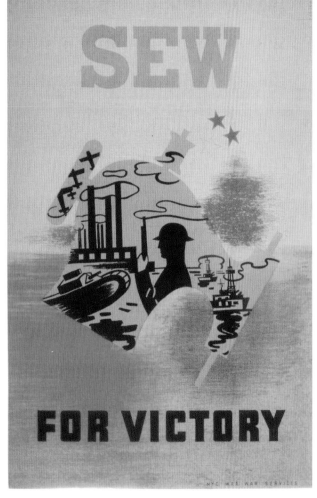

New York City, WPA War Services, Library of Congress.

Readsboro Woman Mends Grandmother's Quilt

"The Shelburne Falls News Section," *The North Adams Transcript*, North Adams, Massachusetts, March 30, 1942, page 10.

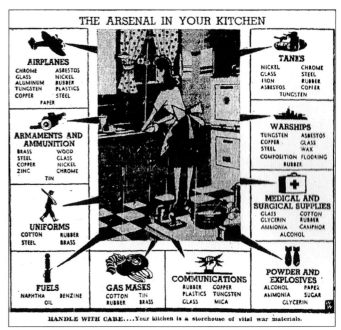

THE ARSENAL IN YOUR KITCHEN

HANDLE WITH CARE....Your kitchen is a storehouse of vital war materials.

The Kokomo Tribune, Kokomo, Indiana, June 2, 1942, page 6.

old and worn wool blanket. If this is used, the finished quilt should always be washed in tepid suds and water as though it were made of wool. When the layers have been basted together, the quilting frame or a large embroidery loop is called into action and the quilting design applied.[15]

The slogan "Save Scrap" found perfect application in World War II quilting activities!

The principle of "Waste Not! Want Not!" widely practiced out of necessity during the Depression years was easily adopted when the war got under way. This mantra was repeated in newspapers, on posters, and in ads throughout the war and applied to just about every consumer good. Salvage was preached at centers where women met to quilt. Silk and nylon stockings were collected and made into powder bags which propelled projectiles in big defense guns. Nylon was used to make parachutes; consequently, rayon was now being used for ladies' stockings. In August, 1945, Mrs. Alice Thomson of Lincoln, Nebraska fed up with those uncomfortable rayon hose stated in the local *Lincoln Journal and Star*, "I've seen and worn about all the sagging rayon hose I can take in one lifetime. I can't think of anything more pleasant than a whole drawer full of nylons and I'll bet that every woman in Lincoln wants a whole dresser full."

Our neighbors to the north in Canada were practicing the same doctrines of thrift for their country, for Great Britain and for their soldiers on the battlefront. The *Lethbridge Herald,* Lethbridge, Alberta, Canada on March 17, 1943 printed the following about the Red Cross chapter's gathering: "FARM HILL, March 17.—The March meeting

of Farm Hill W.I. was held in the teacherage of Provo school, with the principal, and vice-principal as hostesses....An interesting article on "What to Sale for Salvage" was read by the secretary, Mrs. Henderson, and an appeal to save and give more to the Red Cross was made by the president. The Institute is collecting grease and scrap fat and papers, magazines, rags, bones, also scrap metals."[16]

In the United States, "Scrap Collection Campaigns" were held. Governor Herbert O'Conor, of Maryland, declared, in the *Denton Journal,* on October 17, 1942, that "in a free country, where every man is entitled to think his own thoughts, the public press has ever been the most important single factor in moulding public opinion....In accepting full responsibility for the promotion of the Scrap Collection Campaign, the newspapers have enlisted in the war for freedom as effectively as if every member of their staffs had joined the armed forces."[17]

Not every woman went out of the house or neighborhood to do her part in the war. Many stayed close to home planting victory gardens, salvaging scrap, volunteering as Air Wardens, and searching the skies for enemy planes as spotters.

Ruth Snow Bowen, of Chaplin, Connecticut, was the postmistress of her town. The post office was housed in her own home. This busy Connecticut woman played the organ in her church of worship and helped to keep her neighborhood safe by patrolling at night, volunteering as an Air Warden. This poem was penned by her life-long friend. It references her many activities during World War II including her prolific quiltmaking. Her Grandmother's Flower Garden quilt is one of the three hundred and fifty plus quilts completed by Ruth during her lifetime. She was honored in the 1950s in Life Magazine for her quiltmaking skills. Ruth's tombstone in Willimantic, Connecticut is engraved with the words "The Quilt Lady."[18]

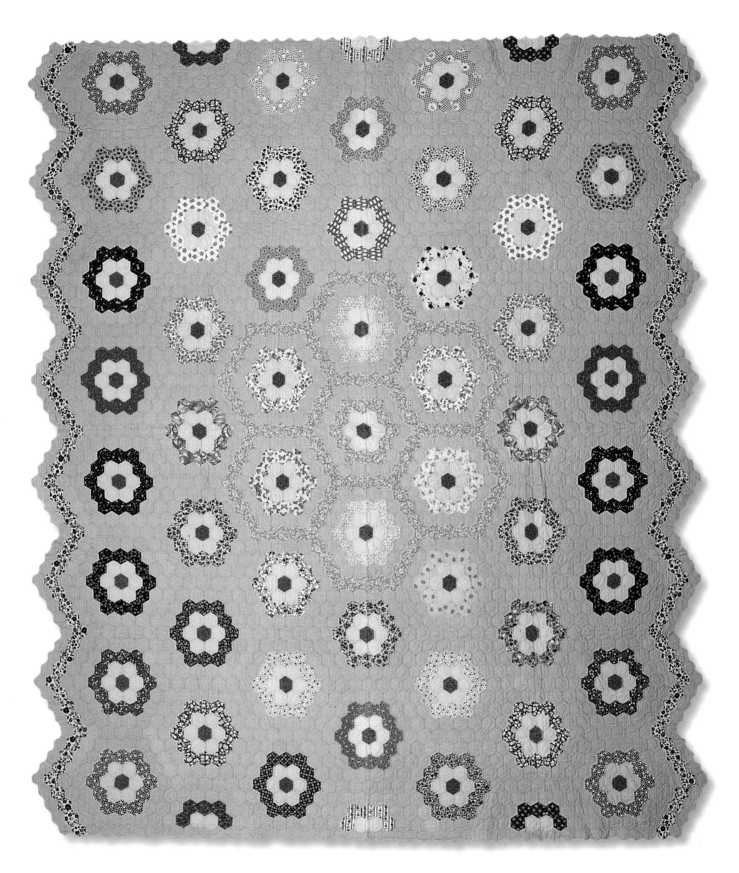

Grandmother's Flower Garden Quilt, made by Ruth Snow Bowen (1895-1983), Chaplin, Connecticut. Hand pieced, hand quilted, 86 inches x 99 inches, cotton.

The Quilt Enthusiast

In the big white house on Main Street
Lives a lady quite petite
She plies her needle night and day,
And feels it's quite a treat.

She set the quota just a hundred
To piece and tie the quilts
So far she's pieced just forty-two
And feels a sort of guilt.

She's quilted, oh yes, ninety-five
For folks all round the town—
They're pieced in every pattern
Colors: pink, red, yellow, brown.

She cooks and keeps her house so clean
She knits, crochets and tats,
She's edged a thousand handkies,
 Now what do you think of that?

She will sell you pretty post cards
Any kind you like—
Her fingers fly over piano keys
And I'll bet she can ride a bike.

If you want a pretty picture
Of a favorite spot in town,
Just give to Ruth your order
She'll gladly write it down.

O Sunday there is time for Church
There is time for a friendly smile,
That is what makes life worth living
And shortens the longest mile.

Now, when she goes to bed at night
She sets the old alarm—
Goes out at three in the morning
To guard the town 'gainst harm.

All I can say is, she is faithful
 No matter what her task,
To have her patience and faithfulness
Is all anyone could ask.

If I've omitted anything
I gladly leave this space
For any word you wish to add,
 Now is the time and place.

May, 1942 HELEN SNEDEKER [19]

In the Name of the OPA [20]

The Office of Price Administration (OPA) was a government agency in charge of the distribution of nearly all consumer goods during World War II. Its operation began in 1941, before the bombing of Pearl Harbor, in anticipation of shortages of everything from nylons and gasoline, to milk and metal. The office was responsible for the fair allotment of rationing books that were exchanged for necessities to meet the basics of daily life at home in America. Restrictions imposed by the OPA made them the recipient of considerable criticism.

The following article in the *Zanesville Signal,* and the unusual design of a quilt made by Bertha Stenge, provide some indication of the public's unfavorable attitude of the Office of Price Administration.

Irreverent poems printed October 19, 1943, in the *Zanesville Signal*, Zanesville, Ohio, were titled "Gracie Allen's Alman(i)ac." They were prefaced with the following explanation: "We live in a world of realism today. I believe our children should enjoy Mother Goose as we did, but it might be wise to revise the classics slightly to condition their little minds along useful lines, such as:

Hey diddle, diddle, a rationing riddle.
The price of cow jumped over the moon:
The OPA mourned to see such sport,
And said "Okay, the dish can run away with the spoon.
There isn't much else for them to do.

Little Miss Muffet sat on a tuffet
Eating of curds and whey
There came a big spider and sat down beside her.
Saying: "What! Not butter today?"

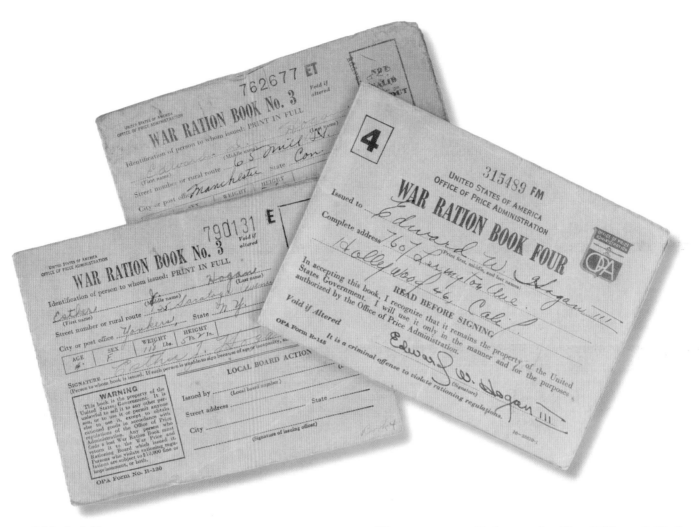

Little Jack Horner
Sat in a corner
Eating a meatless pie:
He stuck in his thumb
And pulled out a plum
And said: "There goes 16 points off my rationing card."

Sing a song a six pence (hack a slice of rye)
Four-and-twenty blackbirds baked in a pie
When the pie was opened the birds began to sing—
'Twas quite a change from horsemeat to set before the
 king.

The Queen of Hearts
She made some tarts
All on a summer's day
The Knave of Hearts
He seized those tarts
In the name of the OPA. [21]

Women were called upon by The Office of Civil Defense to consider using their quilts as "blackout" drapes in their homes. An article in the *Evening Times*, Cumberland, Maryland, on January 29, 1942, stated,

Before you buy anything, though, consider whether you really need to take that stuff out of your nation's war chest. Think of this particularly when you hanker after cotton or wool fabric. Uncle Sam urges you to conserve both. Cotton spinning and weaving machinery are loaded down and additional sudden increase in demand of it would tighten the bottleneck. Wool, even, in the raw, is limited in supply with the armed forces getting first call, of course. So if you can use your ingenuity and use something out of the scrap-pile—and many certainly can—Uncle Sam says "Please do". [22]

The OCD cautioned that care must be taken to prevent "light leakage" and the "blackout" drapes must be "splinter proof" in the event of flying glass.

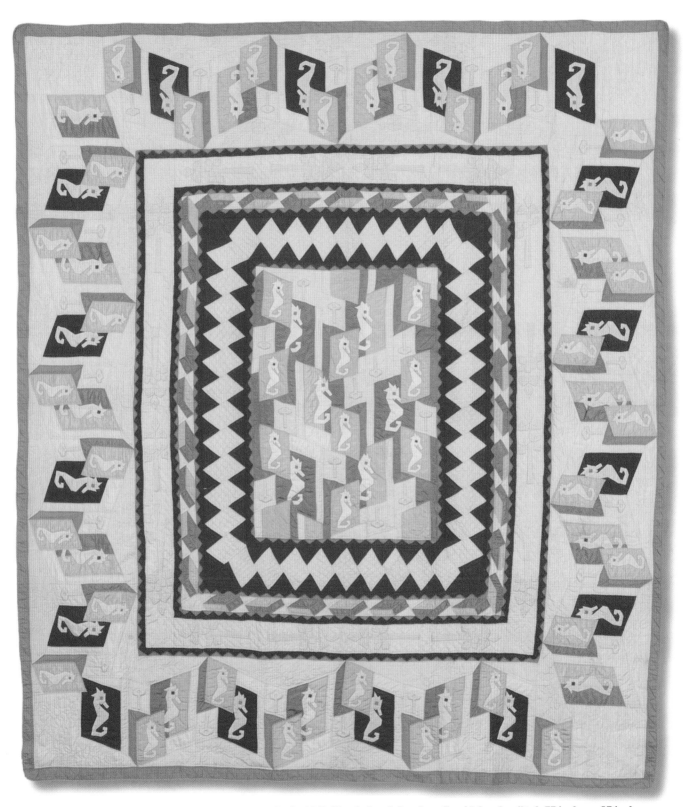

The OPA Quilt, made by Bertha Stenge, Chicago, Illinois, 1943. Hand pieced, hand appliquéd, hand quilted, 77 inches x 87 inches, cotton. A famous Illinois quiltmaker, Bertha Stenge made at least three quilts with direct connection to World War II. Her Victory quilt and her Four Freedoms quilt, are also featured in this book. Bertha may have employed humor, criticism or satire when she designed and pieced her OPA quilt. The appliquéd ocean creatures resemble seahorses and make little sense with the fish tin keys. The intricate background pattern is similar to a block known as "Card Tricks." Piecing this quilt was very difficult. There are no obvious blocks to define the piecing technique. The quilt was constructed with polished cottons in pastel colors that most observers would never connect to the World War II years. There was no provenance beyond the quilt's name, provided by Bertha or her family. *Courtesy of Illinois State Museum.*

The Saturday Evening Post, **August 28, 1943, page 93.**

These thrifty practices were also extended to quiltmaking ads and many of the quilt patterns published during the war. In a *Farm Journal* advertisement for Mountain Mist® Quilt Cotton Glazene Batting, in March, 1945, quiltmakers were encouraged to "Use Your Scraps To Piece or Patch a Quilt."

Pattern designer, Laura Wheeler, published two quilt patterns in 1942 with the following directive:

Scrap quilts conserve materials! And the more varied your scraps, the prettier your quilt will be! And the Star of the East blocks add up quickly! [23]

With the "Nosegay Quilt," pattern # 254, were these words:

In these times of constant strain and worry, there's a blessed comfort to be had in working with your hands. More and more smart modern women are finding needlework as an outlet for emotional tension. This quilt is a perfect way to use up the colorful odds and ends in your scrap bag. [24]

And on July 28th, the *Monessen Daily Independent,* featured the "Friendship Fan," #395, with the following encouragement:

Be economical! Don't let those scrap prints lie idle. Place them together into this quilt, Friendship Fan – an old-time favorite that's as colorful as it is easy to make! [25]

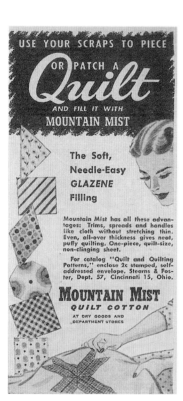

Farm Journal, **March, 1945.**

That's what a lot of people think, Madge. True enough, Cheney and Silk were synonymous for nearly a hundred years. But you'd be surprised what Cheney means now, in addition to silk.

For example, Cheney means parachutes of nylon. Because their skill in designing textile machines and in weaving processes were vital time-factors when war broke, Cheney became the world's largest producers of parachutes.

Like other textile manufactories across the United States during World War II, the Cheney Silk Mills, of Manchester, Connecticut, focused their production efforts on providing goods solely for the United States war effort.

Collier's, June 2, 1945, page 41.

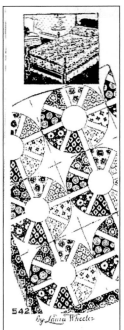

Bottom Row, left-right:

The Daily Independent, Monessen, Pennsylvania, Tuesday, July 26, 1943, page 3

The Daily Independent, Monessen, Pennsylvania, Saturday 15, 1942, page 3, and *The North Adams Transcript*, North Adams, Massachusetts, Thursday, July 30, 1942, page 17.

The Amarillo Daily News, Amarillo, Texas, March 20, 1942, page 4.

Kingsport Times, Kingsport, Tennessee, Monday, March 23, 1943, page 5.

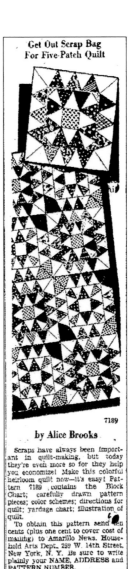

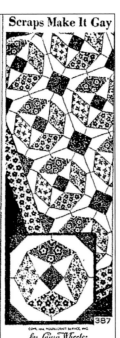

Eyes Aloft, made by Mary Smith Landry Grant between 1942 and 1945, for Theodore Twisselman, who was in charge of the local Aircraft Warning Service, called the Annette-Choice Valley observation post. Mary embroidered the names of the spotters who served at this post in white on the blue stars. In the center of the quilt embroidered in red are the names of the men from the area who were in the military. This photo was taken when the quilt was on display at the Reagan Library. *Courtesy of Frank and Pat Twisselman*

Franklin Delano Roosevelt

A Wartime President

Late in the 1930s, United States President Franklin Delano Roosevelt warned the American people several times about the gathering threats to world freedom growing in Europe. On January 6, 1941, in his State of the Union Address, he laid out the need to bring the peace and freedom to our allies in Europe.

In the future days, which we seek to make secure, we look forward to a world founded upon four essential human freedoms.

The first is freedom of speech and expression – everywhere in the world.

The second is freedom of every person to worship God in his own way – everywhere in the world.

The third is freedom from want – which, translated into world terms, means economic understandings which will secure to every nation a healthy peace time life for its inhabitants – everywhere in the world.

The fourth is freedom from fear – which, translated into world terms, means a world-wide reduction of armaments to such a point and in such a thorough fashion that no nation will be in a position to commit an act of physical aggression against any neighbor – anywhere in the world."

—excerpted from the State of the Union Address to the Congress, January 6, 1941[26]

President Roosevelt died on April 12, 1945, while serving his fourth term in office, just a few short months before V-E Day (Victory in Europe) and V-J Day (Victory in Japan).[27] During Roosevelt's terms in office, there were many quilts and quilt patterns designed and made in his honor.

Bertha Stenge's Four Freedoms Quilt was featured in the August, 1945, *Woman's Day Magazine*, on page 41.

Four Freedoms Quilt, made by Bertha Stenge, Chicago, Illinois, 1941. Hand pieced, hand appliquéd, hand quilted, 84 inches x 102 inches, cotton. *Courtesy of Illinois State Museum.*

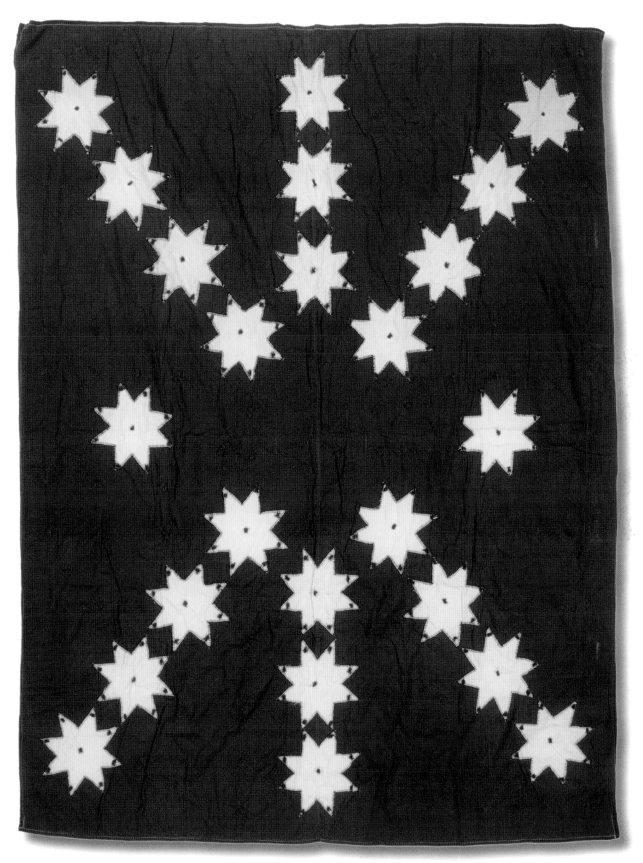

1941 Red, White, and Blue Quilt. Quiltmaker unknown. Machine pieced, hand appliquéd, hand tied, 79 inches x 103 inches, cotton. This patriotic quilt was made at the beginning of the War. The quiltmaker left us with few clues except for the date, 1941, and her choice the patriotic colors.

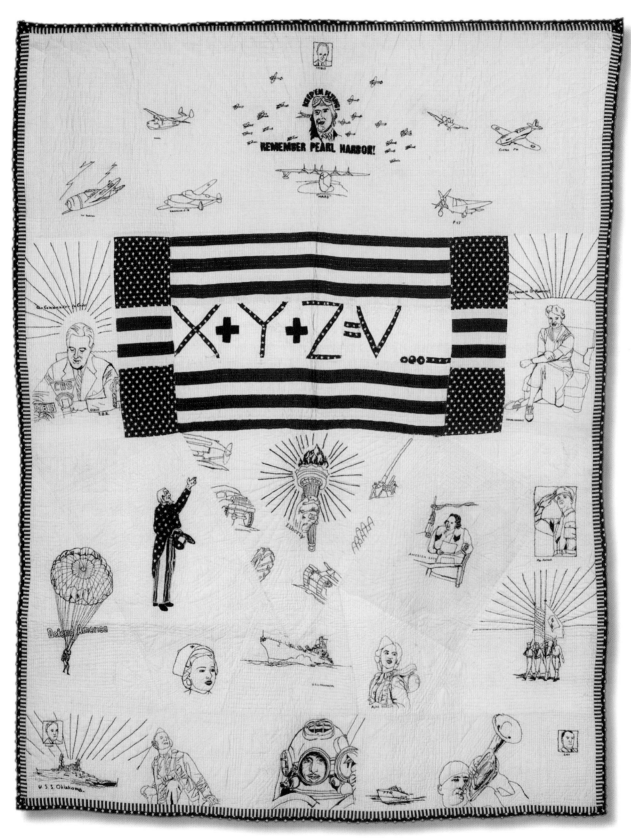

"Keep 'em Flying. Remember Pearl Harbor." Quiltmaker unknown. 52 inches x 66 inches, cotton. Images of Franklin and Eleanor Roosevelt with patriotic symbols embroidered in black: a pilot, several planes in flight, a large rectangle with the stars and stripes, and "X + Y + Z = V." There are also images of a hand holding a torch and various means of transportation and figures from the Armed Forces. *Courtesy of the Franklin D. Roosevelt Library and Museum. Photography by On Location Studios, Poughkeepsie, New York.*

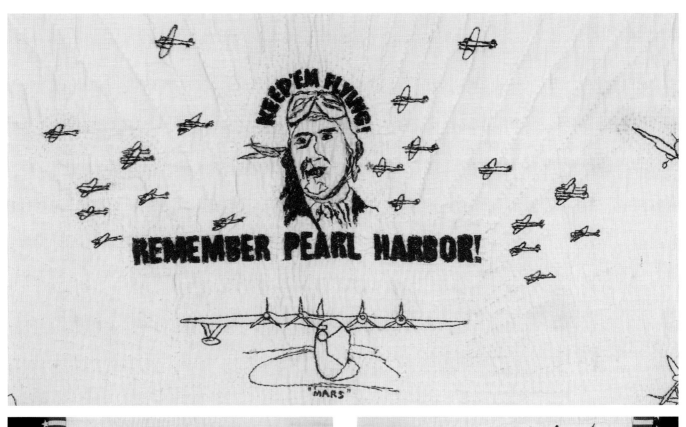

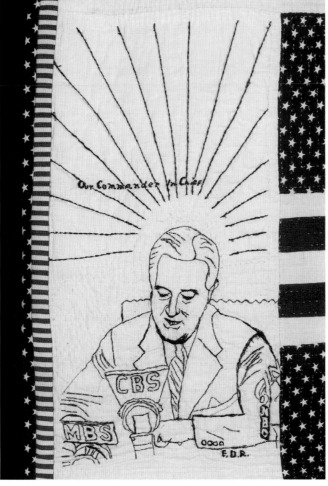

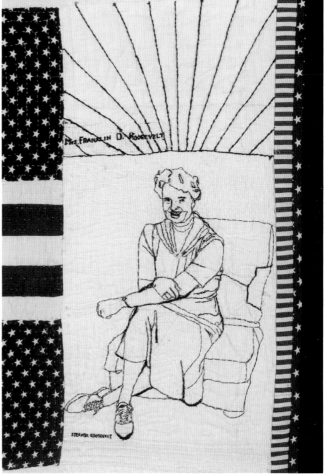

The President Franklin D. Roosevelt Quilt

Canadian-born Hermina Mathilda Gervais proudly expressed her patriotic zeal for America in the red, white and blue quilt she made to honor Franklin Delano Roosevelt. The quilt, dated 1933-1940, was expertly appliquéd with detailed eagles in the four corners, and the center embroidered with a portrait of President Roosevelt flanked by two American flags. Initially, Hermina had appliquéd the dates of "1933-1936" on her quilt. When Roosevelt won a second term in office, she changed the 1936 date to 1940. After Roosevelt's subsequent successful elections, Hermina left the 1940 date on her quilt.

Hermina Giroux came to live in Vermont in 1919 at the age of 20. After marrying in 1922, she settled in Hinesburg, Vermont, to raise her three sons. Prior to her marriage, Hermina worked as a seamstress. She continued to use her sewing skills to make clothes for her children, 21 grandchildren, and for herself. Hermina enjoyed craftmaking and quilting. With the exception of this quilt made in honor of Franklin Roosevelt quilt, most of her quilts were scrap and utility quilts.

Hermina demonstrated her love for America and its President with the creation of her quilt in the late 1930s. At that time, her homeland of Canada was already fighting to help defend England in the European theater. By the war's end in 1945, Hermina expressed her ultimate commitment to the United States by becoming a Naturalized American citizen. [28]

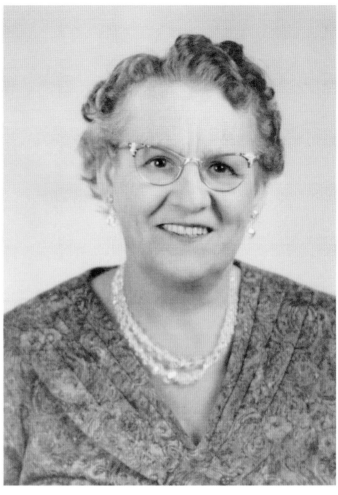

Hermina Mathilda Gervais Giroux, Hinesburg, Vermont, 1899-1992.

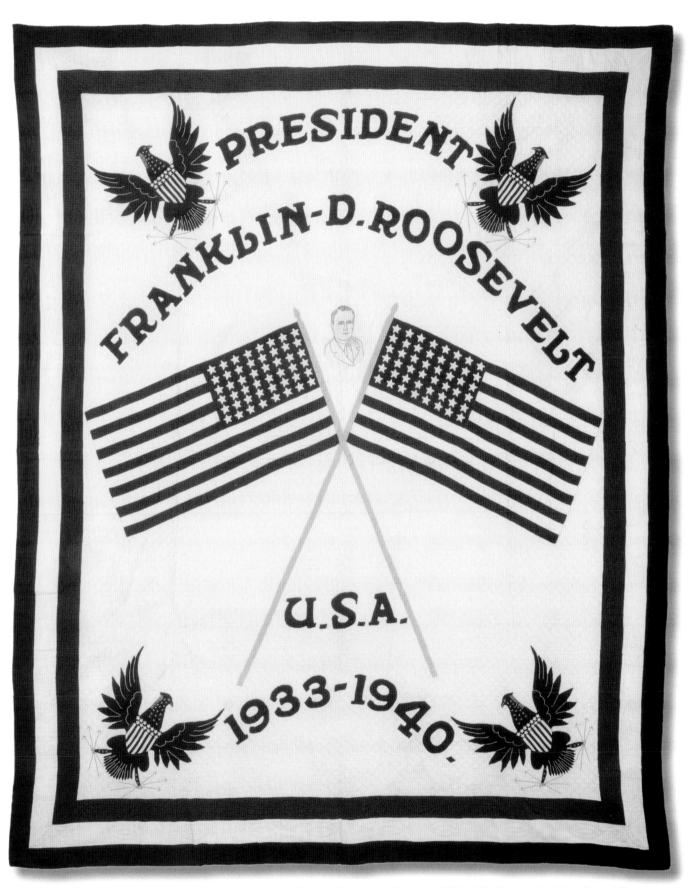

President Franklin D. Roosevelt Quilt, made by Hermina Giroux, Hinesburg, Vermont, 1933-1940. Hand embroidered, machine assembled, hand quilted, 83 inches x 104 inches, cotton, polished cotton, felted wool. *Courtesy of Sue McGuire*

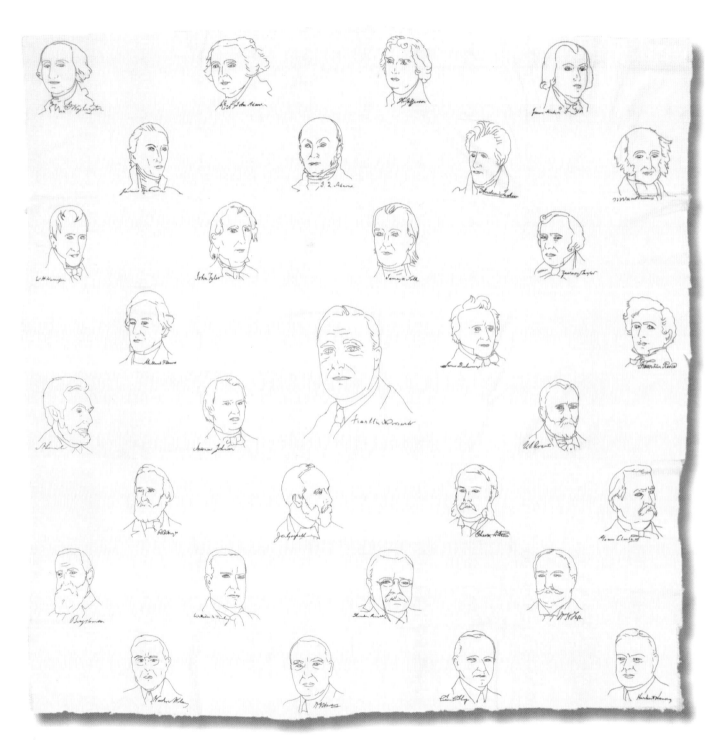

The Presidents Quilt Top. Quiltmaker unknown. Machine assembled, hand embroidered, 63 inches x 67 inches, cotton.

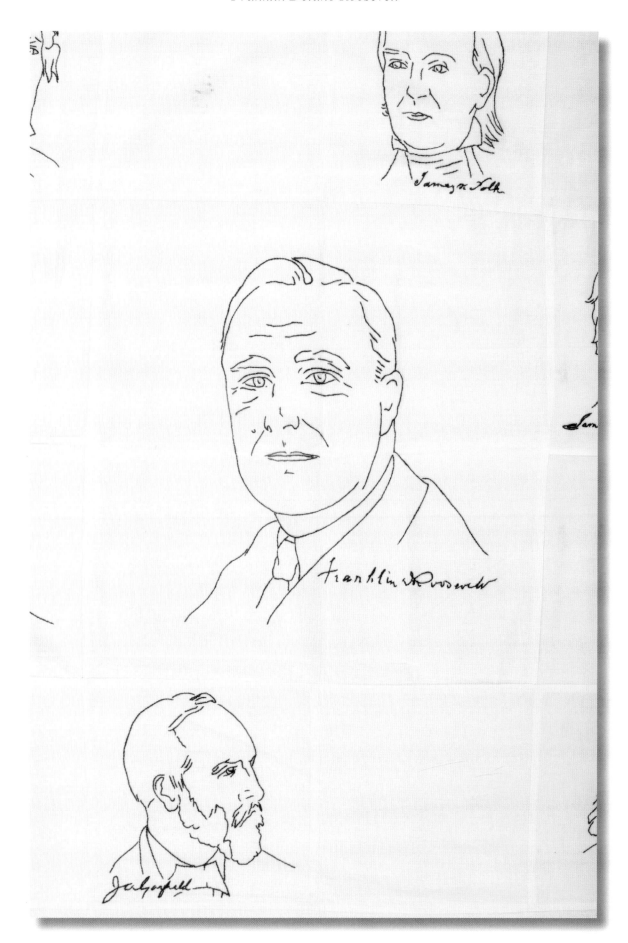

The President Roosevelt,
Kansas City Star – Bulliner,
May 17, 1944.

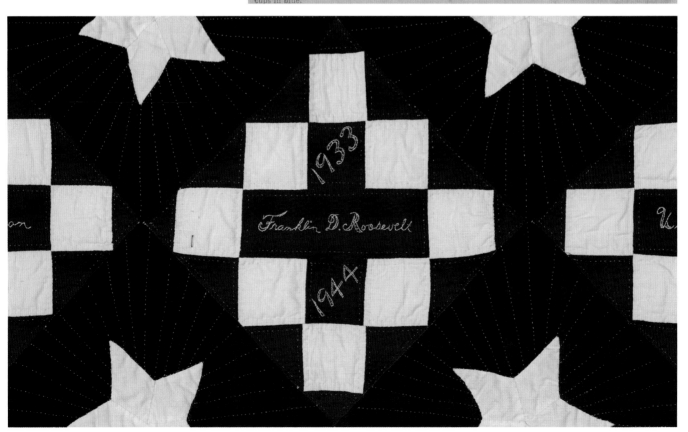

Detail of the Presidential Album and Star Quilt.

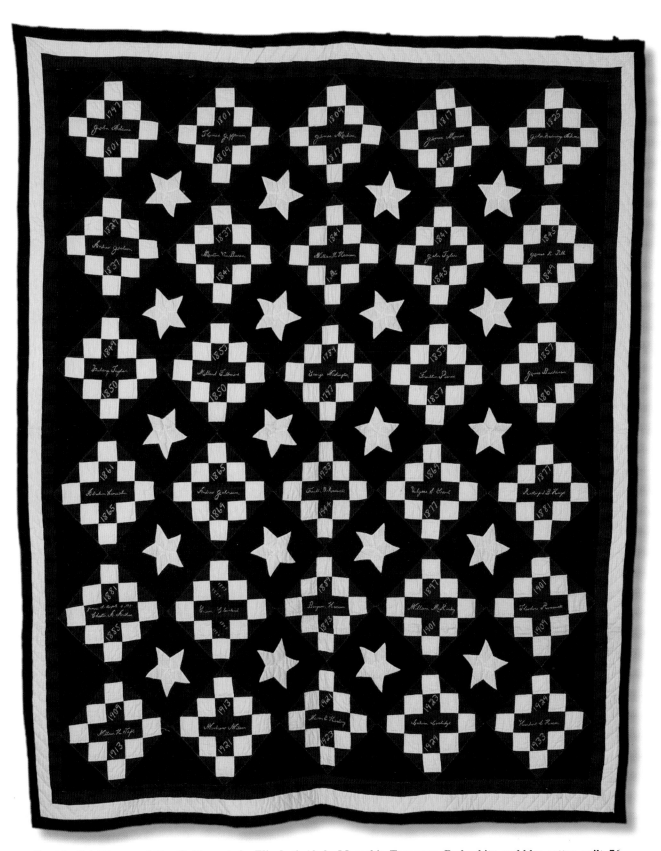

Presidential Album and Star Quilt, made by Elizabeth Abele, Memphis, Tennessee. Red, white, and blue cotton quilt, 76 inches x 93 inches. The Album blocks of this quilt were embroidered with the names and dates of office of the US Presidents up to and including President Franklin Roosevelt, who is in the center. *Courtesy of the Franklin D. Roosevelt Library and Museum. Photography by On Location Studios, Poughkeepsie, New York.*

Eleanor Roosevelt, First Lady

Dear Lord,
Lest I continue
My complacent way,
Help me to remember that somewhere,
Somehow out there
A man died for me today.
As long as there be war,
I then must
Ask and answer
Am I worth dying for? [29]

Eleanor Roosevelt's wartime prayer reflects her complete understanding and sympathy for the supreme sacrifice over 400,000 Americans would make for their country during World War II. She and Franklin Roosevelt were married for 36 years when America officially entered the war.

On St. Patrick's Day, 1905, Franklin Roosevelt wed Eleanor Roosevelt, his fifth cousin once removed. Eleanor's uncle was President Theodore Roosevelt, the 26th President of the United States.

Throughout FDR's presidency and during World War II, Eleanor wrote a syndicated newspaper column, "My Day." She personally visited war-torn Britain. Her monumental achievements as First Lady and through the years beyond brought her international acclaim. Historically, she is one of America's most respected and admired women

Many quilts and quilt patterns were produced in Eleanor's honor. "Roosevelt Rose" was designed by Republican Ruth Finley in 1938, and she presented the quilt to Eleanor Roosevelt. Democrat Minnie Pearl, of Bristol, Connecticut, was such a big fan of President Roosevelt that she created her own "Roosevelt Rose" quilt from the Ruth Finley design. [30]

Eleanor Roosevelt's speech on V-J Day at the end of the war embodied her advocacy for the women of our nation.

For the happy wives and mothers of my own country and of the world, my heart rejoices today, but I can not forget that to many this moment only adds poignancy

'ROOSEVELT ROSE' QUILT ACCEPTED

Authority on American Handicraft Creates Design to Memorialize Present United States Administration

Left, "Roosevelt Rose" quilt; right, Mrs. Ruth E. Finley.

By Central Press

Mrs. Ruth E. Finley, authority on quilting, and author of the book, "Old Patchwork Quilts and the Women Who Made Them," designed the quilt pictured, which is the "Roosevelt Rose" pattern and was presented to Mrs. Franklin R. Roosevelt by Miss Helen Koues, director of a national magazine fashion bureau.

Mrs. Roosevelt, in accepting the beautiful quilt, expressed her interest in the movement to stimulate among the women with leisure the revival of quilt making—a strictly American folk art that has occupied American housewives since before the Revolution.

The "Roosevelt Rose" quilt is an excellent specimen of the amateur quiltmaker's art, and continues the series of historical quilts which were designed to symbolize the administrations of United States presidents.

Among the quilts treasured at the White House were "Washington's Own," "The Dolly Madison Star," "Harrison's Rose," and "Log Cabin." Pres. Lincoln was the last president to have a nationally known quilt pattern named after him, although one more was named for an occupant of the White House. This was "Mrs. Cleveland's Choice." The record stopped then, until the "Roosevelt Rose" came to being.

Mrs. Finley attributes the decline of quilting after the Civil War to the general use of the sewing machine. Her research reveals that handwork and handicrafts always are revived in times of depression and she expects that with the new leisure brought about by the turning to the old arts, and that quilting will revive to a greater extent than it has in the depression just passing.

The Brownsville Herald, **Brownsville, Texas, Sunday, January 14, 1934, page 6.**

to their grief. All women, wives and mothers, sisters or sweethearts, who have had men involved in this conflict, know what it is to live with fear as a constant companion. Some women will still have to help their men fight the aftermath of war in their own lives. Other have lost forever the men they hold dear....Many of us are hoping that the very suffering which women of all nationalities have been through, will bring about a greater kinship among them than has ever existed before. The power of women for good should be intensified because they will surely determine to work together in order to insure that the forces of the world are used for constructive purposes. [31]

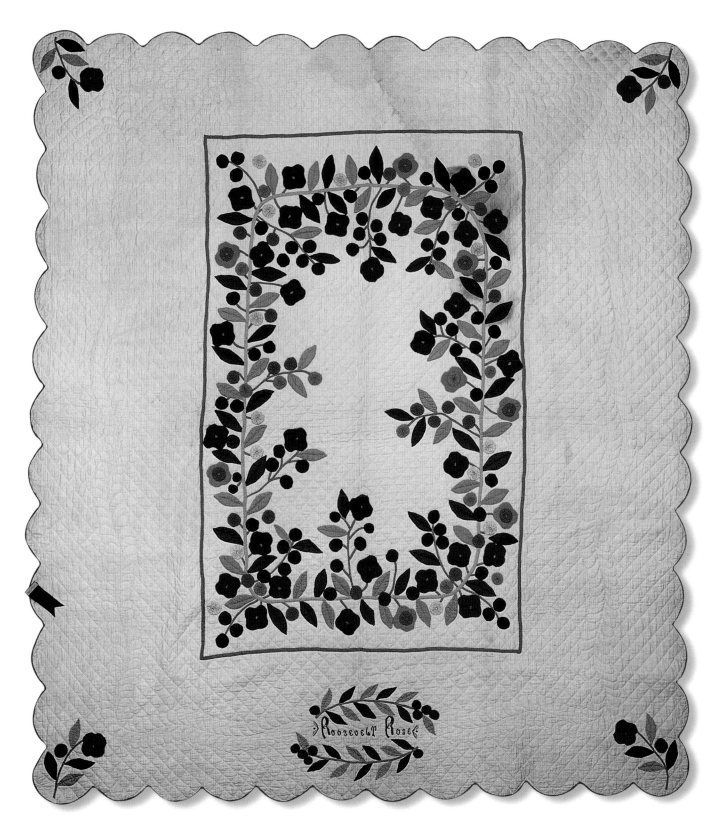

Roosevelt Rose, made by Minnie Pearl Pardee Barrett (1874-1958), Bristol, Connecticut. 90 inches x 101 inches, cotton. *Photo courtesy of the Connecticut Quilt Search Project.*

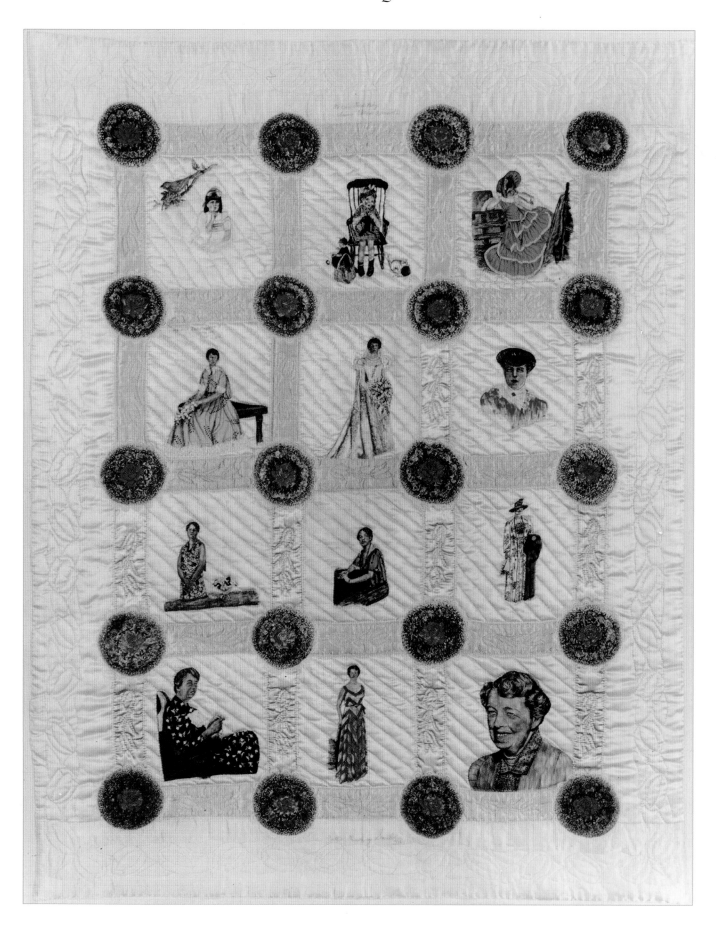

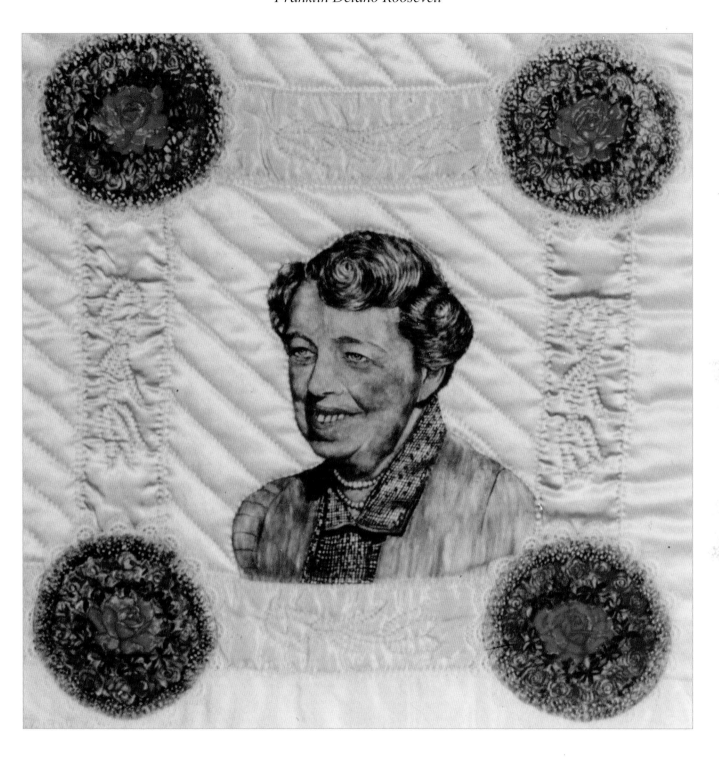

Opposite:
Eleanor Roosevelt Album, made by Callie Jeffress Fanning Smith, 1940. 61 inches x 77.5 inches. An embroidered phrase "to our First Lady," was the endearing message stitched on this quilt. The quilt squares portrayed Eleanor from childhood to her White House years dressed in appliquéd fashions with her face expertly painted. *Courtesy of the Franklin D. Roosevelt Library and Museum.*

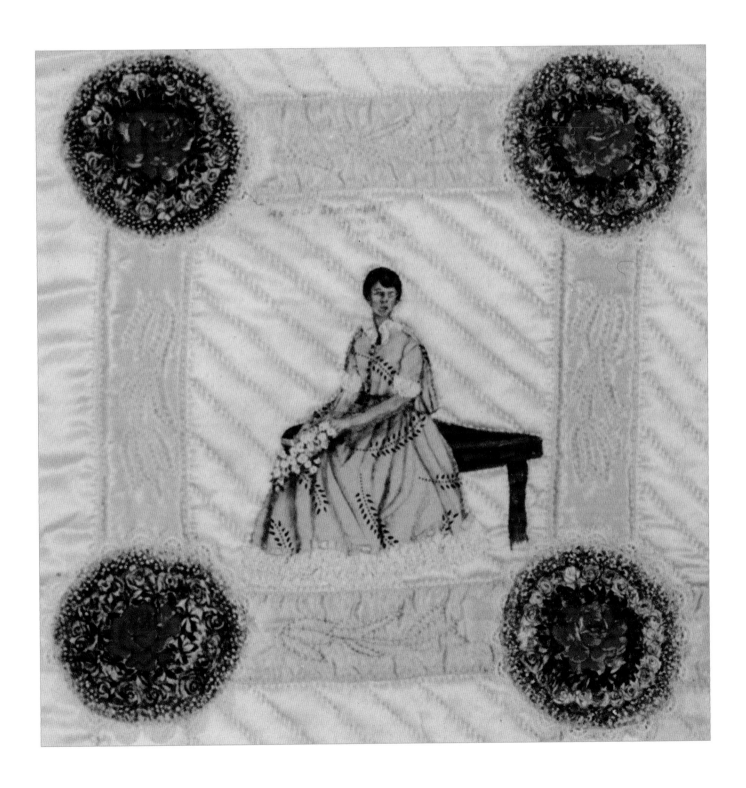

Fala: The First Dog

During this period, many quilts were made to honor Franklin and Eleanor Roosevelt and even their pet dog, Fala, a Scottish terrier. Scotty patterns were popular throughout the 1930s, however, not all were linked to Fala. He only arrived on the national political stage on November 10, 1940.[32] Like most First Pets, Fala became a center of attention for news reporters of the day. Whimsical tales of President Roosevelt's most constant companion were widely reported in the nation's newspapers.

Fala was born in Connecticut, on April 7, 1940. His official name was Murray Falahill, and he was called Fala for short.[33] An article published just a few months after Fala arrived at the White House in *The Zanesville Signal*, Zanesville, Ohio, on October 9, 1941, titled: "Fala Sits In on So Many Conferences That He's Beginning to LOOK Like a Statesman!" The article reports that:

> He might have given "Bundles for Britain" some stiff competition judging from the number of sweaters and jackets that have been knitted for him.[34]

On April 7, 1942, newspapers updated the public on Fala's latest capers in celebration of his second birthday. He was noted as "a little guy who knows President Roosevelt and Winston Churchill so well he can tell you the color of their shoelaces had a birthday today," and "who, at the age of two, has been a part of more historic conferences than any human alive, except his boss, the president." [35]

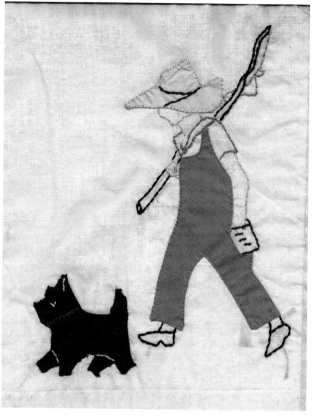

This youthful applique block was made in patriotic colors.

Ironwood Daily Globe, Ironwood, Michigan, Monday, October 19, 1936, page 6.

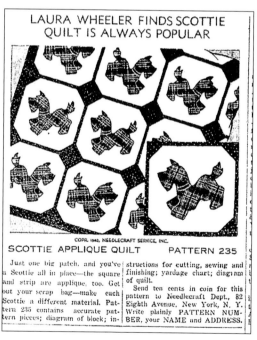

The Daily Independent, Monessen, Pennsylvania, Monday, January 19, 1942, page 3.

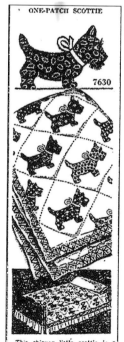

The Zanesville Signal, Zanesville, Ohio, Saturday Evening, November 13, 1943, page 4.

Children, Wives, Mothers, and Grandmothers of World War II

The quiltmakers of the World War II era were the children, sisters, wives, mothers, grandmothers, and aunts of the soldiers on the battlefield. Daily newspapers across the United States and Canada contained thousands of accounts of quiltmaking to meet the war effort. Many more thousands of quilts were made and kept within their families, stored in trunks and attics as Americans moved on with their post-war lives.

Children of World War II

The children were the young people up to 18 years of age. Most of them grew up during the Depression years; their seeds were set for frugal living. They listened to fireside radio reports about the war in Europe and the Pacific. Blackout blinds darkened their homes at night as they snuggled into bed. In daylight hours, they collected cigarette wrappers, tin cans, scrap metal, and many other objects that would normally be placed in the trash. The youth of World War II proudly served their country as industriously as the adults around them. Many of the young men, upon reaching the age of eighteen years, quickly enlisted in the nation's military services.

In the *Denton Journal*, Denton, Maryland, on October 17, 1942, a column entitled "Newsy Items About Events At Caroline High School," reported the following:

We're Building a Mountain of Scrap—Let's Keep It Coming!

Yes, we're building a mountain of scrap but remember! We can never get too much! Mr. Crouse

has proclaimed the town's contributions excellent, and collection of scrap from farms is progressing favorably. Last Saturday, October 3, much scrap was collected in Denton, and some was brought in from surrounding

SERVICE ON THE HOME FRONT

★ CITIZENS DEFENSE CORPS
★ CITIZENS SERVICE CORPS
★ AMERICAN UNITY
★ SALVAGE PROGRAM
★ VICTORY GARDENS

There's a job for every Pennsylvanian in these CIVILIAN DEFENSE EFFORTS

PENNSYLVANIA STATE COUNCIL OF DEFENSE
CAPITOL BUILDING, HARRISBURG, PENNA.

areas….Much credit for the success of these drives goes to the splendid cooperation of school boys and girls and to those who generously lent the services of their trucks. With such a spirit of cooperation and patriotism there is no limit to how much scrap we will be able to collect! An all out effort must be made if our steel mills are to be kept going full blast for victory. A reservoir of scrap metal must be built up now to see us through the winter when collection of scrap is very difficult because of ice and snow. Collection of scrap will continue until the war is won, but we must go all out now to relieve the present scrap crisis. In Germany and Japan a person found possessing valuable scrap would be fined and punished severely. Surely no fine or punishment is needed in America to induce everyone to turn in his scrap for a cause we know is right. Let's do it the American way, and shower the Axis bandits with scrap until they are crushed beneath it. Let's go Caroline! Let's go, America![36]

The high school-aged youth served many important roles in World War II. They were permitted to leave school to search the skies for enemy aircraft. To prepare for this, they studied booklets and charts identifying friendly aircraft and the planes of the enemy. The airplane quilts of this period strongly resemble those instructional charts and pamphlets.

As early as primary school, children sewed and knitted to raise money for the war effort, the Red Cross, and Bundles for Britain.[37] They participated in these activities through church groups, the Girl Scouts, and within their schools. *The Mason City Globe-Gazette*, Mason City, Iowa, reported on March 5, 1942, "NORA SPRINGS—Grade pupils in the Nora Springs school are taking an active part in Red Cross work this spring, devoting every spare moment to the piecing of quilt tops…."[38]

In *The Kingsport Times,* Kingsport, Tennessee, on January 15, 1943, gave this account: "Twenty-two Senior Service Scouts are completing their 20 hours required for Red Cross certificates in first aid, and the Fordtown Girl Scouts are making a quilt to be donated to the Red Cross."[39]

Victory Leaders Bands Quilt

Perhaps one of the most extraordinary wartime quiltmaking efforts came from the youth of a church whose national offices were located at the Bible Place, in Cleveland, Tennessee. Known as the Victory Leaders Bands, the young people of The Church of God wanted to show their support for the leaders of their states and nation. A letter, dated August 28, 1943, was sent to Major General Edwin D. Watson, Secretary to President Franklin D. Roosevelt. It stated: "We would like to assure our President that we are standing with him one hundred percent in our prayers and service for our country. God's blessing be upon him as he guides is our sincere desire.[40]

In 1943, the young people of The Church of God were busy using their sewing skills for a very ambitious project. Inspired by a motif of a shield, a symbol with both Scriptural and Patriotic significance,[41] the Reverend John A. Stubbs of The Church of God in Fresno, California, designed a quilt for the president. Most likely, he was inspired by the February, 1941, issue of *Farm Journal* where a pattern called "Liberty," with an appliquéd eagle above an identical red, white and blue shield, was one of the featured quilts. The original design for this shield was first published as Pattern #420, in 1901, by The Ladies Art Company. The pattern was sold in catalogs and booklets throughout the first half of the twentieth century.[42]

The Church of God quilt featured this exact shield enlarged as a central medallion and bordered with red, white and blue stripes and thirty smaller shields of the same design. The quilt, made by the church's young people, was finished for display at their annual assembly beginning on September 8, 1943.

Young people who make quilts are often singled out and praised for their industry. The young people of The Church of God proved their diligence with their ambitious undertaking, but their mission was even more impressive.

45

The quilt for President Franklin Roosevelt was only a fraction of their project, one forty-ninth, to be exact. Here is an account from the church minutes record, of the annual assembly of The Church of God, held on Saturday, September 11, 1943:

> ...at 4:01 p.m.—Honor Parade. This was a parade of the state secretaries (actually state directors who were called State Victory Leader's Band Secretary) and their assistants carrying quilts made for the President and governors. There were thirty-five quilts in the parade.
>
> The V.L.B. Secretary (Willard Boyles) read a portion of a letter she received from the President's secretary.
>
> The Secretary stated the Missouri V.L.B.s made quilts for the governors in the states where we do not have churches. D. R. Holcomb, the Overseer of Missouri, and Missouri V. L. B.s were called to the platform and commended for their good work. The President's quilt was made by Sister Edith Weidner and the church at Sacramento, California. The quilting was done by Zella Swanson and her sister, Cora Goins of California. Those present, who had assisted in preparing the quilt were called to the platform and commended for their faithful service.[43]

The Church's paper, the *White Wing Messenger,* also reported the event. "…The V. L. Bs. had prepared quilts for the President and Governors of states. These were dispersed by the State Secretaries and others. It was a beautiful sight as they marched across the rostrum carrying the quilts."[44]

An official invitation to attend the assembly was extended to President Roosevelt through the Church's secretary, Willard H. Boyles. The event showcasing the ambitious quilting project of the young people was worthy of President Roosevelt's attention, and he was invited to help them present the quilts to the governors of all 48 States. The letter stated: "We would be happy to have you present them, that we might present the gift as a token of our appreciation for your faithful service rendered for our country."[45]

Due to the great demands placed on the leader, President Roosevelt, through his Secretary Major General Edwin Watson, graciously declined the invitation with the following letter:

> The President has asked me to thank you for your interesting letter to him of August twenty-eighth. He was deeply touched to learn of the lovely quilt which the young people of The Church of God, of Cleveland, Tennessee, have made for him. He sincerely appreciates their thoughtfulness and regrets that he cannot attend the September eleventh session and receive this gift from

> them. With reference to your further suggestion that in the event the President cannot attend a member of your congregation be delegated to present the quilt to him here in Washington, may I be quite frank and explain to you our present policy in such instances? Since our entry into the war of 1941, the President has had to delegate to the members of his Secretariat the duty of receiving all gifts as the exceptional demands upon his time preclude his participating in person. May I suggest, therefore, that if you could care to mail this quilt to the President in my care, I shall be glad to see that it is placed before him promptly with a suitable word of explanation. I am sure that you will understand the need for this arrangement and will realize that it is not due to any lack of appreciation on the President's part.[46]

The touching intentions in words and the needlework of the young people may have moved President Roosevelt to an understanding of the tremendous support his countrymen gave the effort. On April 11, 1945, President Roosevelt penned the following for an address he was to make two days later. "But I am with you in heart. And in these times of trial, this greatest of all test of men and the leaders of men, of nations and the community of nations—up to this decisive hour I know that you have stood, and you stand now, most loyally side-by-side with me."[47] He ended his speech with the words, "Let us move forward with strong and active faith."

These were the last words the president wrote to be delivered in an address to the nation. The speech was never delivered on April 13, 1945. President Roosevelt died the day before.[48]

The patriotic red, white and blue shield quilt made by the young people of The Church of God from Cleveland, Tennessee, was received at the White House on October 7, 1943. The satin shields were pieced and appliquéd by hand by the children in support of their President and every State in the Union.

An article that appeared in the *Wisconsin Rapids Daily Tribune*, Wisconsin Rapids, Wisconsin, on July 14, 1944, reported the presentation of a patriotic quilt made by the young people of The Church of God to the governor of their state. Undoubtedly, this newspaper article referenced the same group of quilts exhibited at the Church of God in Cleveland, Tennessee.

> The presentation group, representing the Church of God, presented to Acting Governor and Mrs. Walter S. Goodland a quilt worked in a patriotic pattern. The quilt, made by a group of young people of the Church of God under the direction of Mrs., L.W. Stockwell, of Beloit, is one of 49 presented to each state governor and the President of the United States."[49]

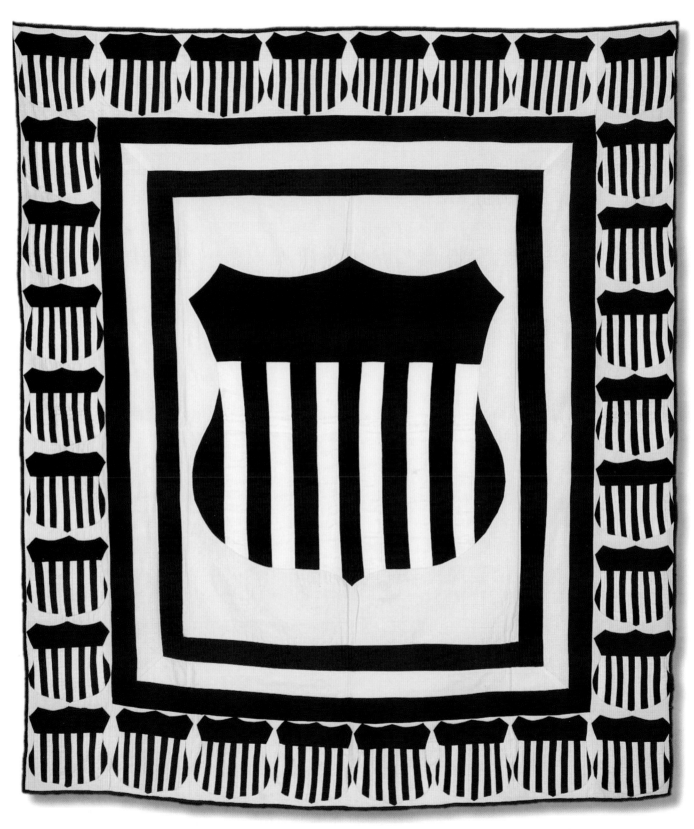

Patriotic Shield Quilt made by The Young People of The Church of God, Cleveland, Tennessee, 1943. Hand and machine pieced, hand quilted, 79 inches x 69 inches, satin. *Courtesy of The Franklin D. Roosevelt Presidential Library and Museum. Photography by On Location Studios, Poughkeepsie, New York.*

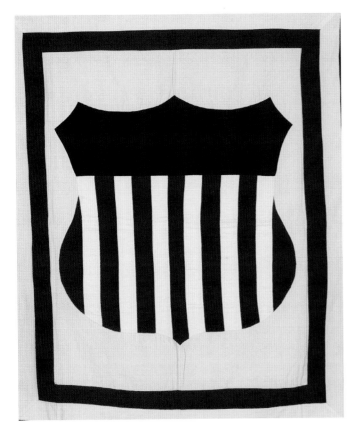

On September 2 of that same year, another report of the presentation of a Victory Leaders Band quilt was recorded in the *Salisbury Times*, Salisbury, Maryland. This article mentions a shield pattern most likely identical to that of President Roosevelt's quilt.

A presentation of a handmade shield patterned quilt was presented to Gov. Walter W. Bacon at his offices in the Legislative Hall, by Posey A. Shupe, state overseer of the Church of God for Maryland and Delaware, and Coy W. Snow, both of Salisbury, State Secretary for the same states of the church's Victory Leaders Band.[50]

The Wives of World War II

Who were the wives of "The Greatest Generation?" This deserving descriptive was coined by news correspondent Tom Brokaw to define the men and women who fought in World War II, both on the battle front and at home.

The wives of "The Greatest Generation" were born between 1900 and 1925. Many were children during World War I and others were born a decade later. For many of them, their teen years occurred during the Roaring Twenties decade. Undeniably, their most formidable experiences took place during the 1930s, the years of the Great Depression. Unknown to them, those years of strife were only a warm-up

for the sacrifices that would become necessary after 1941. During World War II, the young women, aged from 20 to 40, represented the group who left the home to assume jobs in the work force and defense industries. They often filled jobs usually held by men.

An article printed in a regular column, "WE, THE WOMEN," in the Edwardsville Intelligencer, Edwardsville, Illinois, November 6, 1941 sums up the dilemma that many women faced at the beginning of the War. "Most women have quit going around saying, "If I just knew what I could do to help with the national defense program….. The ones who were just talking to hear themselves talk have settled down to playing bridge again, already weary of the idea of becoming USEFUL. (They always spoke the word in capital letters.) The ones who meant what they said have thought up ways in which they can be useful and are preparing themselves for the kind of jobs they want to do…..

(Young married women) These young women have given the word "useful" a more practical meaning than the women who thought of it only in terms of learning to drive an ambulance or fly an airplane. If war comes and the husbands of these young women are called into the army, Uncle Sam will consider the women useful if they have prepared themselves so that they can earn a living for themselves and their children. If the conditions that exist in England today should ever exist here and city children

are taken from their homes and herded together for safety, these young women will find themselves actively engaged in national defense…..These young women have chosen a sure way of making themselves "useful." Other women could find just as practical solutions to the problem if they put their minds to it." [51]

Girlhood fantasies of fairy-tale weddings were dashed for wartime brides. Many women married when their fiancés arrived home on furlough from the battlefront. Others tied-the-knot in hurried-up ceremonies just prior to their deployment. Many of the dilemmas facing young war brides were recorded in the newspapers.

One of the winners of the 1943 National Sewing Contest was Mary E. McLaughlin, of Seattle, Washington. "

She won first prize in her standard pattern group senior division, for a navy blue gabardine suit she had planned to wear at her wedding. When she learned it had to be sent to New York to be judged in the finals, she sat down and whipped up another bridal outfit.[52]

Nuptial arrangements during the war years were humorously reported during June of 1943.

War brides are beginning to refer to it as their 'hopeless' chest. Those days of a hope chest stuffed with luxurious, satin-bound woolen blankets, delicate Irish linens, French and Belgian laces, are waning with the war. The war-time June bride stows her hope chest now with serving trays of plastic instead of silver, tablecloths of cotton instead of linen, and silverplate instead of sterling. And barring an heirloom gown, she'll probably walk down the aisle in rayon instead of silk. Her veil, if any, will be pre-war, because machines that once made lace, are now making camouflage nets. Guests, if they follow economists' hints, will thrown flower petals, instead of traditional rice—to save food. There will still be a trickle of linen arriving from Ireland, but not enough for all the hope chests of America. Table linens will be made of cotton. Sheets and blankets are shorter by several inches and the popular candlewick bedspreads are becoming scarce because the laborers in the South, who did the hand tufting, are now in war plants. Her chances of buying good utilty blankets now are better than they were six months ago, but those luxurious feather quilts are pretty much out, as is kapoc for pillows—it goes in life preservers now. [53]

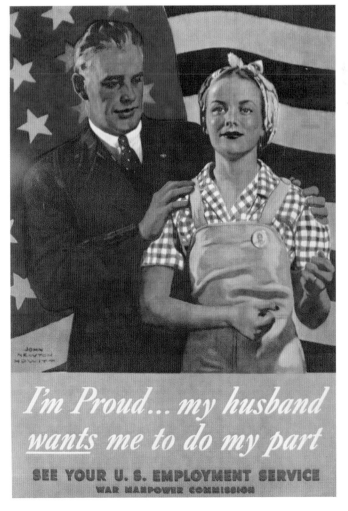

Photo taken at the Dedication of the World War II Memorial, June, 2004.

Parachute cloth and shrouds; warping nylon threads for use in the making of parachute cloth in an Eastern U. S. plant. The number of threads is 1,000. When one thread breaks, an electric switch stops the operation of all of the machines. This woman, of German descent, has a son in the U.S. Army. July, 1942. *Courtesy of the Library of Congress*

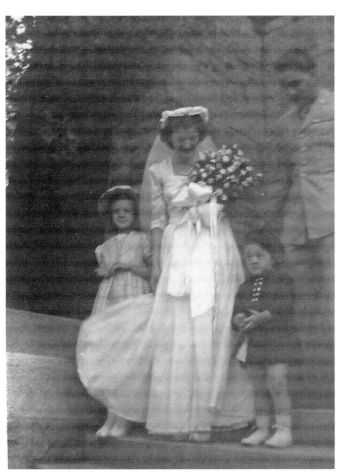

Mary Frances Winklmann was married on August 16, 1945, in Pittsburgh, Pennsylvania, in a wedding dress made from the nylon parachute brought back by her fiancé, David Moore, from his service with the 8th Aviation in France. He returned home with his parachute only two weeks before the wedding. Mary's mother and her two sisters spent hours undoing all of the parachute seams. Her Uncle Leo Weigl, a tailor, stitched Mary Frances Winklmann Moore's wartime nylon wedding dress. Parachute material and airplane wing fabric can be found in World War II era clothing, in the piecing of quilts, and sometimes as a quilt backing.

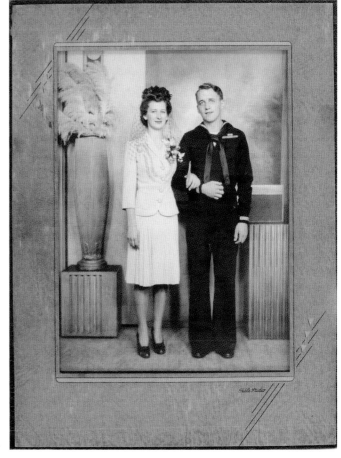

This is the wedding photo of Ruth and Harry Yeager, married in Philadelphia, Pennsylvania, on July 9, 1943, while Harry was on leave from the United States Navy.
Courtesy of Barbara Garrett

Bow Tie Quilt, made by the Ladies of the Congregational Church, Coaldale, Pennsylvania, July 9, 1943. 75 inches x 75 inches, cotton. This three-color quilt was made for the wedding of Ruth and Harry Yeager. Ruth grew up in Coaldale and moved to Philadelphia about 1938. Her mother quilted with the Congregational Church group. *Courtesy of Barbara Garrett*

Bridal Bouquet. Quiltmaker unknown. Hand pieced, hand quilted, 67 inches x 87.5 inches, cotton. The background area of white in this quilt was originally blue. Despite the fading in those blocks, the overall design of this quilt is patriotic red, white and blue.

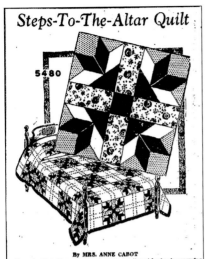

Steps-To-The-Altar Quilt

5480

By MRS. ANNE CABOT

Give an old fashioned "piecing" party for the girl who is marrying into the Army or the Navy. Each friend should be able to make one of the blocks at the party. You supply the material! Make the arrows leading to the "Altar" of plain material—the "aisles" should be a small flower-patterned material. This quilt design is an old one and as popular as matrimony itself!

To obtain cutting pattern for Steps-To-The-Altar (Pattern No. 5480) finishing directions, amounts of materials specified, send 10 cents in COIN, YOUR NAME and ADDRESS and the PATTERN NUMBER to Anne Cabot, The News-Palladium, 530 So. Wells St., Chicago, Ill. Enclose 1 cent postage for each pattern ordered.

Anne Cabot's FALL and WINTER Album now available—contains timely helps for warm knit and crocheted garments, patch work ideas, quilts, embroideries—send for your copy. Price 15 cents.

The News-Palladium, Benton Harbor, Michigan, Wednesday, December 30, 1942, page 4.

In these times of constant strain and worry, there's blessed comfort to be had in working with your hands. More and more smart modern women are finding needlework a useful outlet for emotional tension. This charmingly quaint nosegay quilt, photographed in a colonial setting by W & J Sloane, is made from the Laura Wheeler Pattern 254. It's a perfect way to use up the colorful odds and ends in your scrap bag. You'll find it easy to do, too! Why not make a daily habit of turning to the Laura Wheeler designs for knitting, embroidery, crocheting and quilting—they're a popular and exclusive feature of this newspaper. To get Pattern 254, send TEN CENTS, plus ONE CENT to cover cost of mailing, to The Morning Herald, Needlecraft Dept., 82 Eighth Avenue, New York, N. Y.

The Morning Herald, Uniontown, Pennsylvania, Tuesday, February 10, 1942, page 7.

History in the Making

BY HENRIETTA MURDOCK
Interior Decoration Editor of the Journal

War Bride's Quilt and Navy Wives' Quilt, *Ladies Home Journal*, January, 1943, page 40.

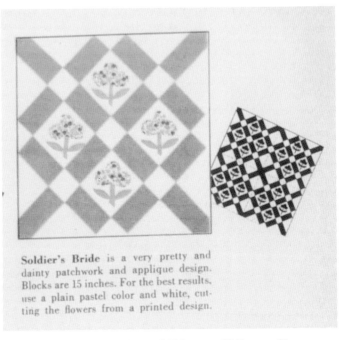

Soldier's Bride is a very pretty and dainty patchwork and applique design. Blocks are 15 inches. For the best results, use a plain pastel color and white, cutting the flowers from a printed design.

"Soldier's Bride," *Farm Journal*, February, 1943, page 62.

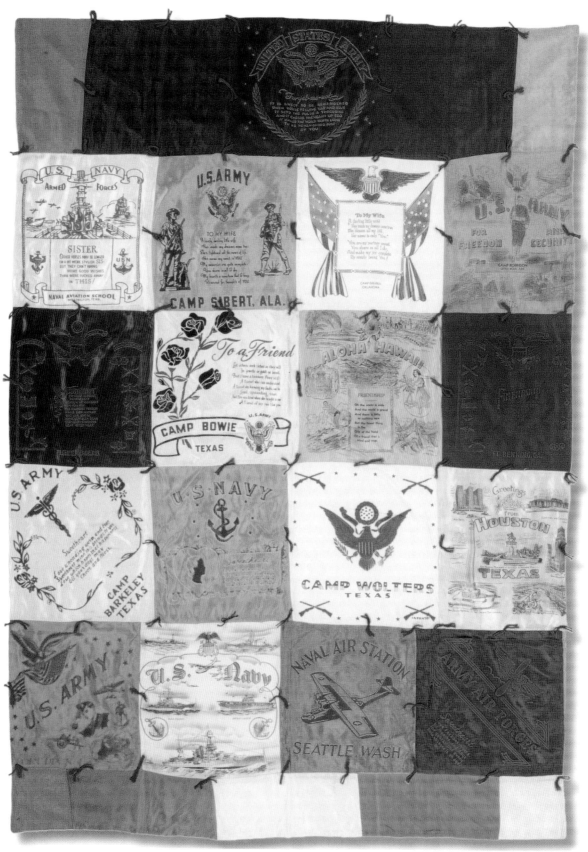

Sweetheart Pillow Quilt. Quiltmaker unknown. Machine pieced, hand tied, 59 inches x 86 inches, silk. Seventeen different sweetheart pillow covers that had been sold on military posts were sent to this lucky woman by her friend, sweetheart, husband, and brother serving in World War II. These popular souvenirs were sold at military stations across the U.S. They are printed with touching poems of appreciation and love for the recipient and for the country.

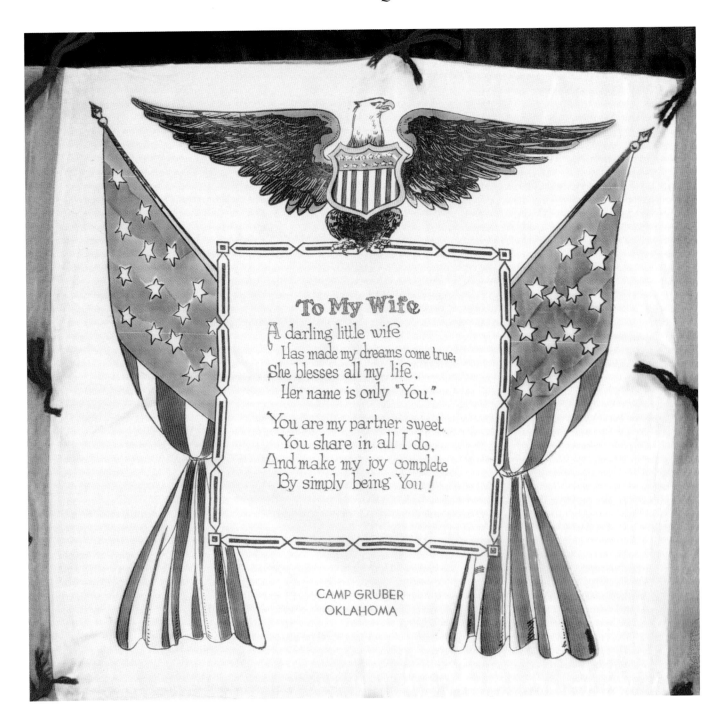

To My Wife

A darling little wife
 Has made my dreams come true,
She blesses all my life,
 Her name is only "You."

You are my partner sweet.
 You share in all I do,
And make my joy complete
 By simply being You !

CAMP GRUBER
OKLAHOMA

Victory Quilt, made by Francoise Millette, L'Original, Ontario, Canada, 1945. Hand pieced, hand appliquéd, hand quilted, 60 inches x 64.5 inches, cotton. This quilt was made by Francoise Millette while her husband, Dollard, was serving in the European theater during World War II. The quilt was made to celebrate his homecoming at the end of the War in 1945. It was purchased directly from the quiltmaker's son, Royal. The red, white and blue design represented the colors of the Canadian flag during World War II.

Mothers of World War II

The mothers of World War II soldiers were born from 1890 to approximately 1920. They began their lives in relative peace and prosperity at the height of the industrial revolution and experienced amazing societal changes with the advent of electricity, telephones, automobiles, indoor plumbing, air travel, etc. Many were teens, newly-married, or young mothers during World War I. Their husbands and brothers fought that war in Europe. During the Depression, necessity forced them to learn to make do. Those years of hardship prepared them endure the deprivation and sacrifices that go hand-in-hand with a World War.

MOTHER'S PRIDE

Dedicated to my son, Alfred Smith, U.S.N., stationed in Jacksonville, Fla.

> Very, very proud are they
> Who sent their sons away,
> Bravely stood and said "Good bye",
> Turned to hide the misty eye,
> And, until the war shall end
> Have an empty room to tend.
>
> Where are all the boys?
> Off to war they've gone;
> Gone are their companions, too—
> All those smiling lads we knew,
> Now on land or sky or sea
> They serve the cause of liberty.
>
> All the mothers everywhere
> Have this common ache to bear—
> Loneliness, through night time long,
> Void of laughter and of song;
> But, though little do they say,
> Very, very proud are they.
>
> Read their letters, snipped and blurred,
> Some forbidden line or word;
> Read aloud that all may hear—
> Here is pride which conquers fear;
> Deep and lasting, brave and good,
> That's the pride of Motherhood.
>
> —Mrs. Oscar Smith [54]

Most of the mothers of World War II soldiers were not employed outside the home. The women in this age group were the mainstay of Red Cross workers and organizations such as the Women's Society of Christian Service (WSCS), the United Service Women's Association Auxiliary (USWA), and

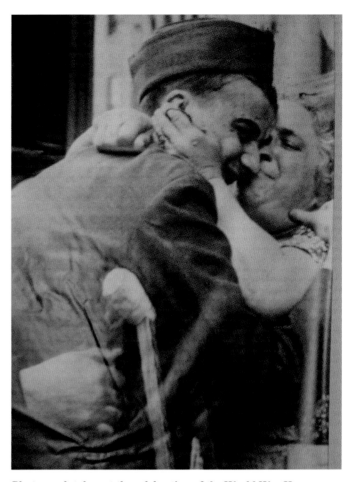

Photograph taken at the celebration of the World War II Memorial Dedication, June, 2004.

the American Legion Auxiliaries. The massive volunteerism of these dedicated women occurred while their sons fought on the battlefield and their daughters struggled on the home front. Surviving World War II quilts with intact provenance most often were made by the women of this age group.

The stories of three mothers are related below. Aldora Howe, Ida Beattie, and Callie Schaeffer each had a son who served the country during World War II. Their war experiences represent the three colors of the Service Flags: Blue Star for men serving in military service, Silver Star for men who were missing in action, and Gold Star for men who lost their lives. During their sons' deployments, each mother most probably proudly displayed a Blue Star Service Flag as a symbol of love, hope, and grave concern that their sons be returned safely home. The star on Ida Beattie's flag soon turned to silver. Her son became a prisoner of war in 1942 in the Philippines and thankfully was welcomed home at the end of the war. Callie Schaeffer's Blue Star Flag changed to gold when her son, Charles, was killed in action in France.

In a time of war, universal fear faces each mother who worries of losing a child. Hopefully, quiltmaking provided them with a meditative solace during concern and despair, while their sons served the country.

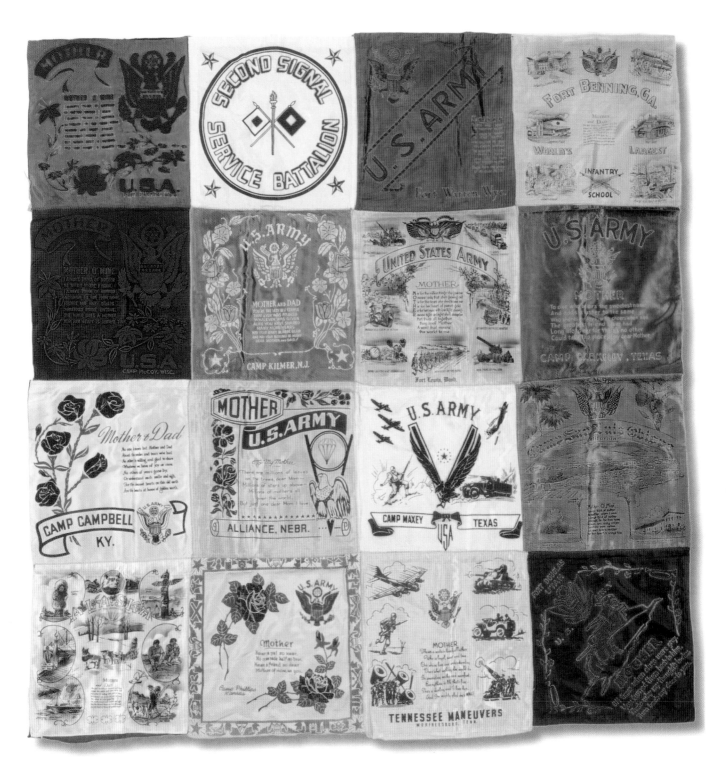

Parents Sweetheart Quilt. Quiltmaker unknown. Machine pieced, 65 inches x 66 inches, silk. Sixteen sweetheart pillow covers that had been sold on military posts were sent to these lucky parents by their son, who was in the Army. These popular souvenirs were sold at military stations across the U.S. They are printed with touching poems and tributes to his parents and his country.

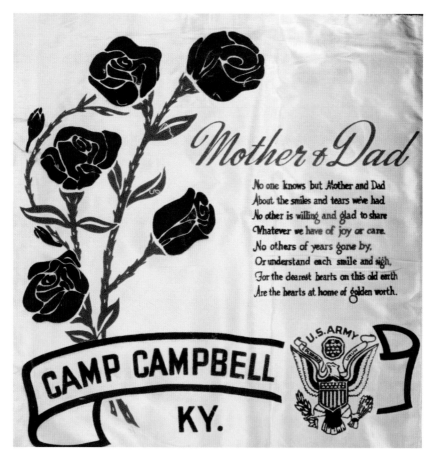

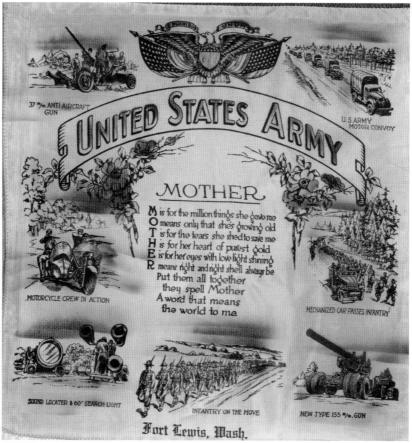

THE ROBERT HOWE COAST GUARD QUILT

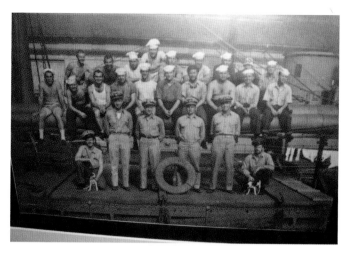

Robert Howe and his shipmates during World War II.

Prior to World War II, Robert E. Howe worked as a farmhand in Patterson Township, Woods County, Oklahoma. When the call came to serve his country, he lived on the farm with his parents, Aldora and Rufus, his younger brother, Joe, and sister, Irene.[55] Robert enlisted in the United States Coast Guard, one of the country's five armed forces, whose motto is *Semper Paratus*, "Always Ready." The mission of the Coast Guard is to protect the public, the environment, and the United States' economic and security interests in any maritime region in which those interests may be at risk, including international waters and American coasts, ports, and inland waterways.[56] After Robert's enlistment, Aldora believed that he would serve safely within the boundaries of the United States. However, his assignment as a Motor Machinist on the US *FS200* took him to the Pacific theater.

While her son was deployed at sea in a war zone, Aldora found solace in quiltmaking. She acquired the names of Robert's shipmates, their serial numbers, and their home states. Inspired by the many state flower and state bird quilt patterns that were designed in the 1930s by pattern companies, such as "Aunt Martha" and the "Rainbow Quilt Company;" Aldora created a quilt to commemorate her son's service. Robert's shipmates were represented with the birds and flowers of their respective states. Two Coast Guard insignia were expertly embroidered at the top corners of the quilt. Providing further provenance, Aldora included Robert's enlistment and commission records, and even information about herself, the quiltmaker. The entire quilt is framed patriotically with red, white and blue borders.

Happily for Robert Howe's family, he safely returned to Oklahoma in 1945 after V-J Day. He was one of the 241,093 Americans who served in the United States Coast Guard during World War II. Sadly, the country lost 1,917 Coast Guardsmen who were killed or missing in action.[57] Robert went on to marry and live his life in Texas. His story of service and the service of his shipmates will be remembered historically through the quilt his mother, Aldora Howe, so lovingly made.[58,59]

"Semper Paratus." The official seal of the United States Coast Guard, which was founded by President John Adams in 1790.

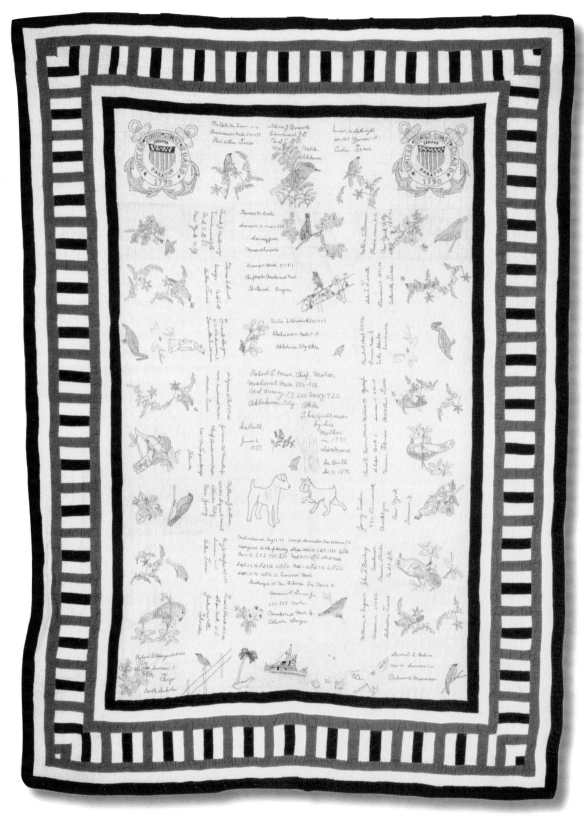

**World War II Coast Guard Quilt, made by Aldora Howe, Paterson Township, Woods County, Oklahoma.
Hand embroidered, machine assembled, hand quilted, 75 inches x 100 inches, cotton, cotton floss.**
Courtesy of Delaine Gately

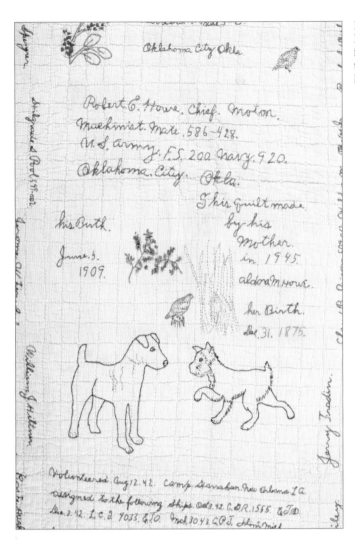

In the center of the quilt, Aldora Howe embroidered important information about her history and that of her son, Robert Howe, and his military record.

Aldora Howe embroidered the record of her son's service in the Coast Guard during World War II.

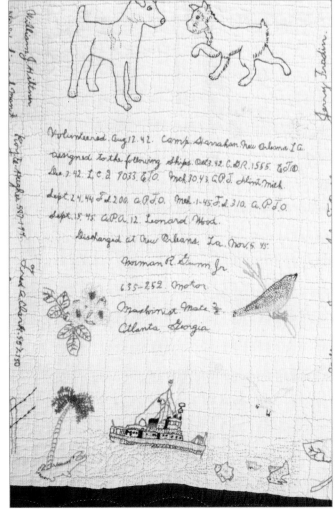

The Bataan Death March Quilt

Strange things were done under the tropic sun
By the men in Khaki twill
Those tropic nights have seen some sights
That would make your heart stand still
Those mountain trails could spin some tales
That no man would ever like
But the worst of all was after the fall
When we started on the hike. [60]

World War II veteran Irving L. E. Beattie, age 79, was interred at Arlington National cemetery in Section 66 Site 6847 on April 5, 2002.[61] Sixty-one years earlier, on September 10, 1941, as a strapping, six-foot, one hundred and sixty pound college sophomore, Irving enlisted in the United States Army. Nineteen year old, Private Beattie served in the Medical Corps as a surgical technician or an orderly, and was stationed in the Philippines.[62] Seven months later, on April 7, 1942, the Bataan Peninsula, situated between the South China Sea and Manila Bay, fell to enemy attack. Approximately 75,000 American and Filipino soldiers, suffering with malaria and exhaustion from the battles of war, were ordered to surrender to the Japanese. These brave but defeated men became known as The Battling Bastards of Bataan.[63]

The very next day the surrender came
Then we were men without a name
You may think here's Where the story ends
But actually here's where it begins
Tho' we fought and didn't see victory
The story of that march will go down in history.[64]

Horrific facts of the torture and suffering of these 75,000 American and Filipino soldiers occurred as they were forced to lay down their arms and march ninety miles, from Mariveles, Philippines to their imprisonment in Camp O'Donnell. Their fate was untold until a few brave men escaped in 1944. The first and most detailed account was reported in newspapers nationwide, in the winter of 1944, by Lieut. Col. W.E. Dyes, a survivor of Bataan and The March of Death.[65] He told of the extent of the tortuous march, starvation, suffering, and tragic loss of 16,000 soldiers.

Irving Beattie was the only child of Ida and Ralph Beattie, of Denver, Colorado. Ida was a first-generation American born in Nebraska, to parents who came to this country from Sweden. Ralph, a steel worker, hailed from Ohio. His parents came from Canada and Kentucky.[66] Ida Beattie saw her son off to war when she was 52 years old. Sometime in the spring of 1942, Ida and Ralph became aware of their son's fate as a prisoner of war.

Its provenance indicates this quilt was made between 1942 and 1945, although exactly when she began to stitch her sampler quilt for Irving is unknown. Hopefully, making this quilt fortified Ida Johnson Beattie through the most trying three years of her life.

Two dates are embroidered in the center of the quilt record: "PEARL HARBOR ATTACK DEC. 7-1941" and "PHILIPPINE ATTACK DEC. 9-1941." Irving was already deployed to the Philippines when these attacks occurred. With grave concern for the well-being of her son serving on an island under attack, then as a prisoner-of-war, Ida found the composure to stitch this patriotic quilt. Her embroidered blocks repeated the slogans popular during the World War II era: "VICTORY," "FORWARD WITH UNCLE SAM," and "UNITED WE STAND." Clearly, the block that best reflected Ida's belief in her country and hope for her son's safe return, was pieced into the last row on the bottom of the quilt. On this block is a cannon, symbolizing war, "Old Glory" representing freedom, and the last four lines of the fourth stanza of the Star Spangled Banner, appliquéd and embroidered on the block.

THEN CONQUER WE MUST,
FOR OUR CAUSE IT IS JUST
AND THIS BE OUR MOTTO,
IN GOD IS OUR TRUST
AND THE STAR SPANGLED BANNER
IN TRIUMPH SHALL WE
O'ER THE LAND OF THE FREE
AND THE HOME OF THE BRAVE.

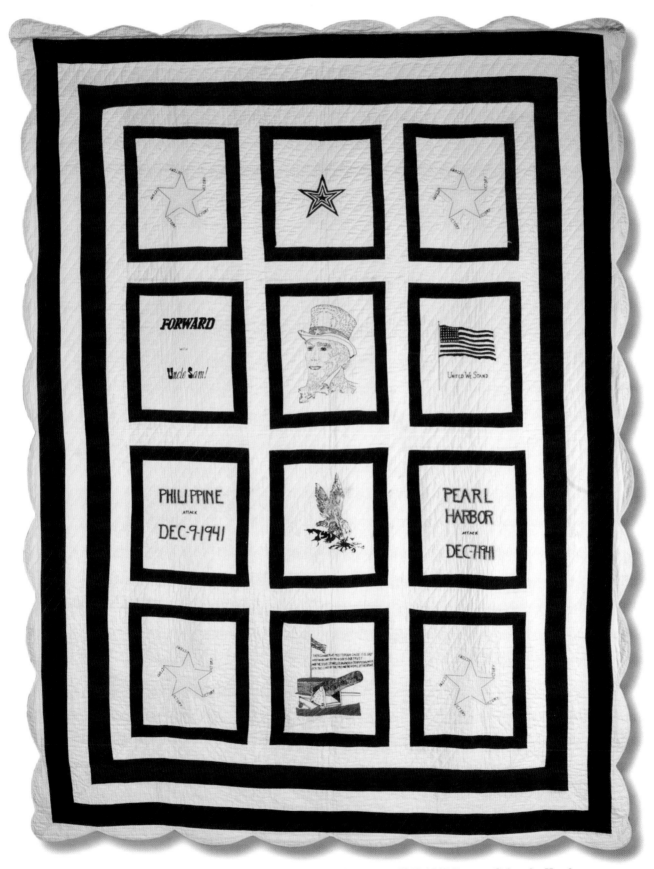

The Bataan Death March Quilt, made by Ida Johnson Beattie between 1942-1945, Denver, Colorado. Hand pieced, hand appliquéd, hand embroidered, hand quilted, 78 inches x 102 inches, cotton. *Courtesy of the Colorado History Society.*

A Gold Star Mother's Quilt

Blue Star Mothers have tomorrows with their children, but Gold Star Mothers only have yesterdays.[67]

In 1930, Callie Shaeffer was a young mother of 33 living happily with her large family on Ninth Street in Canton, Ohio. Callie and her husband, Earl, were proud parents of eight children, seven boys and a daughter, ranging in age from two years to fifteen.[68] A year later, they moved to 1176 Greenwood Avenue, Zanesville, Ohio, where Earl became a rising star in the composing room at the town's two main newspapers, the *Times Recorder* and *The Zanesville Signal*. Earl was a member of the International Typographical Union (ITU),[69] and Callie volunteered alongside him as an active member in the ITU Auxiliary. Her multiple terms as president of the Auxiliary were reported in *The Zanesville Signal* on May 16, 1944. Two months later, the same paper sadly reported tragic loss for the Shaeffers, that would make them a Gold Star family.

By 1944, Callie and Earl Shaeffer had sent six of their seven sons to battle in World War II. Four served in the Army and two were stationed somewhere "with the fleet in the Atlantic."[70] On June 14, 1944, while serving in France, their fourth child, Charles, age 22, was killed in action. It was another month before the Shaeffer family was notified of his death.

Prior to enlistment in the Army, on November 17, 1942, Charles worked at a defense plant in Canton, Ohio. He was stationed at Camp Barkeley, Texas, for basic training and was sent overseas in February of 1944, four months prior to his death. He left behind a widow and his three and a half month-old son, Charles.[71] His family was presented with the Purple Heart.

The Silent Tears

Oh, Gold Star Mother you knew well,
The million silent tears that fell,
From eyes which pierced into the night
To glimpse a once familiar sight.

How often did you wake from sleep
Expecting to see him at your feet,
Sitting with some favorite toy,
He often played with as a boy.
Remember how fast your heart would beat
At a certain sound of moving feet,
Because you thought it might be he
Returning unexpectedly.

It took some time, before you learned
To say, my son will not return.
But you soon found out, that hearts can take—
The cruelest pains and, yet not break.
But I believe, that, if we could see
A glimpse of heaven there would be
For Mothers a crown, of crystals clear,
God made with all silent tears.
(Submitted by Helen Kearney Lambert,
 Patterson, New Jersey)

Many women turned to quiltmaking to grieve the loss of a loved one. Others turned to groups for support in resolving their sorrow. After the loss of her son, Callie Shaeffer chose both sources of respite. She became active in the local Gold Star Mothers club and she made the Radiating Star quilt. Callie pieced gold cotton diamonds into a star centered on a white background to represent her family's ill-fated status. Each diamond was stitched with black embroidery thread, in script, with the names of others from her area of Ohio who were killed in action, and the words "World War II." Her quilting stitches are in black thread on the gold star and in white thread on the white background.

Callie Shaeffer used her sewing skills to memorialize her son and the sons and daughters of other Gold Star Mothers of the Zanesville, Ohio, area. She provided one of the most honorable tributes in fabric of the ultimate sacrifice of her son and his comrades in war who gave their lives for our country's freedoms.

The Gold Stars Mothers of Zanesville, Ohio. Mrs. Earl (Callie) Shaeffer is seated second on the left.

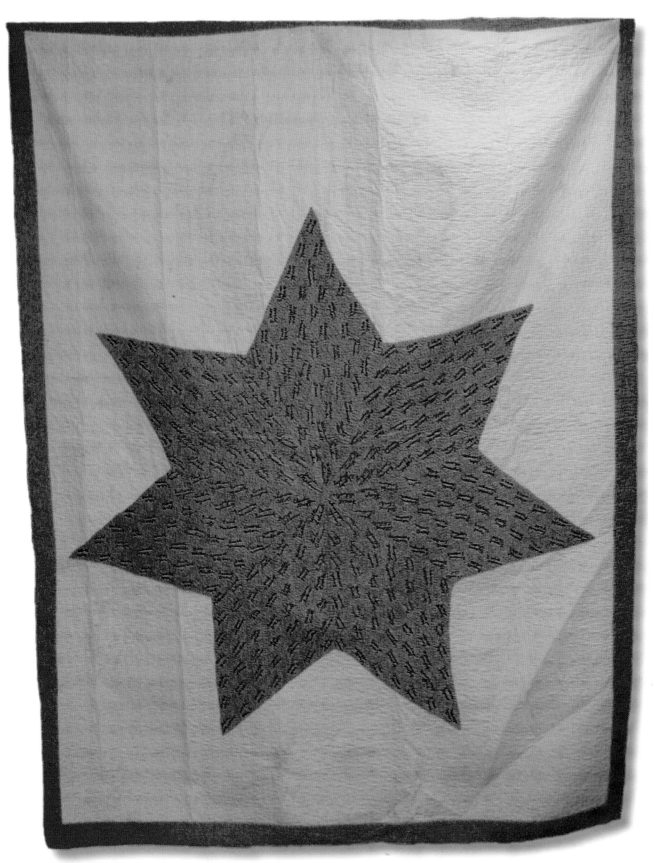

Gold Star Mother's Quilt, made by Mrs. Earl (Callie) Shaeffer (1897-1959), c. 1945, Zanesville, Ohio. Hand pieced, hand quilted, hand embroidered, 68 inches x 88 inches, cotton. *Courtesy of the Pioneer and Historical Society of Muskingum, Zanesville, Ohio.*

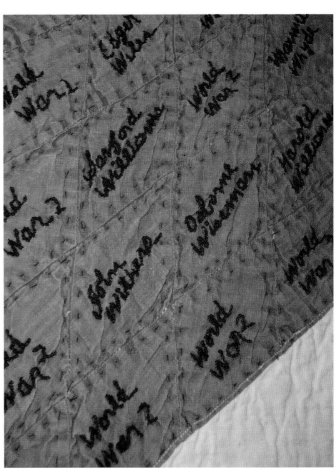

Featured in the book *Index to Home Arts Studio Quilt Designs*, compiled by Rose Lea Alboum.

Gold Star Wall at the World War II Memorial in Washington, D.C.

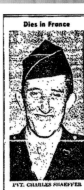

The Zanesville Signal, Zanesville, Ohio, Wednesday Evening, July 12, 1944, page 2.

Pvt. C. G. Shaeffer Killed in Action

Pvt. Charles G. Shaeffer, 22, son of Mr. and Mrs. Earl Shaeffer of 1176 Greenwood avenue, has been killed in action in France, according to word received from the War department yesterday.

While no details surrounding his death were given, the message said he was killed on June 12.

Pvt. Shaeffer was a native of Canton, and had made his home here since 1931. He attended Lash high school and was employed at a defense plant in Canton before entering military service.

He was inducted into the army Nov. 17, 1942 and took his basic training at Camp Barkeley, Tex. He had been overseas since February of this year.

Surviving in addition to his parents are his widow, Dorothy; a three and a half-months-old son, Charles, whom he had never seen; a sister, Mrs. Dorothy Springer of Greenwood avenue, and six brothers, Pvt. Raymond Shaeffer of Fort Dix, Tex.; Pvt. Eugene Shaeffer of Camp Hood, Tex.; Lister P. Shaeffer, of Commissioner street, recently discharged from the army; Edgar of the home; Seaman Second Class Francis Shaeffer of Shoemaker, Calif., and Seaman Second Class Earl Shaeffer, Jr., stationed somewhere with the fleet in the Atlantic.

Appliquéd Rose Bouquet Quilt, made by Frances Lucy Guinchi Baldi (1895-1993), Litchfield, Connecticut. Hand appliquéd, 77 inches x 93 inches, cotton. Frances began this quilt during World War II while her son, Albert Baldi, fought on the warfront. A self-employed seamstress, Frances made her floral appliqué quilt from a purchased kit. Sadly, Albert was killed in the service of his country and never returned to his Litchfield home. Frances finished the appliqué on her quilt, but it lay folded at the foot of her bed until the 1980s. The quilting was completed by a lady from the neighboring town, Washington, Connecticut. *Courtesy of Roberta M. Coffill Healy.*

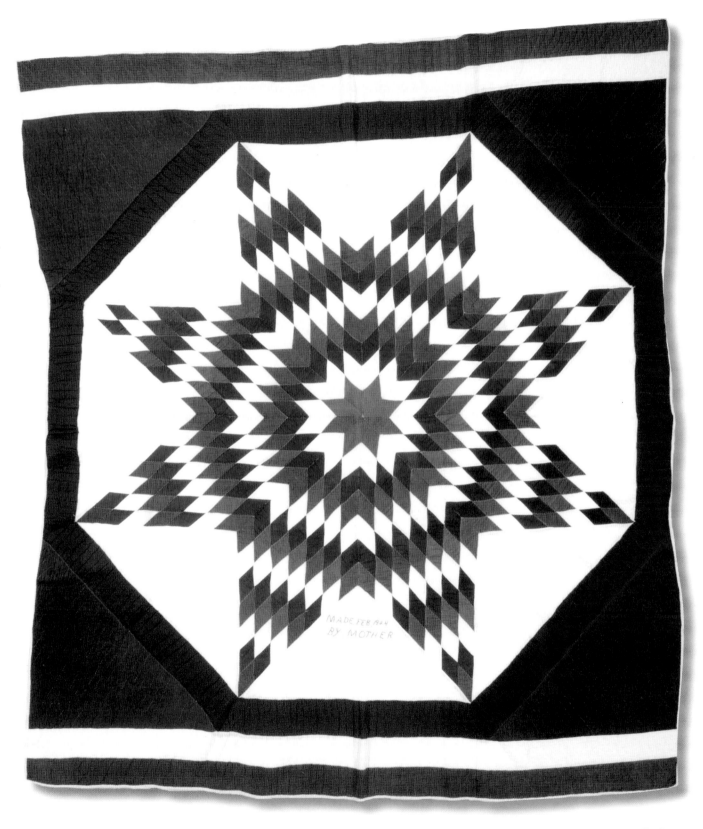

Robert Frank Patriotic Star Quilt, inscribed "MADE FEB. 1944 BY MOTHER." Quiltmaker unknown. Hand pieced, hand quilted, hand embroidered, 73.5 inches x 62 inches, cotton. This Radiating Star quilt was handmade by a mother while her son was at war. It comes from the state of Texas. If you look closely, someone removed the embroidery stitches of the son's name at the bottom of the quilt. On close inspection, the picked out letters look like "Charles Thompson."

Robert Frank Needlework Supply Company of Kalamazoo, Michigan also named this pattern "Star of Hope" and sold die-cut diamonds in red, white and blue fabric, and the border and background fabrics to make radiating, patriotic star quilts during World War II.

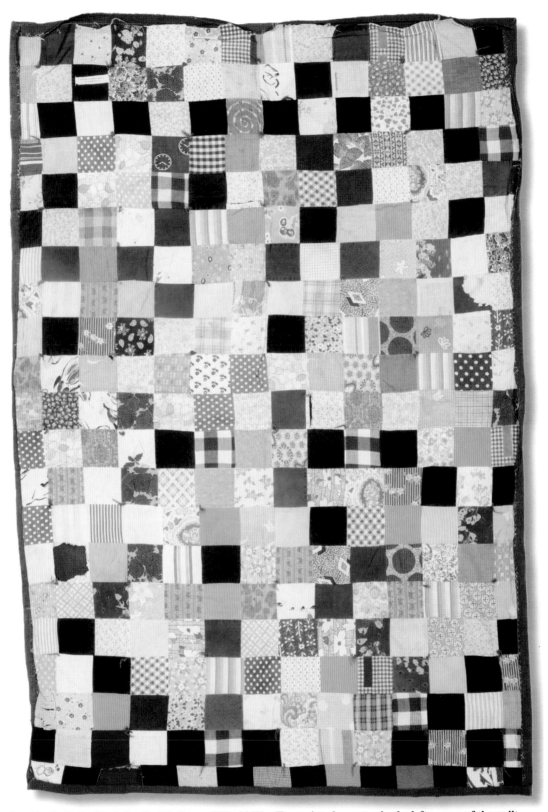

One Patch Quilt. Made by the Mothers of World War Two printed on a tag in the left corner of the quilt. Bethlehem, Pennsylvania. Machine pieced, hand tied, 34 inches x 56 inches, cotton and wool. These crib-size quilts may have been made for the children of World War II soldiers for babies born during the war years. Mothers of World War Two was an organization founded in 1943. War mothers united to work for the welfare of their sons and daughters in the service and planned for the post-war era. As reported in the *Vidette Messenger*, Valparaiso, Indiana, "By 1944, there were units in 15 states and 18,000 members in Indiana." The organization was still active in 1963.

Nine Patch Quilt, made by the Mothers of World War II, Bethlehem, Pennsylvania, Unit 3. Machine pieced, hand tied with cotton floss, 39 inches x 56 inches, cotton. Made with early twentieth-century shirting and mourning prints.

The Grandmothers of World War II

The grandmothers of World War II were infants born just prior to the Civil War until the 1880s. During their youngest years, they experienced the reconstruction of the South and the height of the industrial revolution in the American Northeast. Their husbands may have served with Teddy Roosevelt's Rough Riders in 1898 in the Spanish-American War, or helped to dig the Panama Canal. Their sons served the country fighting "The Great War," from 1914 to 1918. In the 1940s, the grandsons of these women were the newest generation of Americans to go to war.

Women between the ages of 60 to 90 were very involved in quiltmaking during World War II. Mrs. Maria Yorke, of Kensington, New Hampshire, plied her needleworking skills for three of the country's wars. Newspapers of the era stated, "Mrs. Yorke has knitted more than 1,000 pairs of mittens for servicemen and has just completed a quilt of 1,782 pieces." [72] During the weekly, Tuesday, Red Cross meetings, Mrs. Charles Finney, age 93, completed and donated a quilt top that she pieced in less than two weeks. [73]

A newspaper from Iowa gives an account of 84-year-old Mrs. E. W. Appelman, who did her part for the war:

Mrs. E.W. Appelman, a resident of Clermont for many years, but who now resides at New Hampton with her daughter, Mrs. J.M. Kerwick, has the honor of having made a quilt which sold for $113.00. Mrs. Appelman, who is 84 years of age, donated the quilt to be sold for the benefit of the Red Cross and she, herself drew the name of the winner. The winner gave it back to the Red Cross and it will be sold again.

It has been said that some hearts and minds never grow old, but continue to spread good will all along life's way, never tiring, never failing. Mrs. Appelman is a splendid example of such a life. During the First World War, she was active in Red Cross and other organizations. Mrs. Appelman is truly deserving of admiration, praise and honor. [74]

Aids Red Cross Drive

Mrs. Edith Schwartz of 1234 Greenwoon avenue is doing her share in the current Red Cross drive, despite the fact that she observed her 86th birthday this month. She recently made a quilt, sold it, and turned the proceeds over to the Red Cross. Mrs. Schwartz is extremely active and puts in most of her time sewing, weaving or crocheting. She boasts the fact that she has never been forced to wear glasses.

The Sunday Times-Signal, **Zanesville, Ohio, Sunday, March 11, 1945, page 20.**

Stars of Stripes

Laura Allard lived on the prairie of Brookings, South Dakota. She was inspired to make this quilt for her grandson, Joseph Zacek upon his enlistment into the U.S. Army Air Corps in 1942. He followed in his father's footsteps as a soldier. Joseph Otto Zacek, of Austrian/Hungarian descent, served as an American soldier in World War I. Laura commemorated their service in a quilt, connecting her son and grandson as soldiers in two great wars. Between each star she quilted winged motifs, similar in design to the patch with embroidered wings that Joseph wore on the sleeve of his uniform.[75]

In 1942, while her grandson was serving in World War II, Laura Allard proudly exhibited her patriotic quilt at the Butte County Fair in Nisland, South Dakota. She won a Blue Ribbon for her creative efforts and support of her grandson.[76]

Joseph's family proudly displayed a Blue Star Flag in their window during his deployment in the China-Burma-India theatre. He penned the following shortly after arriving in India, "Had a pass the other nite and went out to see what there is to see. What a place!! I can't begin to put it in writing what all I saw, so I will tell you about it when the war is over. Am I ever glad I'm an American."[77]

Today, Joseph's red, white and blue Stars of Stripes quilt is still cherished by his family. It is kept by his daughter, Lynne Zacek Bassett, quilt historian of Palmer, Massachusetts, and great-granddaughter of the quiltmaker.

RED, white and blue are starred in an attractive quilt which bears the intriguing name—Stars of Stripes. You'll be charmed with the easy piecing of these clever eight-pointed star blocks of which just 20 are required. Diagonal setting is used and with a narrow border, the size is about 90 by 110.

• • •

Accurate cutting guide with estimated yardages and directions for the Stars of Stripes is Z9380, 15 cents. The quilting may be either diagonal cross lines or a star motif. Send your order to:

AUNT MARTHA
Box 166-W Kansas City, Mo.
Enclose 15 cents for each pattern desired. Pattern No.............
Name....................................
Address.................................

Soda Springs Sun, **Soda Springs, Idaho, November 6, 1941, page 7.**

Laura Allard, Brookings, South Dakota. *Courtesy of Lynne Zacek Bassett*

Stars of Stripes Quilt, made by Laura Allard, Brookings, South Dakota. Machine pieced, hand quilted, 72 inches x 84.5 inches, cotton. With the quilt blocks set straight, the red, white and blue Stars of Stripes Quilt was completed with simple style and grace. *Courtesy of Lynne Zacek Bassett*

Stars of Stripes with Nine Patch Corner Blocks Quilt. Machine pieced, hand quilted, 87 inches x 87 inches, cotton. The blocks of this quilt are set straight, with pieced corner blocks, giving another variation to the popular World War II pattern of Stars of Stripes. The pattern for this quilt, designed by Aunt Martha, was published throughout the war in newspapers, beginning in 1941. The ad states: Red, white and blue are starred in an attractive quilt, which bears the intriguing name—Stars of Stripes."
The basic quilt block could be set on point or straight. Versions of this quilt design vary from the elegant simplicity of Laura Allard's quilt (made for her grandson) to the colorful variation with triple sashing.

Stars of Stripes Quilt Top. Quiltmaker unknown. Hand pieced, 73 inches x 89 inches, cotton. A triple border in red, white and blue make a frame for this patriotic top.

Stars of Stripes. Quiltmaker unknown. Hand and machine pieced, 89 inches x 80 inches, cotton. Set on point with triple red, white and blue sashing, this setting provides a visually pleasing version of the Stars of Stripes pattern. *Courtesy of Pat Cox.*

Symbols of a Country at War Expressed in Quiltmaking

Between 1940 and 1945, quilt pattern companies, such as Mountain Mist, Aunt Martha's Studios, and Workbasket, designed quilt patterns specifically related to World War II. Magazines, such as *American Home, Ladies' Home Journal,* and *Farm Journal* also featured patriotic designs that echoed popular slogans and sentiments during the war. Victory Vs, stars and stripes, flags, military insignia, Blue Stars, airplanes, eagles, and anchors are just some of the symbols repeated time and again in World War II quilts. Prior to the invention of television, information and war news was distributed via radio, newsreels at movie theaters, posters, magazines, and newspapers. These became the inspirations for symbols translated into appliqué and pieced blocks on World War II quilts.

World War II-era posters used few words with powerful symbols to carry messages of war. The articles and advertisements in magazines featured more detailed information addressing the needs and concerns of those on the home front. After the bombing of Pearl Harbor, a call went out to the editors of the nation's periodicals to publish a patriotic cover for their July, 1942 issue. Over three hundred magazines responded with what has become known as "The United We Stand" issues. The American flag and that patriotic slogan were featured prominently on each cover. For the next three years, magazine covers continually illustrated wartime activities at home and on the battlefields. Victory gardening, buying War bonds, salvaging essential items, and supporting the military were among the most common themes. Many covers supplied the imagery that was transferred to (the medium of) cloth and used in quilts made during World War II.

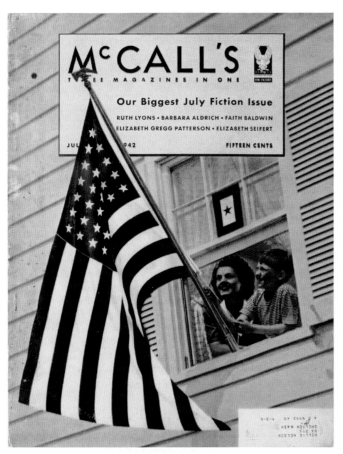

World War II Sampler Quilt. Quiltmaker unknown. From Lady Liberty to the family pet, this World War II quilt contains appliquéd images of this young family's activities living during the war. Centered on the quilt is a sad little baby boy, whose father is in the Army. Mom is serving the country as a Spotter, watching the skies for enemy aircraft. Other children featured on the quilt are involved in youth's activities during the war. The quilt is topped with an eagle, whose wings form the letter V for Victory, and is surrounded with 48 appliquéd stars to represent the United States. Even the family's dog holds his head high, keeping watch over the family until their soldier Dad comes home from war. *Courtesy of the Dallas Museum of Art*

A Canadian World War II Sampler Quilt

Sarah Robar led a simple life on the family farm, in Upper Cornwall, Nova Scotia, where she lived in a large family with seven brothers and sisters. Her fifth-grade education enabled her to read and do multiplication and division. Despite losing an eye from an infection as a child, Sarah was literate, reading her *Bible* at least 18 times.

During her life, Sarah learned to make due and live with meager circumstances. Her adult life was marked with tragedy with the death a child, and then her husband, who died in a tractor accident. Her descendants report that Sarah never owned a store-bought dress. She sewed for herself and her children and also spun wool and knitted. Her knitted patches were mostly made into pot holders, and some were made into quilts that now are in the collection of the Parkdale-Maplewood Community Museum.

Sarah's sampler World War II quilt includes many of the symbols of war, from airplanes to Victory Vs, and the portraits of Winston Churchill, President Franklin D. Roosevelt, and Eleanor Roosevelt. Her quilt blocks were made from scraps of material and ends of embroidery cotton that were given to her by friends and neighbors.

Sarah Robar, Upper Cornwall, Lunenburg County, Nova Scotia, Canada.

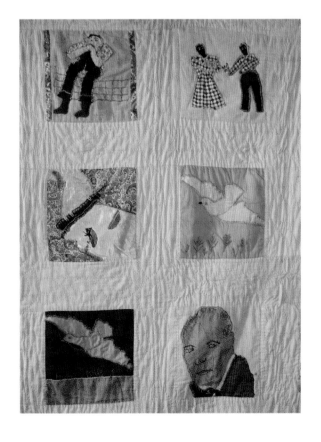

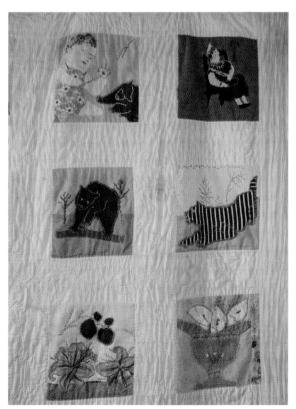

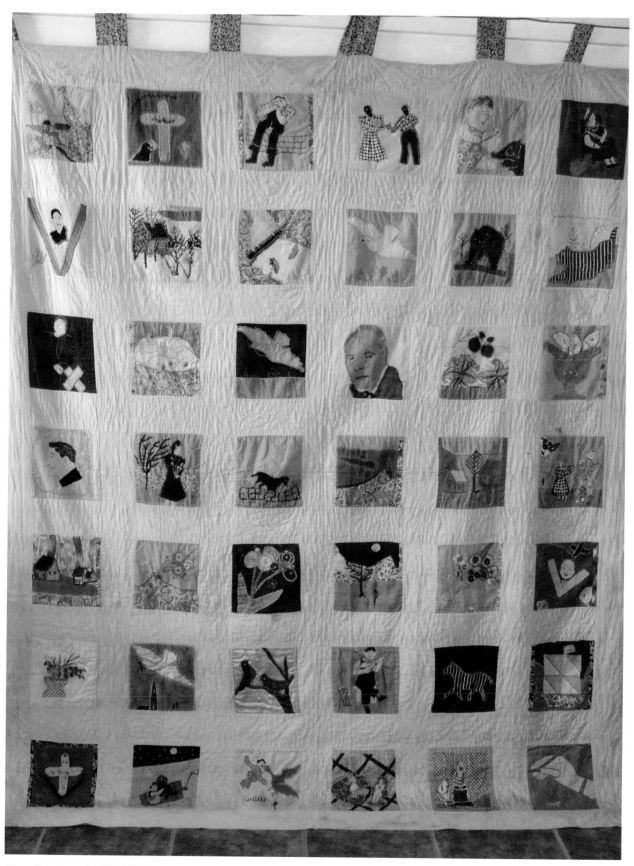

Canadian Sampler World War II Quilt, made by Sarah Robar, Upper Cornwall, Lunenburg County, Nova Scotia. *Courtesy of the Parkdale-Maplewood Museum, Nova Scotia*

"WIN THE WAR"

The slogan "Win the War" was depicted on the three-cent stamp during World War II. This design became the center medallion block embroidered by Welthea Blanche Thoday on her World War II-era quilt. The slogan and many other designs incorporated in Welthea's quilt epitomize the multitude of symbols and slogans popularly seen during the war years.

Between 1941 and 1945, Welthea's family, friends, and neighbors along Commonwealth Road in Watertown, Massachusetts, and her co-workers at a Boston textile publishing company, America's Textile Reporter, combined their sewing skills to appliqué and embroider blocks for her sampler quilt. The Statue of Liberty, an Eagle, ten Victory Vs, a Red Feather (for the Red Feather Community Fund), the OPA (Office of Price Administration), a Minuteman, a Blue Star Flag, a Red Cross, V-E Day, V-J Day, and an Air Warden block representing Welthea's service during the war all are featured on this quilt.

Welthea Thoday was born in Scituate, Massachusetts, as a first-generation American and the eldest daughter of Fred Ezra and Margaret MacEachern.[78] Both of her parents were of English descent. Her father was a carpenter, born in England, and her mother was Canadian English, born on Prince Edward Island.[79] Welthea spent the majority of her life with her family in Watertown, Massachusetts.[80] While she remained true to her English heritage, Welthea's pride at being an American was well illustrated in the World War II quilt she designed and created. In 1935, as Adolf Hitler was rising to power in Germany, Welthea risked the dangers of war and sailed to England, returning on the USS *Samaria*.[81]

In 1995, nearing the age of 100, Welthea was interviewed by her niece, Susan C. McKenna, about the construction of her World War II sampler quilt. The tape recorded interview and a small journal were donated to the National Museum of American History, along with her quilt. In her two-inch-by-four-inch journal, entitled *Record of World War II Historical Quilt*, she gave a detailed account of the design and creation of the quilt. In her handwriting, accompanied by sketches of each block, the journal reads:

> This quilt reproduces the emblems, symbols and slogans of World War II, made by friends, neighbors, co-workers, and family members during the war period December 7, 1941 to September 2, 1945.
>
> Ethel Thoday's square represents a Victory Garden * Single Star with border represents one family man in the service.
>
> Layout and quilting done by Welthea B. Thoday. The large center panel by Welthea B. Thoday is taken from the U.S. 3-cent postage stamp issued during the war period.

In 1975, this patriotic, World War II quilt was displayed at Watertown's Free Public Library and at the Boston Bicentennial Exhibition in 1976.[82]

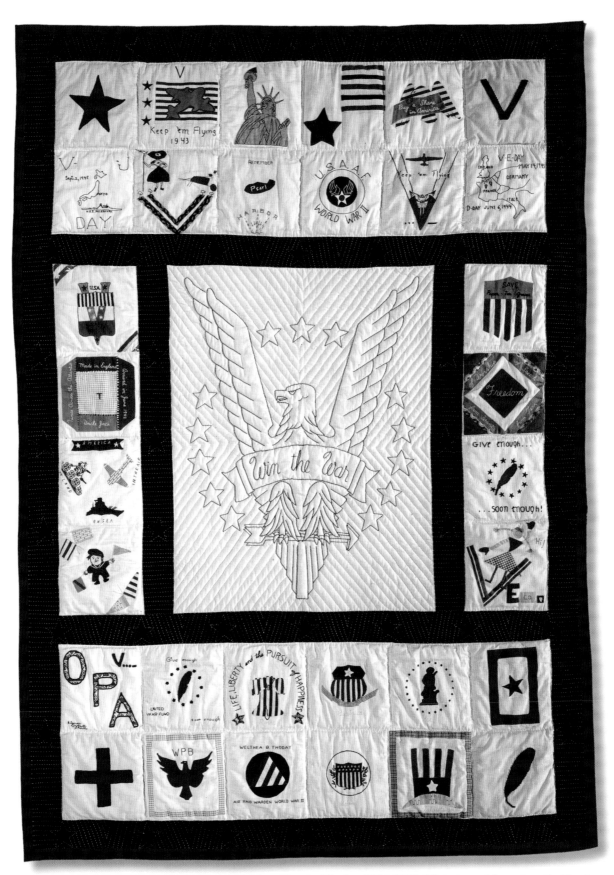

World War II Friendship Quilt, made by Welthea Blanche Thoday (1896-1997), Watertown, Massachusetts. Hand pieced, hand embroidered, hand appliquéd, hand quilted, 50 inches x 71 inches, cotton. *Courtesy of the Smithsonian National Museum of American History*

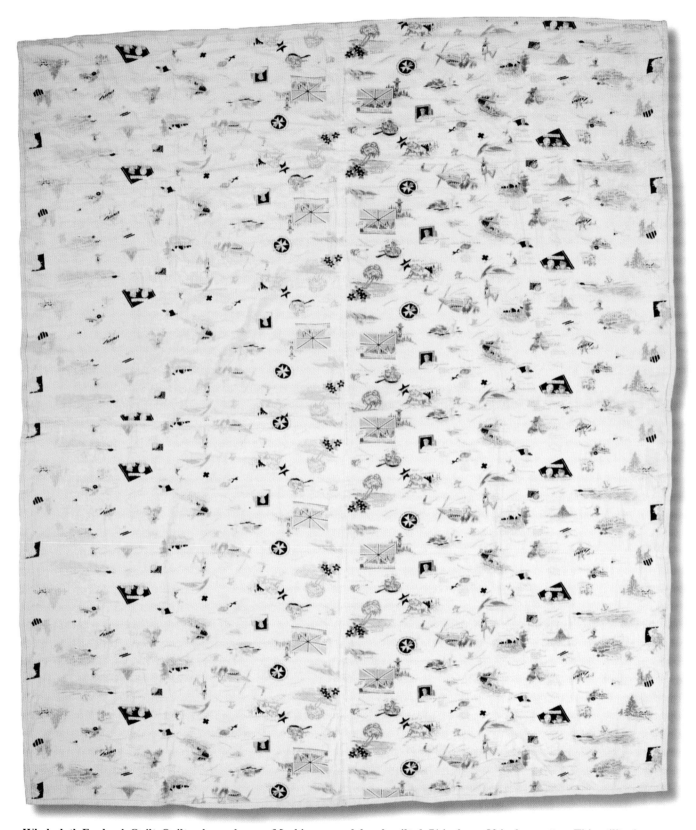

Wholecloth Feedsack Quilt. Quiltmaker unknown. Machine seamed, hand quilted, 71 inches x 83 inches, cotton. This utilitarian quilt served its owner well over the past 65 years. Four feedsacks, depicting images and motifs of the major political and military events of World War II, were opened up and stitched back together to make a twin-size quilt. It is badly faded on one side suggesting that it suffered sun damage from its placement on the bed. This feedsack was known as Kent's Cloth of the United Nations; it is also called "Three Bad Eggs," featuring Adolph Hitler (German), Benito Mussolini (Italy), and Emperor Hirohito (Japan) in a frying pan. As members of World War II's "Axis of Evil," the textile depicts the true American sentiments of the time.

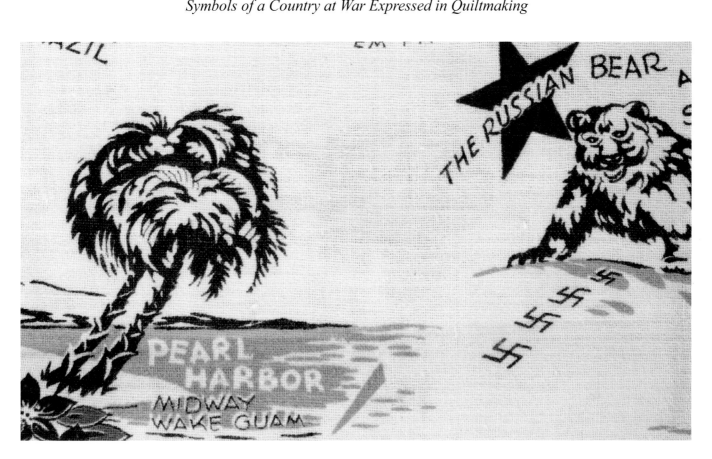

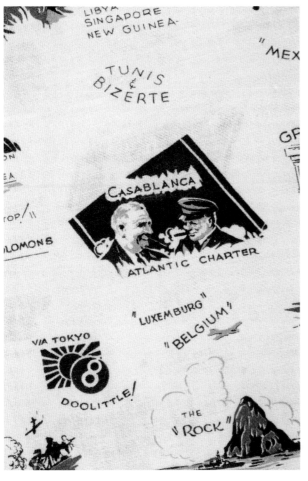

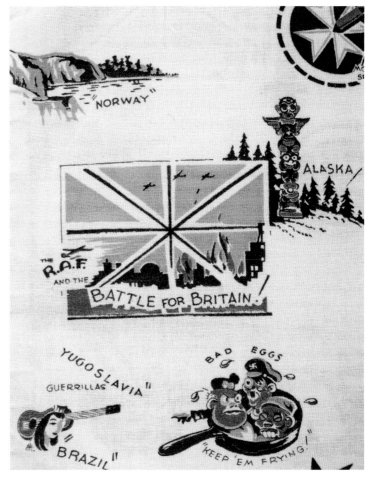

Swastika Quilt Pattern

One symbol commonly found in quilts of the late nineteenth and early twentieth century has been banned in Germany and will forever be associated with ultimate evil. Beginning in ancient cultures, and for the next three thousand years, the swastika design was used to symbolize life, sun, power, strength, and good luck across many civilizations. The design was also known as the "fylfot cross."[83]

Early in the twentieth century, many clubs across the United States, including quilting clubs, used swastika in their group's name. For example, the following announcement was published in the *Colorado Spring Gazette*, Colorado Springs, Colorado, on October 20, 1909. "The Swastika sewing circle will meet at the home of Mrs. John Carnahan, 530 West Dale Street, this afternoon." In 1920, this image, representing "good," was adopted by the Nazis, and its meaning was forever changed.[84]

A newspaper article by Ruth Millett, entitled "Busy-Bodies Will Start Bad Feeling," appeared in the *Ironwood Daily Globe*, Ironwood, Missouri, on August 29, 1942. It illustrated the new reality for the swastika design.

The other day a housewife in a southern city washed two quilts and hung them on the clothesline to dry. When she went to bring them in, one quilt, made [by] her mother years ago, was gone. Next day she discovered it tied to her car with a note saying, "Take the damned Nazi swastika back to Hitler where it belongs." The "damned Nazi swastika" was nothing but an old-fashioned quilt pattern called "sunshine and shadow."

But, some malicious busybody had glanced at the pattern and decided it was the Nazi swastika. That is the kind of thing we are going to have to guard against as the war goes on and feeling runs higher and higher. It is hard to stop stupid people from wrongly accusing innocent people of being Nazi sympathizers. To the person who is stupid enough, a German name makes a Nazi out of an honest American. But, if responsible, sensible people refuse to have anything to do with spreading rumors about their neighbors after they are started by some irresponsible person, there won't be a great deal of harm done. That is where most of us come in. We'll hear "Nazi sympathizer" talk about this person or that. But, if we refuse to repeat it, the rumor won't travel far or do a great deal of harm. And, if we bother to track down the "Nazi sympathizer' rumors we hear, we'll find that most of them are started by some ignorant or malicious trouble-maker who can see a swastika in something as old fashioned as a quilt pattern. If, on the other hand, there are real grounds for suspicion, we should notify the police.[85]

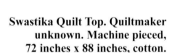

Swastika Quilt Top. Quiltmaker unknown. Machine pieced, 72 inches x 88 inches, cotton.

Flags, Banners, Stars and Our Country's Military

"Keep Old Glory Up There Flying"[86]

On November 3, 1943, the *Oelwein Daily Register* reported, "Old Glory is believed to have been first raised at Portsmouth, N.H., where John Paul Jones was preparing to sail on the *Ranger*. The young ladies of that port made a flag of their own and mothers' gowns, which was flung to the breeze in Portsmouth Harbor on July 4, 1777."[87] Fueled by a noble history and pride in our national colors, our American flag has always been the country's leading guidon.

One month after the bombing of Pearl Harbor on January 7, 1942, the *Oelwein Daily Register,* Oelwein, Iowa, printed the following instructive article about our national flag. "From many homes the American flag is being seen these days. Be not ashamed to display your flag on all days from sunrise to sunset that the weather permits. The American flag should be displayed every day from every

home. America is at war. Keep Old Glory up there flying. Our own Red, White and Blue, Red for valor, White for purity and Blue for truth."[88]

Patriotic spirit was abundant during World War II. Flag display was the most obvious show of the intensely loyal spirit of our nation. On June 13, 1942, the *Denton Journal*, Denton, Maryland, reported in a similar article,

"Blue for loyalty; white for liberty; red for courage. Joined together in our banner, there, our colors proclaim our faith undying. Keep it flying! Fight with words to defend the spirit of it. Fight to the finish, that our children too may live with it. Forty-eight states: one hundred and thirty million people—to hold high our flag, untouched by twisted, slimy, fascist, lying. Our flag! Keep it flying! Old Glory it is: now glory it will bring. The stars and stripes forever—in their name let freedom ring! Freedom—life isn't worth the living bereft of it: but death is

The Land and Flag that I Love

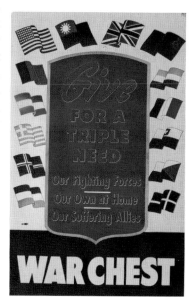

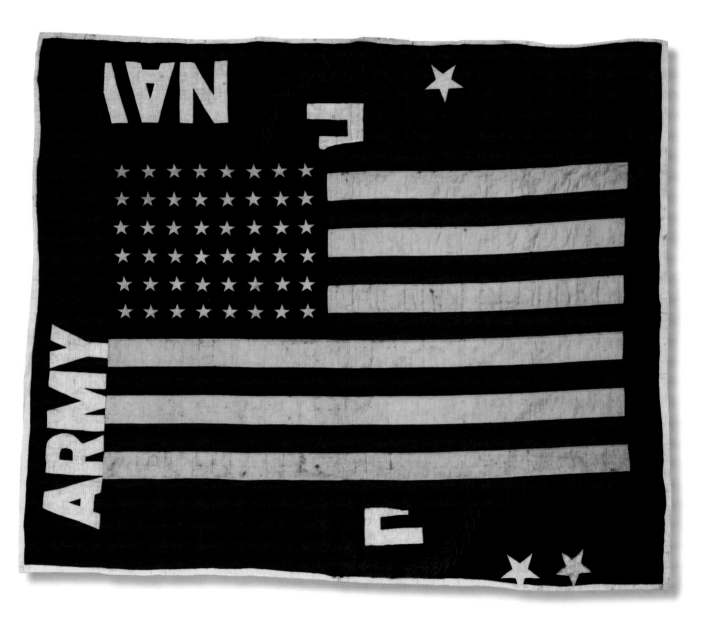

Army-Navy "E" Award and Flag Quilt. Quiltmaker unknown. Machine pieced, machine appliquéd, hand quilted, 81.5 inches x 65.5 inches, cotton. The Army-Navy "E" Award was presented to many manufacturers excelling in the production of war equipment during World War II. The award was in the shape of a pennant with a capital "E" within a wreath of oak and laurel leaves. "Army" was appliqued on the red background and "Navy" on the blue background. White stars were issued to plants for continued excellence.

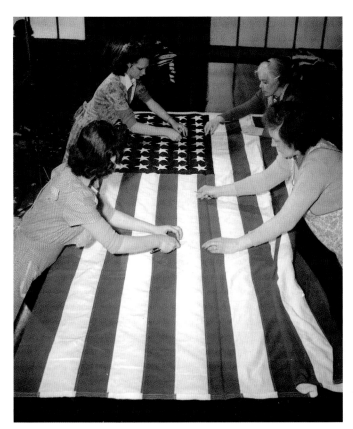

Women shown trimming threads from a flag made for the government, at the Annin Flag Company, Verona, New Jersey. March, 1943. *Courtesy of the Library of Congress*

Flag quilts with forty-eight stars could have been constructed any time between July 4, 1912, and August 21, 1959, when Alaska and Hawaii were admitted to the Union. The 48-star flag was our country's twenty-sixth official flag. Eight Presidents served under this flag:

> William H. Taft (1909-1913)
> Woodrow Wilson (1913-1921)
> Warren Harding (1921-1923)
> Calvin Coolidge (1923-1929)
> Herbert Hoover (1929-1933)
> Franklin D. Roosevelt (1933-1945)
> Harry S. Truman (1945-1953)
> Dwight D. Eisenhower (1953-1961)[90]

A very close look at the fabrics used in flag quilt construction is sometimes the only indicator in determining whether it was made early in the twentieth century or during the World War II years. Flag quilts from the World War I years are not commonly seen. The red fabric provides the best clue of the quilt's date. The reds of the World War II years remain brighter and have not had time to fade. The dyes of the 1930s and 1940s were more stable, keeping the colors more vivid. The blue fabrics used during this period are not as easy to determine. Early in the twentieth century, they were generally grey-blue or dusky blue in color. During the 1920s and 1930s, they tended to be more pastel in shade. As World War II approached, the blue became a primary-color blue. White fabric is not a reliable indicator of the age of a quilt.

Solid bunting fabric of red, white and blue stripes was commonly used in quilts, most often in borders and sashings, as seen here in Emily Robison's *Music Teacher's Quilt* from Bullitt County, Kentucky. If print fabrics were used in quilts, determining the age of a mid-twentieth century quilt can also be very tricky. Textile manufactories that printed quilt and dress

worth the dying to keep its torch lit. Let the Madmen's roars express wild frustration. They can't shut out the piercing cries of nations whose only plea is—'Set us free!' They can't blackout the hope that shines in the eyes of men who fight for liberty. Unfurl Old Glory alongside the banners of our valiant allies who fight with us to free the world." [89]

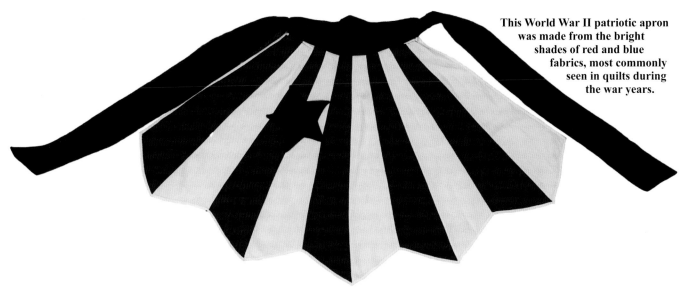

This World War II patriotic apron was made from the bright shades of red and blue fabrics, most commonly seen in quilts during the war years.

fabric prior to the war concentrated on textiles for the battlefront after the war began. Shortages in clothing fabric necessitated that quiltmakers reach deeply into their scrap bags and use fabrics from 1920s and 1930s. By mixing fabrics from multiple decades of the twentieth century, only quilts with dates or those pieced with World War II novelty prints or in patriotic colors can be positively assigned a World War II attribution. Quilts made from patterns created and distributed between 1940 and 1945 are also confidently identified as World War II quilts.

Music Teacher's Quilt

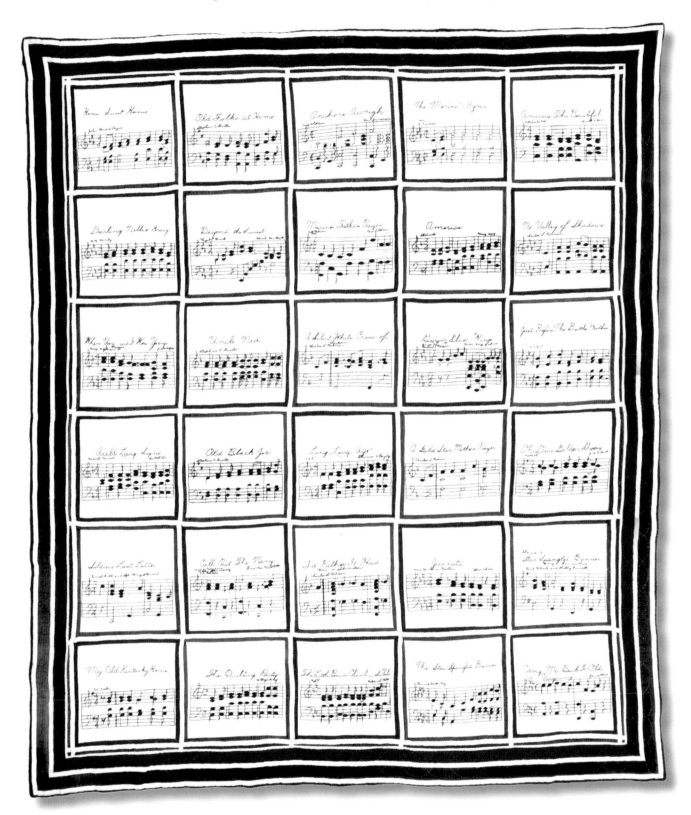

Music Teacher's Quilt, made by Emily Robison, Bullitt County, Kentucky. Machine pieced, hand quilted, hand embroidered, 70.5 inches x 80 inches, cotton. Emily Robison was a teacher near Louisville, Kentucky, during World War II. She made the quilt top in 1943. It was quilted 35 years later, in 1978. Emily expressed her great love of her state of Kentucky, her country, the military, and quilting. She used embroidered first stanzas of her favorite songs for her quilt. The sashing and border of this quilt are made of bunting fabric.

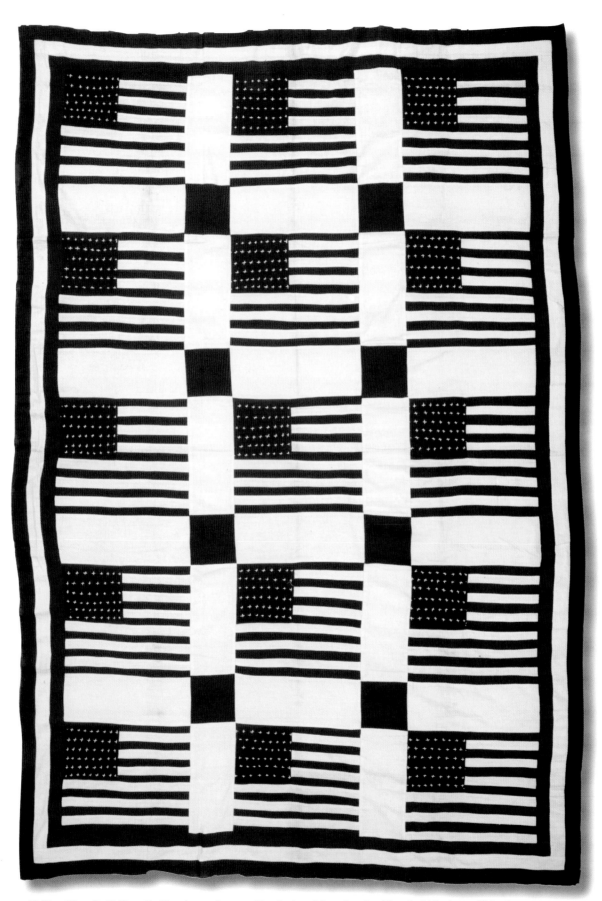

48-Star Flag Quilt Top. Quiltmaker unknown. Hand pieced, hand embroidered, 54 inches x 78 inches, cotton.

Service banners, Honor Roll Quilts and Roll Call Quilts

In the Service of His Country

Three years ago last January,
Harry Byron went away,
To fight for "Old Glory,"
And our grand American way.

Oh! On the day he had to leave,
We tried to be cheerful and gay,
But within our hearts, we did grieve,
For our son to go so far away.

His thoughts were with the G.I. Joes,
Who were defending the Red, White and Blue,
So he proudly volunteered to go,
To be a soldier true.

To service flag with a star of blue,
Our window was seen to hold,
Which soon became a silver hue,
But now, has turned to gold.

On the 20th day of July, 1944,
His sweet young life, he bravely gave,
In France, the battle of St. Lo.
For "Old Glory," the flag he fought to save.

God in all his wisdom,
Does all things for the best,
Harry Byron was called into His kingdom,
Where all is happiness, peace and rest.[91]

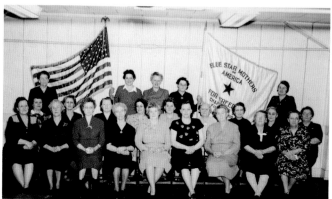

Cleveland's Rotary Club, the originator of the service flag died several years ago. [92]

The use of the Blue Star Service flag began in World War I to designate that a member of the family was deployed to a war zone. *The Denton Journal*, Denton, Maryland, reported the history of the Service Flag in an article on November 12, 1943.

Who first thought of the blue-starred (or gold-starred), red-bordered rectangle of cloth that tells its proud story in millions of American windows today? The answer is to be found in the current issue of the *Rotarian Magazine*, which reveals that the service flag was originated back in 1917 by R. L. Quissner, then a captain in the Fifth Regiment, Ohio Infantry. A Cleveland resident, he designed the emblem for use by families having members in the armed forces. Captain Quissner's idea caught the popular fancy at once, finding official sanction as the city of Cleveland and many other municipalities declared in favor of its use, while the state of Ohio shortly followed suit. A one-time member of

During World War I, Army Capt. Robert Quissner, from Ohio, had two sons fighting on the front lines when he designed the Service Flag, measuring 9 inches wide and 14 inches long with a 2-inch red border. President Woodrow Wilson took special note of American War Mothers shortly after the war, by formally instituting Blue Star Mothers and Gold Star Mothers as national organizations. In the current War on Terror, both organizations continue to be active support systems for military families.

As indicated in the poem about Harry Rann, written by his parents and grandparents, a Blue Star Service Flag was proudly displayed most likely in the front of their house and visible from the street. The symbol reminded passer-bys that preserving America's freedoms demands much. It is a symbol of love, hope, and grave concern that the loved one be safely returned home. Unfortunately, for Harry Rann's family, their worst fears came true; first when the Blue Star Flag was change to silver. A Silver Star reflects a service

member missing in action, followed by the Gold Star of reverence for losing your dear service member.

The following article in the *Sunday Times Signal*, Zanesville, Ohio, on March 21, 1943, provided information about obtaining Service Flags and Service Buttons.

"Service Buttons—White star with red background. Word "Son," "Brother," or "Husband" as you prefer, inscribed in blue in center of star. Especially designed to be worn by relatives of men in our country's service. Five cents at the counter, 10 cents by mail. For your home—Service emblems with flag and star in color all families having members in the service. Suitable for framing. Free at the counter, 10 cents by mail." [93]

Once recognized, the Blue Star symbol can be seen across our great nation. The "Blue Star Memorial Highway," maintained by the National Garden Clubs, is marked by plaques posted on over 70,000 miles of our nation's roads.[94] Each plaque is engraved with the following message, "A tribute to the Armed Forces that have defended the United States of America. Aisles of flowering trees and shrubs are planted to honor their service." [95]

Entire communities, organizations, church groups and families across our nation created their own versions of Blue Star quilts and service flag quilts. As reported in the *Denton Journal*, on October 17, 1942:

The Sunday morning service tomorrow will be devoted to the inauguration of a Service Flag in the Church. The names of men connected with Grace Church who are now serving with the Armed Forces will be called, and a star for each will be placed on the flag. The pastor will preach "This is the Victory.[96]

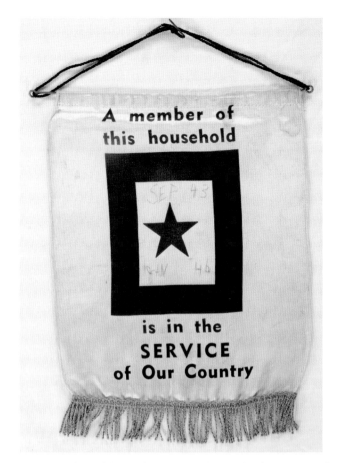

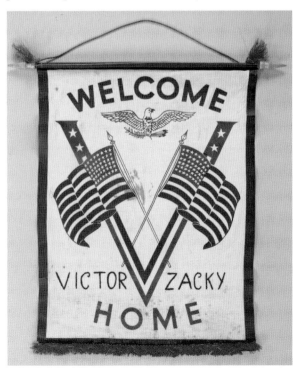

In Canada and the United States, the service banners made by churches and communities were constructed like quilts. The stars were appliquéd or embroidered in place, and soldiers' names were embroidered or inked on the stars or on the background of the quilt. They were rarely quilted. The banners were made for display to honor the members of communities small and large of both countries. *The Lethbridge Herald*, Lethbridge, Alberta, Canada, reported on July 12, 1943:

CLARESHOLM, July 12—An honor roll quilt with names on it of all the Claresholm and district members of the armed forces, is being made by the Sunshine club of Claresholm. They don't want to miss any names and are asking relatives and friends to hand the names of the service people in to any member of the club or deposit them in a box for that purpose which will be in the post office. This quilt will be raffled when it is completed.[97]

Other quilts listing soldiers' names were also used as raffle quilts to raise money to fight the war effort. The *Ada Weekly News*, Ada, Oklahoma, included, on November 30, 1944, an article from the town of Bebee.

Bebee will have a bond sale Friday night, Dec. 8 at 8 o'clock. The women have made a patriotic quilt to be sold. It is a beautiful quilt, designed in red, white and blue, with the names of service men from this district embroidered in different blocks.[98]

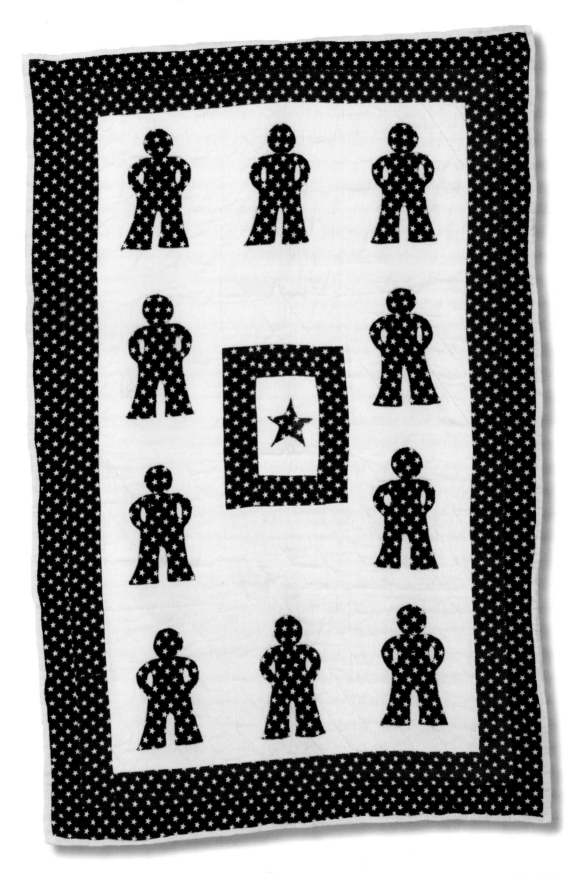

Blue Star Child's Quilt. Quiltmaker unknown. Machine pieced, hand appliquéd, hand embroidered, 30 inches x 45 inches, cotton. Most likely the young child who received this quilt which featured a Blue Star in the center, had a Daddy who was serving in the Navy during World War II.

Patriotic Star as a "Star of Hope"

The advertisements for the Robert Frank Needlework Supply Co., of Kalamazoo, Michigan, during World War II, boasted:

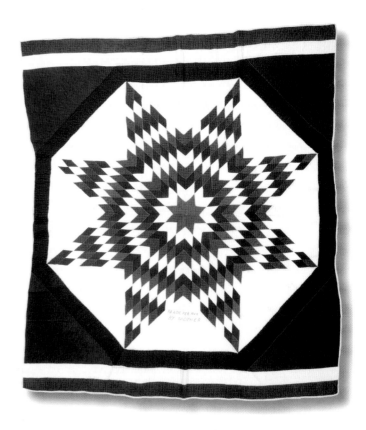

"AMERICA FIRST! In a World of Strife there Is Peace in Quilting………. In these bewildering times, where can one turn to get peace of mind and enjoy the quietude of American Home Life? You…and all women…need each day your hours of peace, rest from worries and anxieties, so that you may think of nothing else but those things you most enjoy.

From time forgotten, American Women have been known for their skill in their making of artistic Quilts, and therefore while our hearts are filled with thankfulness that we may enjoy these peaceful occupations and live in the most blessed country of the world, we created this beautiful PATRIOTIC STAR as a "Star of Hope"…..hope for the return of Peace to all mankind on this troubled earth. A Star, made up of RED, WHITE, and BLUE, the colors symbolizing our Flag, under which our forefathers fought and died, so that we should have freedom and liberty and the heritage of American Citizenship.

Patriotic Star Quilt. Quiltmaker unknown. Hand pieced, hand quilted, 81 inches x 87 inches, cotton. The Robert Frank Needlework Supply Company, of Kalamazoo, Michigan, sold die-cut, diamond patches to be made into Radiating Star quilts. During World War II, the colors were sold in red, white and blue, and the pattern design was renamed Patriotic Star or "Star of Hope."

You want such a beautiful quilt design in your home, you want such a patriotic design, to show posterity that you were filled with emotion at these momentous times, when new history is in the making. And we, who are privileged to turn the new bolts of our "Golden Star" Percale into perfect fitting machine cut pieces, pledge ourselves to supply you with the finest quality and perfection unexcelled, so of red, white and blue, and see them develop into the most breath-taking beauty....this Patriotic Star.[99]

The ad promoted 648 perfectly pre-cut, diamond pieces with a diagram and suggestions for constructing the quilt. The regular price was $2.95, but a coupon was made available during the war for $1.00 off, making the purchase a real bargain at $1.95. The order blank provided the opportunity to buy the parts individually: the Diamonds for $1.95; the Border for $1.25; the Corners, Triangles and Enlarged Strips for $1.40; Special Oblong Enlarged Strips for 50 cents; and the Master Quilting Pattern for 40 cents. You could also order the Golden Star Percale Backing for $2.30; Mountain Mist® Filling for 80 cents; "Nu-Style" Quilting Frame for $4.98; and extra Golden Star Percale for 29 cents/yard.[100]

The many options for border and corner fabrics and matching die-cut diamonds provided quiltmakers with the opportunity to make Robert Frank's *Star of Hope*. These patriotic relics of World War II can be found today in many variations. The quilt inscribed with "MADE FEB. 1944. BY. MOTHER," featured on page 71, used four corner fabrics and two borders. Another Star of Hope quilt featured on page 100 did not use borders. Many variations of quilts made with this design from the World War II years are entering today's marketplace. They have been packed away in trunks and attics for 65 years. As their makers begin to pass away, these red, white and blue Star quilts once again proudly shine.

Patriotic Star Quilt. Quiltmaker unknown. Hand pieced, hand quilted, 81 inches x 87 inches, cotton.

Eight-Point Star Quilt. Quiltmaker unknown. Hand pieced, hand quilted, 65 inches x 81 inches, cotton. The red, white and blue solid colors of this quilt typified the patriotic zeal of the World War II era of quiltmaking.

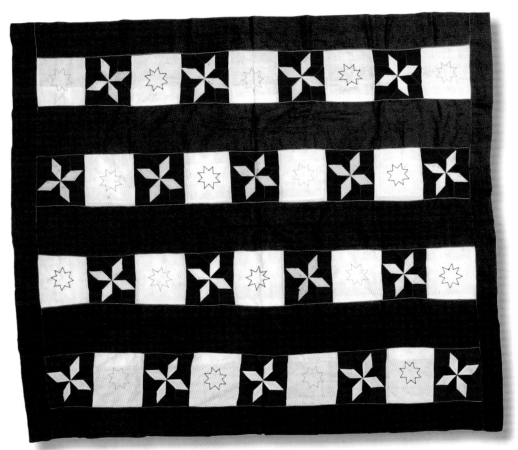

Eight-Point Star Quilt. Quiltmaker unknown. Hand and machine pieced, hand embroidered, 61.5 inches x 74 inches, cotton.

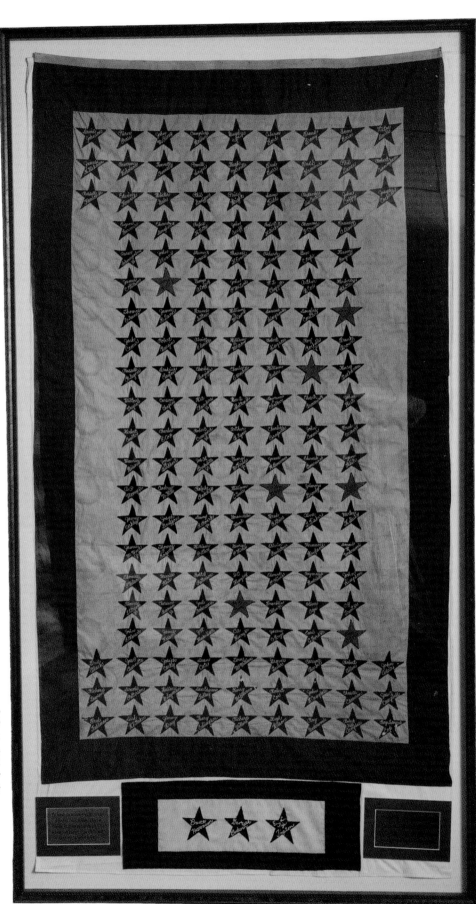

This church banner was made, like a quilt, with appliquéd stars to represent the men and women from Clinch/Locust Methodist Church, Knoxville, Tennessee during World War II. *Photography by Gary Heatherly, Knoxville, Tennessee*

Clinch/Locust World War II Honor Roll Banner

Constructed like a giant Blue Star Flag, the Honor Roll Banner of the Clinch/Locust Methodist Church was proudly displayed in Knoxville, Tennessee, during World War II. The banner was made like a quilt, with 155 appliquéd stars and a red border. The stars were embroidered with the names of the young men and women sent to war from the church. All of the stars are blue with the exception of the six Gold Stars representing the young men from the church killed in action.

Like much memorabilia of the World War II years, this incredible document in fabric was stored away in the church archives for over 60 years. Rediscovered a few years ago, a group of quilters from the church, called the "Tuesday-Bee," dedicated themselves to the restoration and conservation of the historic textile. Celia Shanks, a member of the group, organized the effort which included cleaning and backing the banner with muslin and adding the horizontal addendum to the bottom of the textile. Great care was taken by the "Tuesday-Bee" to match the fabric of the original banner as closely as possible and to record the names of three soldiers overlooked on the original list. The restoration/conservation was completed in time for display near the sanctuary of the First United Methodist Church of Knoxville, Tennessee, in commemoration of Veteran's Day, 2008. The banner was recently encased in a glass frame for further conservation.[101]

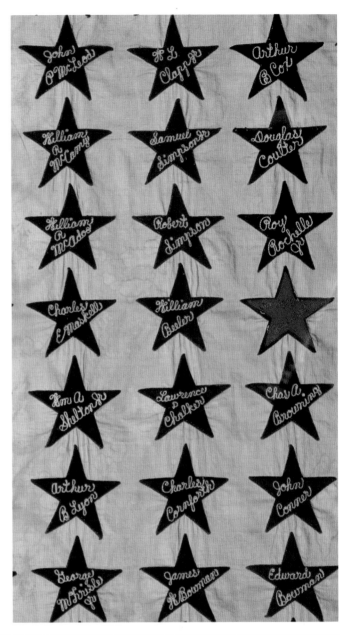

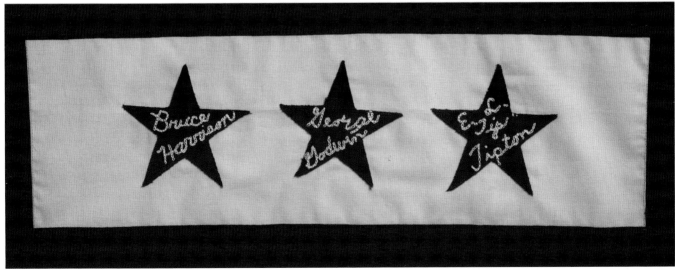

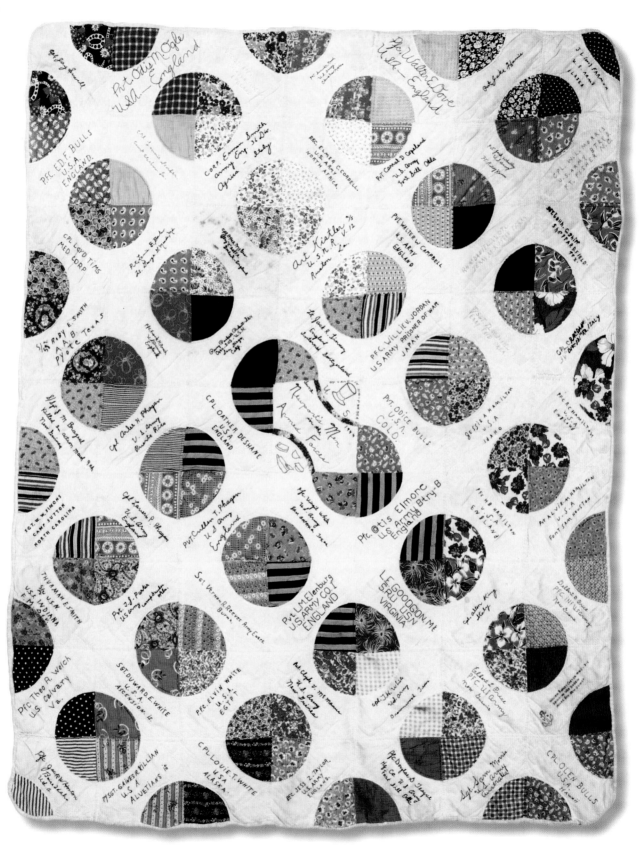

Roll Call or Honor Roll Quilt. Quiltmaker unknown. Newport, Texas. Hand pieced, hand embroidered, 66 inches x 84 inches, cotton. This quilt represents men from two Texan counties serving in World War II. Their ranks, deployments, and branches of the military are listed on the quilt. The quilt pattern has a global design, reflecting the fact that these military men were stationed at the four corners of the world.

The Newport Texas Honor Roll Quilt

Dated June, 1944, this quilt, from Texas, was made to honor "Newport's Men in the Armed Forces." Their names, ranks, branches of the military, and where they were stationed throughout the world were inked or embroidered on the quilt. The quiltmaker chose a pattern called Snowball, or Baseball, to construct the quilt. Piecing with four separate printed fabrics, the quiltmaker achieved a global design, perhaps to represent the four corners of the earth and the world-wide posts of the men of Newport serving during the war. Other important symbols on this quilt are Uncle Sam's Hat and the uniform hats of the branches of the Military.

Newport is a small town in eastern Clay County, North Texas. The men represented on this quilt were from Clay County and Montague County, directly to the east of Clay County.[102] The population of Newport was approximately 280 people in the 1940s.[103] Regardless of the diminutive size of the town, this quilt displayed immense pride and a strong sense of honor for the fighting men of the Newport area. Most touching are the blocks that represent the men who were prisoners of war, missing-in-action, or killed in action. The quiltmakers of the Newport, Texas, have left future generations an amazing textile, a testament in fabric of the contribution their fighting men made during World War II.

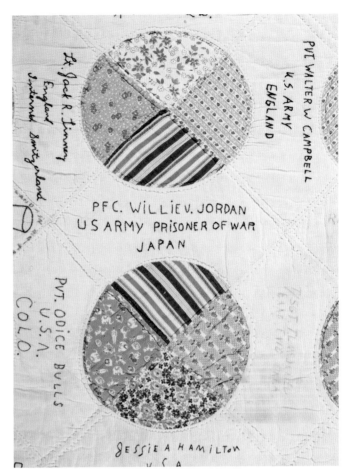

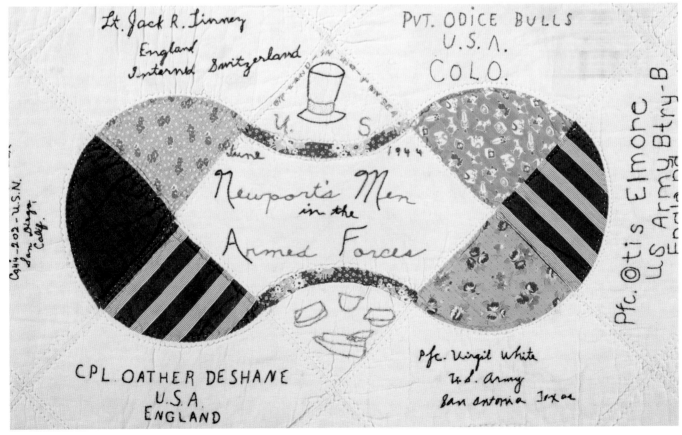

ARMY

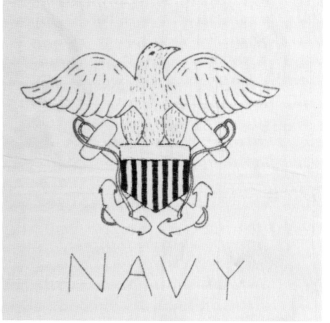

NAVY

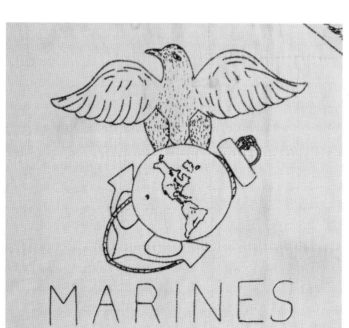

MARINES

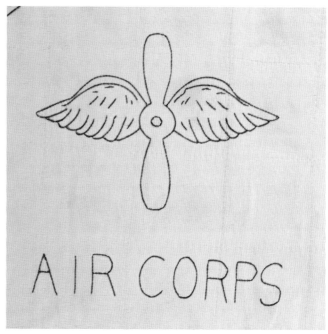

AIR CORPS

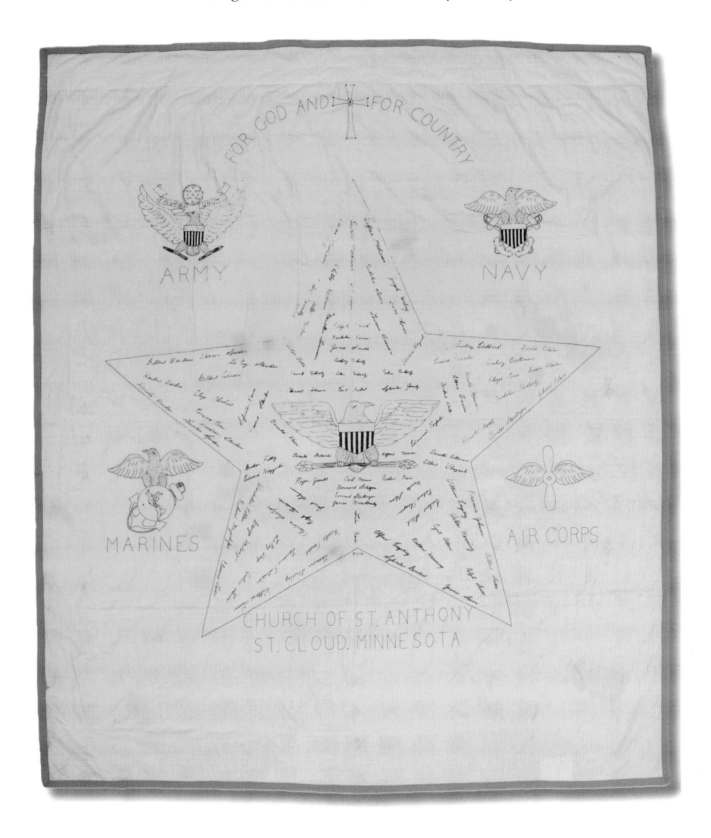

Roll Call or Honor Roll Quilt. Church of St. Anthony, St. Cloud, Minnesota. Dated 9/1/42, machine seamed, hand embroidered, 80 inches x 80.5 inches, cotton. This quilt was made as a tribute to the men and women serving in the Armed Forces from St. Anthony's Church, St. Cloud, Minnesota. Embroidery work depicts symbols of the Navy, Marines, Air Corps and the Army.

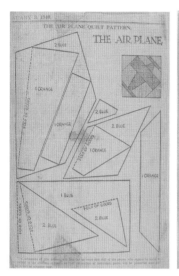

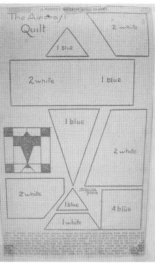

Left: The Air Plane pattern, published on August 1, 1934, January 3, 1940 and June 3, 1942 in the *Kansas City Star* newspaper.

Right: The Aircraft Quilt (Foland) pattern, originally published on July 17, 1929 in the *Kansas City Star* newspaper.

Identification of Aircraft for Army Air Forces Ground Observer Corps, **United States Government Printing Office, Washington D.C. 1942, page 13.**

Airplane Quilts

Keep Them Flying!

Despite the hard times of the Depression years, from the late 1920s and 1930s, quiltmaking remained one of the most popular pastimes in which women indulged themselves. Local newspapers, from urban and rural areas, continually reported record numbers of women quilting in groups.[104] Airplane quilt patterns were first created in 1929. This was two years after Charles A. Lindbergh completed his successful first flight across the Atlantic Ocean. Throughout the 1930s, new airplane quilt designs were introduced to the quilt world. Toward the end of the 1930s, as the realities of a new war approached, our country began to expand its military and the skies over America became filled with planes.

Many variations of airplane quilts were made from the late 1930s to 1945. Assigning a precise date to an airplane quilt can be difficult, unless the specific pattern publication date is known. Airplane quilts made with patriotic red, white and blue material are most likely World War II era quilts. Airplane quilts made with scrap fabrics from the second quarter of the twentieth century are harder to identify as World War II quilts, unless the pattern can be positively traced to just prior to the war years. It was common for scrap quilts, made during the war years, to include fabric printed decades earlier.

The Lockheed Hudson

Canada was officially involved in the war in the European theater earlier than the United States. On Christmas morning, 1940, Lyman A. Chapman, age 12, of Truro, Nova Scotia, received a gift he would cherish throughout his life. To honor the service of his father, Lyman T. Chapman, Commanding Officer of the Royal Canadian Air Command Recruiting Centre, Lyman's aunt, Dorothy Freemen, created a plane quilt depicting a rendition of the Lockheed Hudson bomber. She appliquéd a red silhouette of the plane on a heavily quilted blue background and achieved a dramatic effect.

Dorothy Freeman lived on a dairy farm in East Amherst, Nova Scotia. Her brother, Lyman's father, was the principal of the Nova Scotia Agricultural College when he joined the war effort. After the war began, it was necessary for Lyman's family to move to Halifax.[105]

Lockheed Hudson Bomber Quilt, made by Dorothy Freeman, East Amhurst, Cumberland County, Nova Scotia, Canada. Hand appliquéd, hand quilted, 61.5 inches x 72.75 inches, cotton. Made for her nephew, Lyman Chapman. This appliqué quilt shows a replica of the plane his father flew in World War ll. The Lockheed Hudson served an important role in the Battle for Britain.

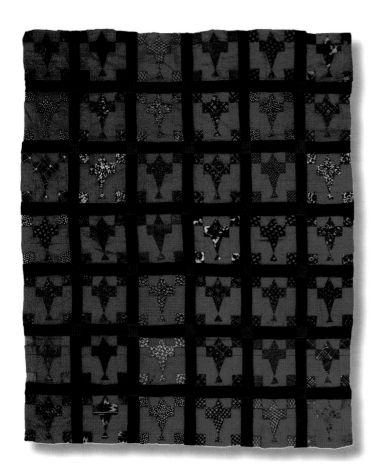

Airplane Quilt Top. Quiltmaker unknown. Hand and machine pieced, 68.5 inches x 82 inches, cotton. This airplane quilt top features prints from three decades, the 1920s, 1930s and 1940s.

Airplane Quilt. Quiltmaker unknown. Hand appliquéd, machine assembled, hand quilted, 61 inches x 81 inches, cotton. The quilt blocks of this airplane quilt were set on point. The red, white and blue color scheme leaves little doubt that it was made during World War II.
Courtesy of Michelle Erker

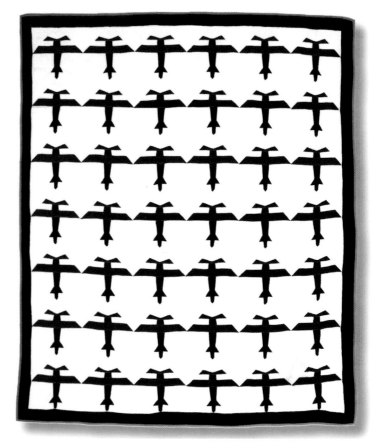

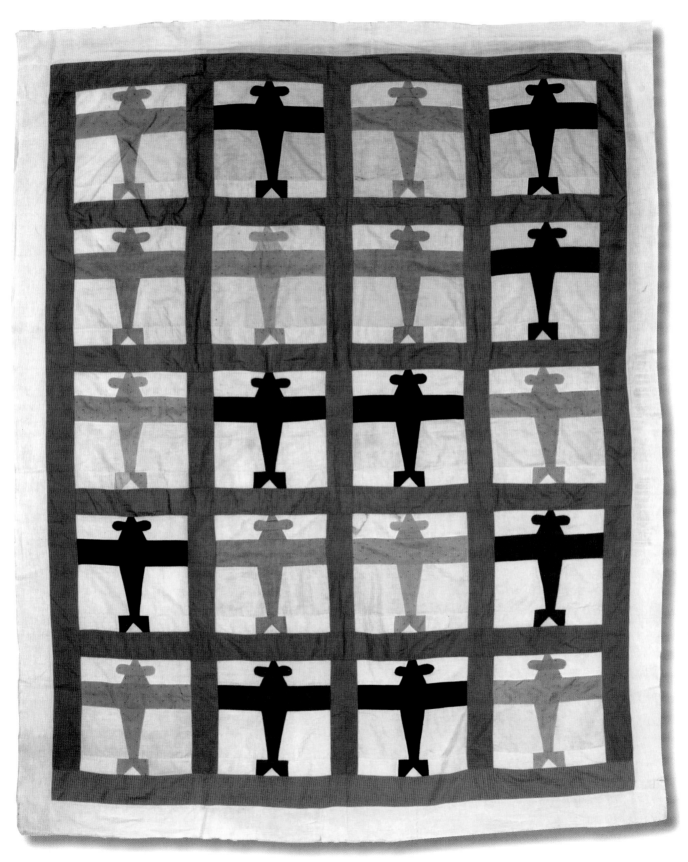

Airplane Quilt Top. Quiltmaker unknown. Hand and machine pieced, hand appliquéd, 72 inches x 85 inches, cotton.
Courtesy of Donna Stikovitch

Airplane Quilt with Quilted Eagles. Quiltmaker unknown. Machine pieced, hand appliquéd, hand quilted, 62 inches x 81 inches, cotton.

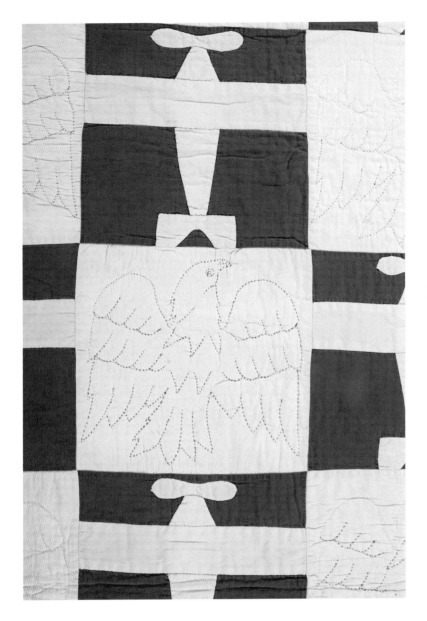

Detail of Airplane Quilt with Quilted Eagles.

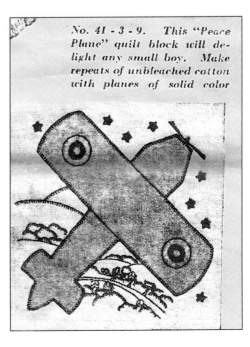

No. 41 - 3 - 9. This "Peace Plane" quilt block will delight any small boy. Make repeats of unbleached cotton with planes of solid color

Peace Plane Pattern, *Home Arts Magazine*, Augusta, Maine, March 1941. The pattern states "This 'Peace Plane' quilt block will delight any small boy. Make repeats of unbleached cotton with planes of solid color. *Courtesy of Michelle McLaughlin*

Military Quilts

Military quilts are the most identifiable group of quilts with a connection to World War II. Insignia, rank, weaponry, airplanes, and ships are all strong indicators of the great pride our country expressed with every medium.

Hail to the Army and the Navy!

The quilt patterns "Sea Wings To Glory" and "Wings All Over" were published by Mountain Mist® in 1943, to honor American Army and Navy aviators. The pieced and appliquéd quilts made from patterns feature insignias of the Navy and Army Air Corps flight, along with anchors, waves and parachutes in the quilting designs. The batting wrappers enclosed with each pattern stated:

Today when we are constantly reminded of the importance of Aviation by the hum of motors overhead, it seems only fitting that we honor the men and women who are flying those planes. Thousands of our young people are learning to fly and think nothing but 'Wings.' So, these quilts are designed as a keepsake from these days of progress.

116

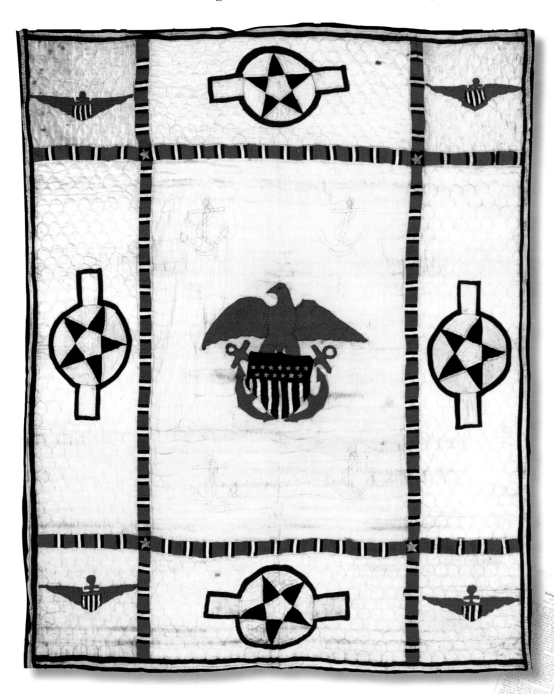

"Sea Wings To Glory Quilt," Mountain Mist® pattern. Quiltmaker unknown. Hand and machine pieced, machine appliquéd, hand quilted, hand embroidered, 76.5 inches x 89 inches, silk.

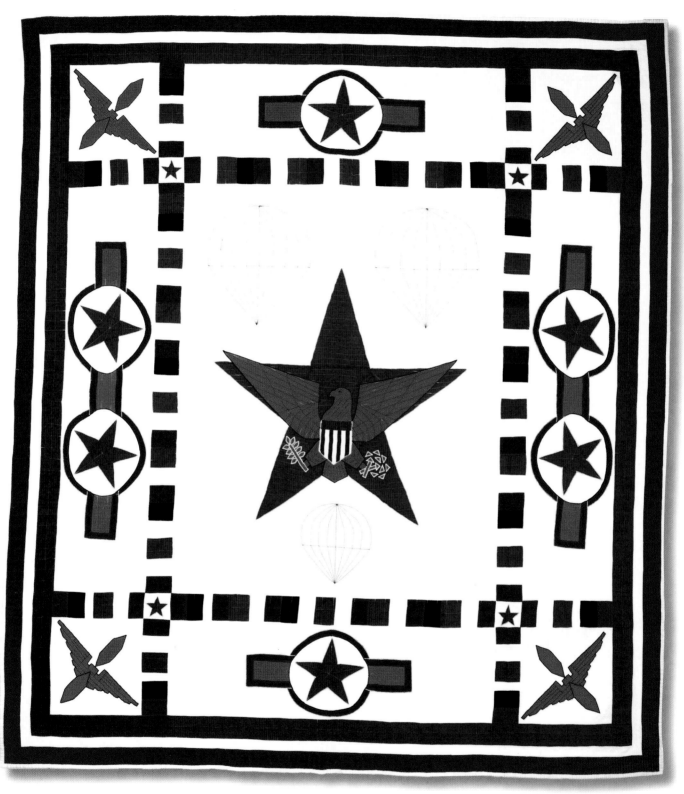

"Wings Over All Quilt," Mountain Mist® pattern. Quiltmaker unknown. Machine pieced, machine appliquéd, machine quilted, 88 inches x 100 inches, cotton.

8th Armored Division Quilt. Quiltmaker unknown. Hand pieced and machine pieced, machine appliquéd, hand quilted, 77 inches x 88 inches, cotton. The 8th Armored Division landed in France in January, 1945, and advanced rapidly to the country's Alsace region by the end of the month. From there, the "Iron Snake" (also called the "Thundering Herd") crossed the Rhine River and moved into the industrial Ruhr region of Germany to become the first unit to liberate a concentration camp in World War II. The 8th Armored Division was recognized for this feat by the U.S. Army's Center of Military History and the United States Holocaust Memorial Museum in Washington, D.C., in 1995.

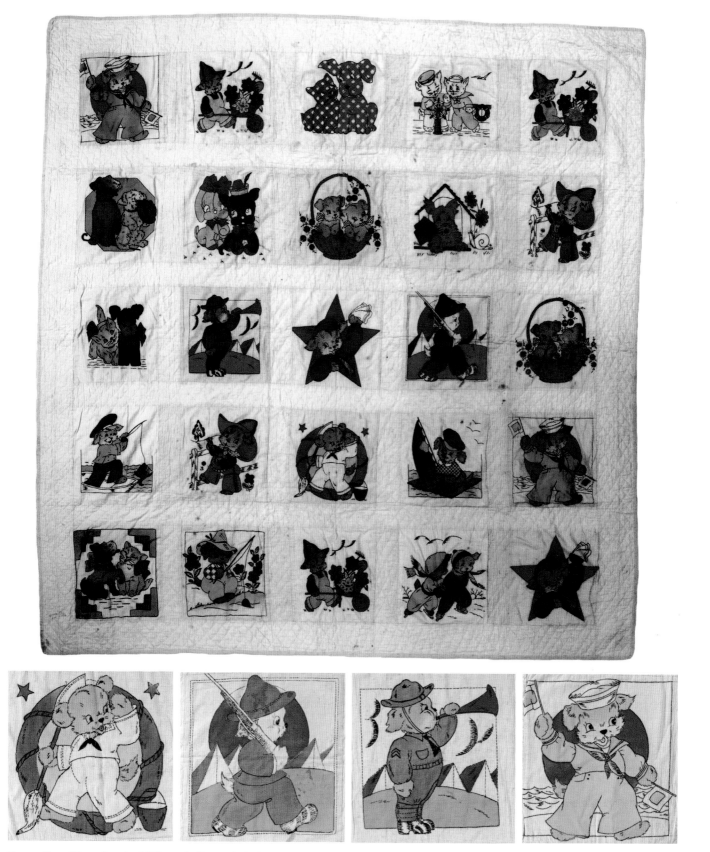

Puppy Dogs Honoring the Military Quilt, made by Margaret Jo Smith Williams and her grandmother, Louisianna Vertress, of Ada, Oklahoma, in 1939. Margaret was then sixteen years old. Hand pieced, hand quilted, hand painted, 83 inches x 94.5 inches, cotton. The blocks feature various scenes with dogs involved in the activities of World War II. The Army, Navy and Victory Gardening symbols are some of the activities shown. *Courtesy of Rebecca Heinze*

Victory or Sergeant's Chevron Quilt. Quiltmaker unknown. Hand and machine pieced, hand quilted, 78.5 inches x 92 inches, cotton. This patriotic red, white and blue quilt has blocks set on point with alternate blocks quilted in an anchor pattern. *Courtesy of Susan Miller*

Chevron Stripes Quilt. Quiltmaker unknown. Machine pieced, hand quilted, 62.5 inches x 86 inches, cotton. The chevron design was made with red, white and blue fabrics. Sashing and corners blocks finish the overall design.

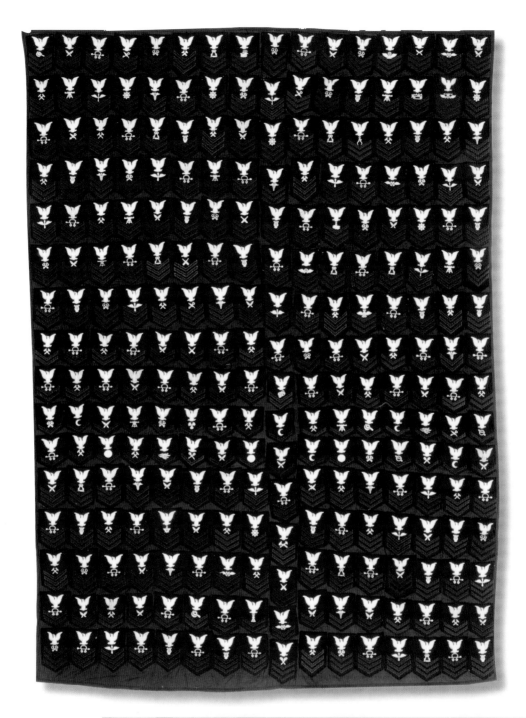

Navy Insignia Quilt. Quiltmaker unknown. Machine pieced, machine appliquéd, 64 inches x 88 inches, cotton, wool. A special story accompanies this quilt. It was made by a seamstress who sewed insignia patches on sailors' uniforms. The sailors gave her a patch to make her quilt in exchange for a package of cigarettes.

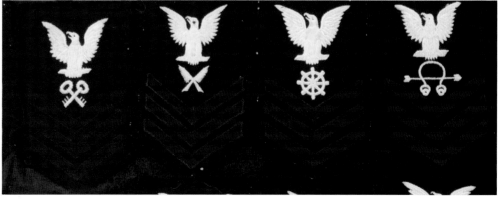

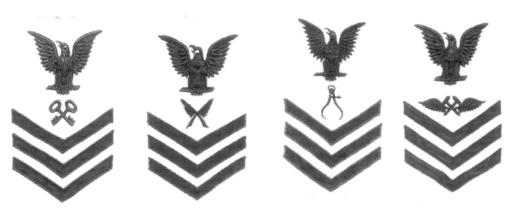

Navy Patches Quilt. Quikltmaker unknown. Machine pieced, machine appliqued, 73.5 inches x 85.5 inches. Two hundred and eighty- four, white, Navy twill patches were sewn onto a cotton base. This quilt is a match to the blue Navy patch quilt and came from the same source.

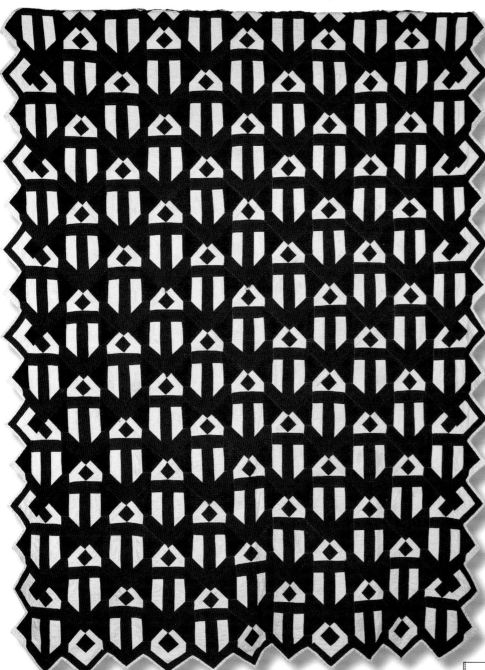

Anchor's Aweigh Quilt. Quiltmaker unknown. Hand pieced, hand quilted, 70 inches x 92 inches, cotton. This quilt is an exact replica of the pattern published in newspapers during the war years. *Photography by On Location Studios, Poughkeepsie, New York.*

by Alice Brooks

The Vidette-Messenger, Valpariso, Indiana, Wednesday, October 21, 1942, page 2.

Marching Soldier Quilt

PATTERN 7148

The pattern for this Marching Soldiers Quilt was featured in *The Charleston Daily Mail*, Charleston, West Virginia, on November 26, 1941

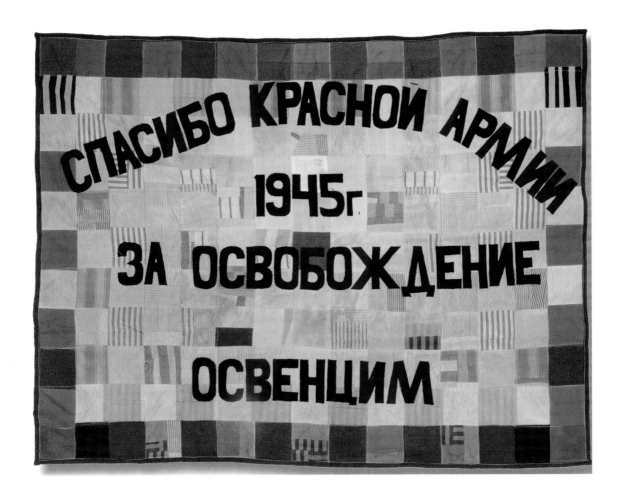

Russian Army Quilt. Quiltmaker unknown. Machine pieced, machine appliquéd, 40 inches x 51.5 inches, cotton. Constructed like a quilt, this banner was made at the end of World War II from remnants and fragments of clothing and shirtings. It was machine appliquéd to a burlap backing. The words are Russian and say "Thank you Russian/Red Army for the liberation of Auschwitz 1945." This quilt was found in the McKeesport area, near Pittsburgh, Pennsylvania. The area was the home of many Eastern European immigrants, primarily from Russia, Poland, Hungary and Czechoslovakia, who came to work in the steel mills after World War II. There is currently speculation about the purpose and origin of this quilted piece. On close examination, many of the squares are patched together with multiple fragments of cloth of gray and blue striped clothing that resembles the work clothes in concentration camps.

Quilting Groups of World War II

Members of "Do Your Bit Clubs" Worked on Quilt Blocks

Across the nation, people from school-age girls to grandmas met in groups to quilt. They quilted at Red Cross centers, in community clubs, in churches and private homes. They made quilts to raise money for the country's defense and to send directly to the needy in war-torn countries. Their quilts were shipped to refugees in Europe and Britain.

Early in the war, an article in the *Anniston Star*, Anniston, Alabama, published on October 28, 1942, encouraged women to quilt.

> Women are getting together on good old-fashioned sewing bees, too, getting a little talk and companionship while they rip up their old dresses and make them over for the children. If they don't use a little imagination, a lot of women are going to find themselves completely tied to their homes, as it becomes necessary for them to take on more and more work. But if they do figure out ways of sharing work and doing part of it together some of their work can offer as much sociability as old-fashioned quilting bees, which, by the way, are coming back into favor as women turn woolen scraps into warm quilts for air raid shelters.

An article published on June 3, 1944, in the *Northwest Arkansas Times*, of Fayetteville, Arkansas, urged women to turn their quiltmaking into a war weapon.

QUILTING BEE
Grandma made thrifty use of cloth "scraps" that might otherwise be discarded. She warred against waste by making things last longer.

Ads of the World War II used military terms to encourage Americans to do their part.

126

Quilt and comfort making is a very old art, but it took the working ability of the Booger Hollow home demonstration club in Pope county to turn it into a modern warfare weapon, according to Mabel Russell, home demonstration agent. Women of the Booger Hollow community decided after war was declared, that they would buy bonds as a club project. Seven $25 bonds, at present, are owned by the club. Most of the bonds have been bought with money earned by piecing and selling quilts and comforts. Club members buy prints for lining, and cotton and thread at an average cost of $1.50 per comfort. The quilts sell from $3.50 to $7.50 each. Meeting in a group in their homes, the women make two comforts in half a day.[106]

The article about the women of Booger Hollow, Arkansas is but one of thousands of short articles recording quiltmaking during World War II.

In Curwensville, Pennsylvania, the ladies of the Rebecca Lodge met to sew in the Odd Fellow's building each Wednesday. As of April 22, 1942, fifty quilts were completed to be used by wounded soldiers. A request for sewing machines and bright woolen patches was printed in the local newspaper with these instructions: "If you have neither patches nor machines but a will to help, join the ladies on Wednesday afternoons."[107]

Organizations that benefited military personnel, such as the United Service Organizations (USO), were also recipients of money raised through quiltmaking. *The Mason City Globe Gazette*, Mason City, Iowa, reported on November 7, 1942 in Decorah, Iowa, "The Merry Sunshine club turned in $40.85 to the USO last week through the sale of a quilt. The quilt was made of 48 blocks, each block having the design of the state flower of one of the states."

The names of these groups of women, gathered together for the purpose of making quilts, have the quaintness of down-home charm.

In Mason City, Iowa, the **Jolly O Club** met at the home of Mrs. Robert Cole, in Greene, Iowa, in January, 1942, to make and sell a quilt for national defense.[108]

In 1942, Kanawha, Iowa, had a number of quilting groups sewing for the war effort. The **Thimble Club** pieced a cover for a quilt and presented it to the Britt Chapter of the Red Cross.[109]

The **Sew and Sew Club** met on Tuesday afternoon at the home of Mrs. Bert Converse. The women finished quilting a flower garden quilt sold at auction at the Kanawha sales pavilion with Mrs. Elmer Nelson and Mrs. E. S. Viken.

The **Stitch and Chatter Club** met to piece a wool quilt to be presented to the Red Cross.[110]

In 1944, members of **Do Your Bit Club** worked on quilt blocks at the home of Mrs. Mel Jacobson.[111]

A women's sewing group mending the hospital linen, March, 1942, at the Provident Hospital, Chicago, Illinois. *Courtesy of the Library of Congress*

The Kokomo Tribune, Kokomo, Indiana, reported on February 28, 1942, the following account of a local quilt group: "The **Loyal Birthday Club** met Friday afternoon with Mrs. Ethel Morgan, the group spending the greatest part of the afternoon working on a Red Cross quilt."

In Moberly, Missouri, "Members of **Sew-So Club** met in all-day session in the Red Cross sewing rooms in the Municipal Auditorium and spent the day quilting for the Red Cross."[112]

New quilt patterns were issued by the Red Cross to the **Friendly Sewing Club**. The group held its meetings at the home of Mrs. Wiley J. Harvey, Abilene, Texas. The group quilted for the Red Cross.[113]

In Ironwood, Michigan on March 6, 1943, "The **Willing Workers** met at the home of Mrs. Frank Kuhuel and tied a quilt for the Red Cross."[114]

The Red Cross was not the only organization to benefit from the generosity of American and Canadian women. In Tanque Verde - Wrightstown, Arizona, women met weekly at Ranch Figeroa, the home of Mrs. F. G. Eberhard. She converted a cottage on her ranch into a sewing workroom with sewing machines, quilting frames and hanging space for the quilts the group made for **Bundles for Britain**.[115] And not all quilts made during the war years went overseas. Crazy quilts saw a revival during World War II. *The Portsmouth Herald*, Portsmouth, New Hampshire, reported on February 13, 1943: "The **Homemakers Club** of York Beach met this week at the home of Mrs. Basil Burnette to complete a crazy patchwork of all wool pieces. This they presented to the U.S. Coast Guard stationed at York Beach.

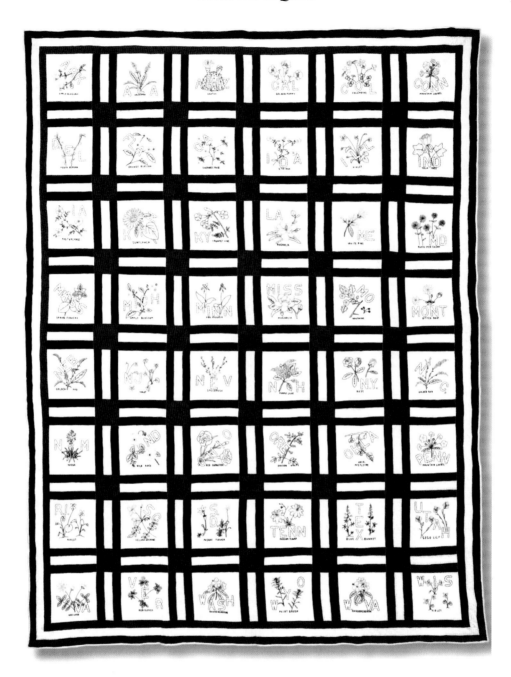

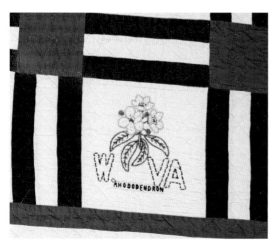 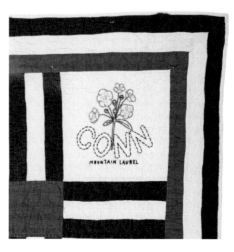

Embroidered States Quilt. Quiltmaker unknown. Hand embroidered, machine assembled, hand quilted, 71 inches x 92.75 inches, cotton, cotton embroidery floss. The state flower designs for this quilt were published by William Pinch's Rainbow Block Company, Cleveland, Ohio, in 1936. *Courtesy of Sharon Waddell*

"Mrs. H. R. Lady, Mrs. Bill French, Mrs. J. E. Murray, and Mrs. Robert Delius met at the Masonic Hall in Kingsport, Tennessee."

"Members of the **O.E.S. Social Club** are reminded to bring two or more 12-inch quilt squares of crazy quilt or string pattern, as well as a book for the Victory Book campaign." [116,117]

Quiltmaking activities were also taking place in Canada. There, quiltmakers surely win the prize for enormous quantities of quilts made and donated to the Red Cross and Bundles for Britain. At Farm Hill, Lethbridge, Alberta, the Canada at War group's February accounts showed: "seven quilts made and given to Red Cross, one quilt made and given to Russian relief, one knitted tuck-in, one helmet, three seamen's quilts to Navy League..."

In addition to quiltmaking, an article on "What to Save for Salvage" was read by the secretary, Mrs. Henderson, and this appeal to save and give more to the Red Cross was made by the president: "The Institute is collecting grease and scrap fat and papers, magazines, rags, bones, also scrap metals." [118] Failed attendance at these meetings was frowned upon. Roll call was taken at every meeting. In April, 1942, in Nightingale, Alberta, a bank was designated to receive the pennies from fines on roll call unanswered. They were making a quilt from a pattern called "Stars and Crescents" in colors red, white and blue.

World War II Fundraising Quilts

For centuries, quilts have been made for purposes other than comfort and warmth. Since the early nineteenth century, and probably before, women made quilts to raise needed money for their churches and communities. From the early nineteenth-century to this day, women used their quiltmaking skills to elevate the social conscience for compassionate causes in their communities. During the Civil War, the Ladies Benevolent Society of Northfield, Connecticut, recorded in their weekly minutes in 1863, "a few tired Soldiers in the Cause met at the Parsonage...with determined hearts to do all in their power for the aid of "Our Brave Soldiers." [119]

Fundraising quilts embroidered with hundreds of names became popular after the Civil War to raise money for the Sanitary Commission, for widows and orphans left destitute by the war, and the Old Soldiers' Homes, as aging Civil War veterans acquired increased care. The Women's Relief Corp (WRC), the women's organization associated with the Grand Army of the Republic (GAR), made quilts to raise money for decorations for patriotic days, to purchase grave markers for veterans, and to continue the work of the Sanitary Commission. [120] Their particular style of fundraising quilt was resurrected during the next two great wars, World War I and World War II. Campaigns were held and money was collected from individuals to have their names embroidered or signed on a quilt. The finished quilt was raffled to collect money for further benevolent purposes.

In Ottawa, Ohio, women of Tawa Rebekah Lodge 821 carried out a "novel scheme." *The Lima News*, Lima, Ohio, reported on March 31, 1942 the making of a "Victory Quilt." The quilt was embroidered with the names of local citizens and raffled to purchase war bonds. [121]

In 1942, the women of the Nekoosa Chapter of the Red Cross began a fundraising campaign to make a quilt to be embroidered with 1,100 names. Mrs. Jess Mosey volunteered to be chairman of the campaign. [122] The quilt was clearly identified as a "name quilt." *The Wisconsin Rapids Daily Tribune*, Wisconsin Rapids, Wisconsin, printed an article on February 23, 1942, that stated:

> The quilt will have 55 blocks with 20 names on each block, and 55 additional blocks each with a red cross. A contribution of 25 cents will entitle a person to have his or her name included on one of the blocks. When the quilt is finished and quilted, it will be placed on display at Heilman's store.

Two weeks later, on March 7, 1942, in the same newspaper, it was announced that:

> ...Material for a Red Cross name quilt has been received. The quilt is to be made up of nine inch squares of white percale with a red cross appliquéd on some squares and names embroidered in red on other squares.

In the next six months, the campaign to collect 1,100 signatures was concluded. Each person paid 25c for the privilege of having their names embroidered on the quilt. The signatures were inscribed and then embroidered on the quilt. After that, it was pieced and quilted in time for display at Heilman's store on September 12th and 13th. On September 15th, it was shown at the Wisconsin theater in Nekoosa. [123] The article also reported the progress on two more name quilts in various stages of completion to be auctioned to benefit the Red Cross. The first quilt was auctioned on September 16th, and the winner was Henry D. Fey, age five, son of Mr. and Mrs. Henry R. Fey, 124 McKinley Street. [124]

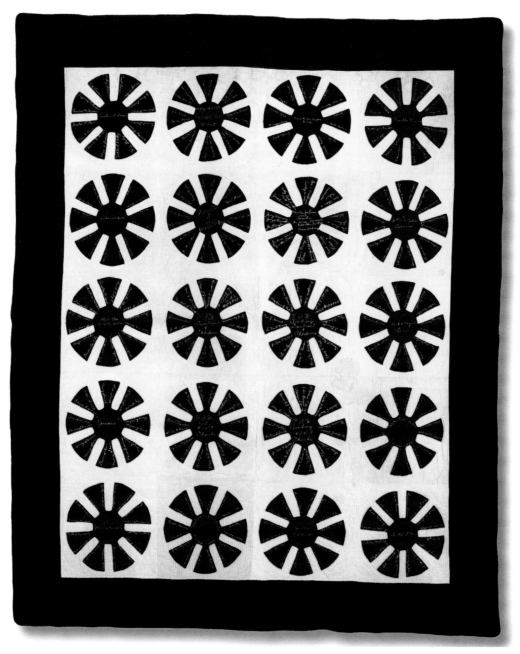

Kansas/Oklahoma Fund Raiser Quilt. Made by quiltmakers from auxiliaries in Kansas and Oklahoma. Machine pieced, hand appliquéd, hand embroidered, 78 inches x 94 inches, cotton. People paid money to have their names embroidered on this fund raising quilt. It was then raffled to raise funds for the war effort. There is a special tribute on this quilt to Gold Star mothers and to the Parents of Gold Star boys.

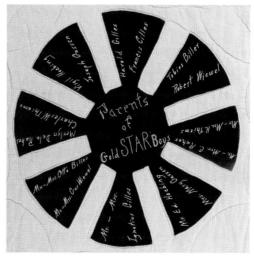

Canada's Famous Names Quilt

During World War II, the entire Bishop family actively participated in the war effort from the Canadian home front. Air Marshall William A. Bishop, affectionately known as "Billy Bishop," was a highly decorated World War I pilot from Owen Sound, Ontario. In 1940, at forty-six years of age, he was placed in charge of recruitment for the Royal Canadian Air Force. His herculean accomplishments during World War I brought him decades of recognition with citations, medals, books, and even an appearance in *Captain of the Clouds*, a movie inspired by a book of the same title to encourage young Canadians to become RCAF pilots. His own son, Arthur, took up the call to arms in World War II to become a Supermarine Spitfire pilot and participate in the Battle of Britain. His daughter, Jackie, earned her own Wireless Sparks badge as a radio operator and his wife Margaret's talents and connections gave us the "Famous Names Quilt."

Billy Bishop met Margaret Burden in 1917, while on leave in his hometown, Toronto, during World War I. Later in life, in an interview for *Liberty* magazine, he described their meeting as love at first sight. "She was a picture of white organdy, with laughing dark eyes and raven hair."[125] Margaret was the socialite granddaughter of Timothy Eaton, founder of the famous Canadian department stores, T. Eaton & Co., that had opened as a dry goods store and haberdashery in 1869. Eaton & Co. was successful and the family was commonly referred to as "Canada's Royal Family."[126] Generations of Canadians warmly recall the Christmas parades, first begun by the Eatons in Toronto in 1905.[127]

In 1941, Margaret Bishop led the Ottawa Air Force Officers' Wives Association in the making of a quilt to raise money to "buy comforts for the airmen both overseas and in Canada."[128] The finished quilt measured 111 inches by 96 inches and was inscribed with the embroidered signatures of 2,000 "Famous Names." It was exhibited in Eaton stores across Canada, and tickets were sold to the eventual lucky winner. The following excerpt from *The Lethbridge Herald* of May 7, 1943, identifies many of the notable personages on the quilt.

The project grew in scope as signatures of notables were secured. Most treasured of squares is that which flew back from England with Air Marshal Bishop. Topped by the name of Winston Churchill, it also bears the signature "Clementine Churchill," "Sholto Douglas," "Brendan Bracken," "Averill Harriman," and the legendary "Chequers."

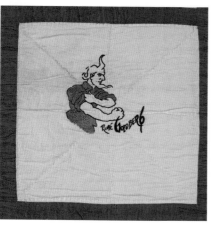
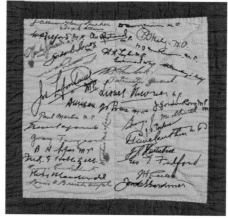
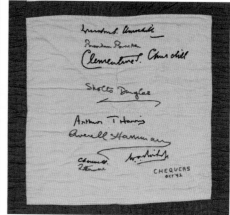

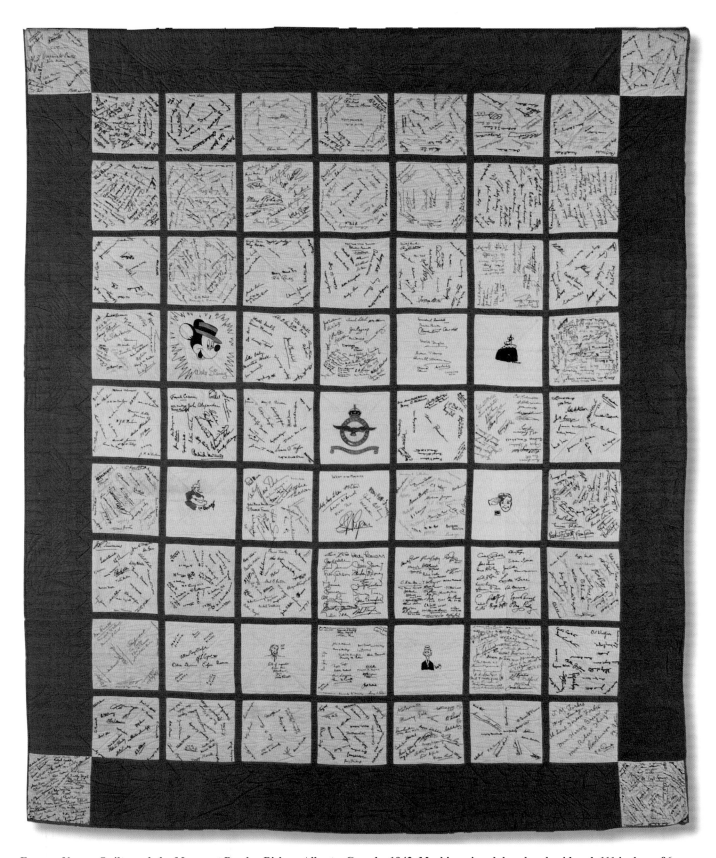

Famous Names Quilt, made by Margaret Burden Bishop, Alberta, Canada, 1943. Machine pieced, hand embroidered, 111 inches x 96 inches, cotton. *Courtesy of the Manitoba Crafts Museum and Library*

Famous Names

Princess Juliana and Prince Bernhard are there, their names topped by delicately embroidered Netherlands crowns. Two squares went up to Ottawa's Capitol Hill and came back covered with autographs any collector would envy—including that of Prime Minister MacKenzie King. Another went down to Washington, and is centered by the graceful signature of Eleanor Roosevelt. Heads of the army, navy and air force have joined forces on yet another. One square found its way to Callender, Ont., and has the carefully printed signatures of the Dionne Quintuplets raying out from autographs of their parents and doctors.

Hollywood and Broadway are well represented, including autographs of the late Carole Lombard and Mae Robson. The cast [of] *Captain of the Clouds* contributed a whole square, as did Paul Muni and the cast of *The Commandos Strike at Dawn*.

Mickey Mouse, Too

Pictures expertly needled, are an added note of interest—a Walt Disney square, with Mickey in an air force blue boater hat; Soglow's "Little King"; Casper Milquetoast; "Terry" of Palooka, centering the quilt

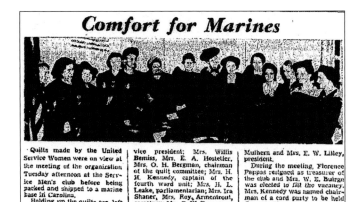

Mason City Globe-Gazette, Mason City, Iowa, Tuesday, January 12, 1945. page 8.

is the air force crest—magnificently embroidered by Mrs. Bishop herself.

Add it up, and there's an autograph hunter's dream come true. Sixty-seven squares, embroidered in soft blue and clear red—assembled after a year and a half of endeavor. To piece the quilt, the nuns of the Good Shepherd were consulted. Mounting the squares on fine blue cotton broadcloth, they stitched a border whose quilted design is the crowned wings of pilot's badge. [129]

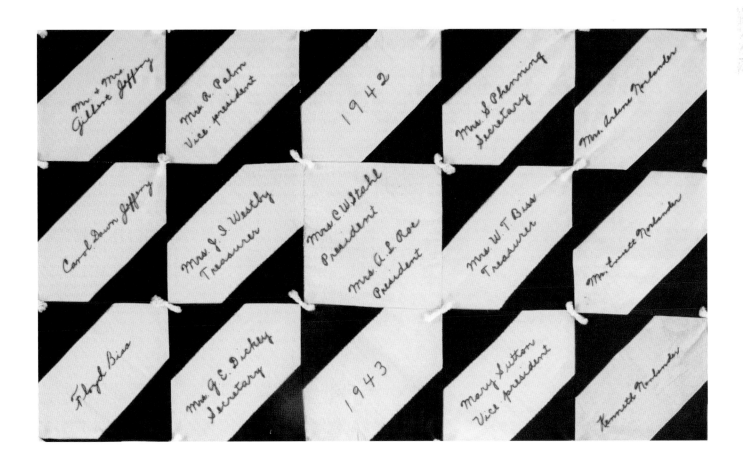

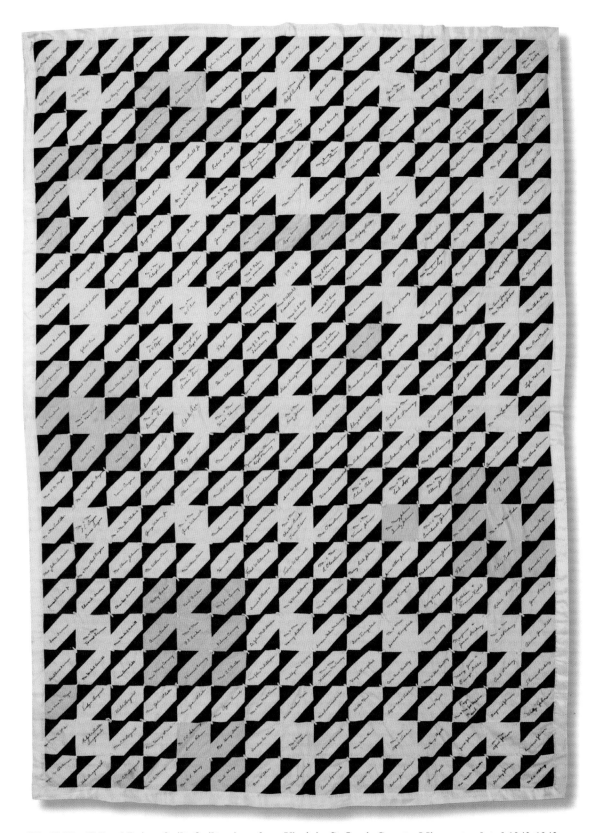

World War II Fund Raiser Quilt, Quiltmakers from Virginia, St. Louis County, Minnesota, dated 1942-1943. Machine pieced, hand embroidered, hand tied, 79 inches x 103 inches, cotton, finished with blanket binding. This quilt was made in Saint Louis County, Minnesota to raise monies for the war effort. It was inscribed and embroidered by one quiltmaker. The sponsoring organization's officers are featured in the center of the quilt, with the dates 1942 and 1943. The presence of polyester batting indicates that it was likely finished in the last half of the twentieth century. Notice the secondary star pattern in the piecing.

Wartime Quiltmaking for the Red Cross

"Turn Old Scraps of Fabric into National Defense Weapons." [130]

Canadian women began quiltmaking in support of the war in the late 1930s, as their fellow countrymen were pressed into service to defend Great Britain in the European theater. In a six-week period during the fall of 1944, Canada sent 25,000 quilts to Britain and Europe for the relief effort via the Red Cross.[131] Attendance at Red Cross meetings was encouraged, essential and expected. When roll call was taken at each meeting of the Raymond Chapter, Alberta, Canada, the participants presented "a penny and a quilt block" to the operating funds and their quiltmaking

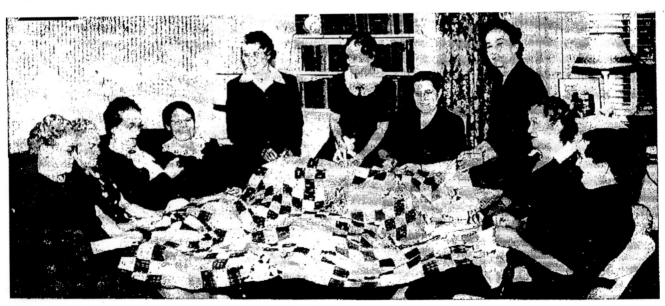

—STAFF PHOTO.

Members of the Pioneer Club working on a quilt for the Red Cross in the home of Mrs. Durward Stephenson, Madera, are, left to right, Mrs. George Shedd, Mrs. Frank Hope, Mrs. Craig Cunningham, Mrs. Arthur McDonald, Mrs. Stephenson, Mrs. T. S. Coffee, Mrs. W. E. Yocum, Mrs. L. R. Adell, Mrs. W. S. Crowder and Mrs. Lelia Willis. The women, many of them born in the Eastin district south of Borden, have been friends all their lives. Among them are grandmothers and great grandmothers.

The Fresno Bee Republican, Fresno, California, November 7, 1943, page 2.

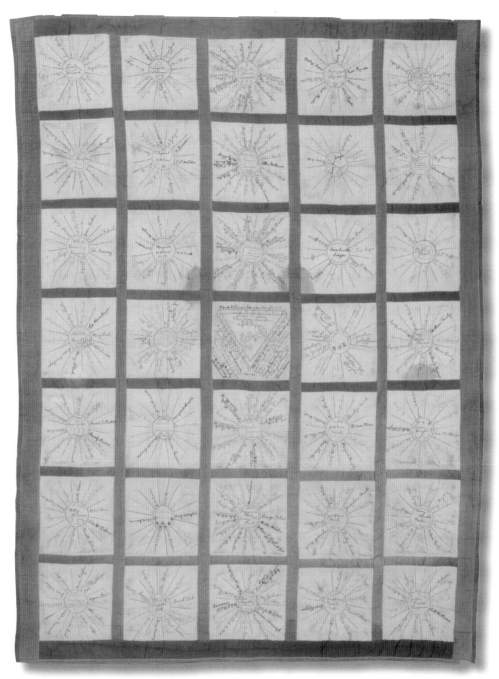

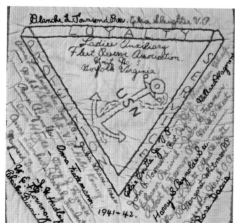

Ladies Auxiliary Fleet Association Quilt, Unit #5, Norfolk, Virginia. Dated 1941-1942. Hand embroidered, machine assembled, hand quilted, 65.5 inches x 87 inches, cotton, cotton embroidery floss. *Courtesy of Karen Alexander*

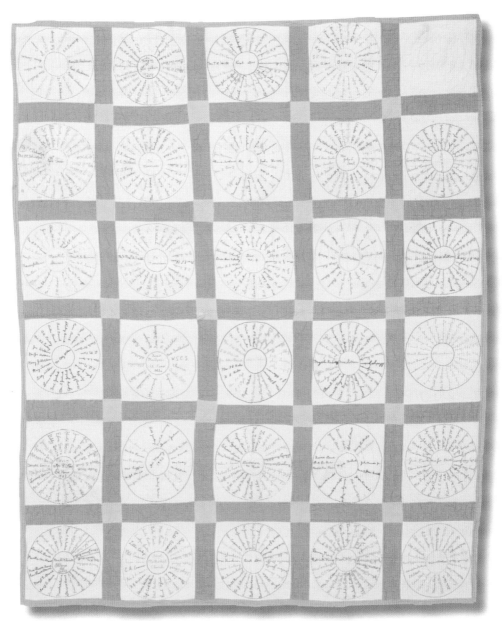

Oklahoma Women's Society for Christian Service (WSCS) Fund Raising Quilt. Hand embroidered, hand appliquéd, machine pieced, hand quilted, 62 inches x 78 inches, cotton. This quilt was hand embroidered with hundreds of names from Oklahoma in 1942–1943. Signature/fundraising quilts have been made since the last part of the nineteenth century. The activities of the WSCS were recorded widely in newspapers across the United States during the WWII years. Quiltmaking was almost always reported as one of their activities. They also sent quilts directly to the Red Cross and to Bundles for Britain.

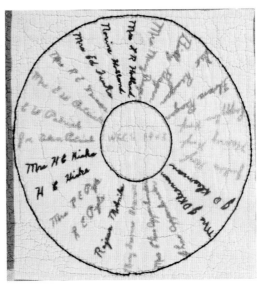

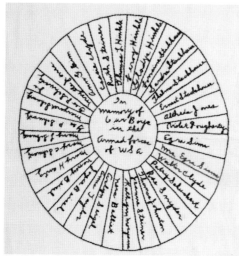

World War II Fund Raiser Quilt. Hazleton and Luzerne County, Pennsylvania, Dated 1943, 1944, 1946. Machine pieced, hand quilted, hand embroidered, 66 inches x 84 inches, cotton. This quilt was made by multiple groups from Hazleton and Luzerne County, Pennsylvania. One block is inscribed "In Memory of Our Boys in the Armed Forces of USA." It was customary for men and women to pay to have their names embroidered on the quilt. The quilt was then raffled, thus increasing the earnings to be donated to the war effort.

efforts. This Red Cross chapter had fulfilled their goal by making a quilt every two months, with members donating 10 cents each month to defer their expenses. [132]

One of the earliest references in the United States to quiltmaking for the Red Cross occurred in 1940. American wartime volunteers provided the essentials of life, such as food, clothing and medical care, through many benevolent associations, including the Red Cross beginning around 1940. They raised money to fund their organizations and pay for supplies for themselves and the goods sent to soldiers and refugees of war-torn nations.

This account of the realities of the war in Europe and the commitment of the locals of Charleston, West Virginia, to the Red Cross was reported in *The Charleston Daily Mail,* on June 5, 1940.

The president of the Turlock, California, Parent Teacher Association (PTA) presents boxes of quilts to the Red Cross. May, 1942. *Courtesy of the Library of Congress*

A little more than half of the $15,000 quota assigned to the local Red Cross chapter has been raised to date. With approximately five million homeless refugees in Europe needing food, clothing and medical care, the Red Cross as one of the greatest humanitarian agencies in the world has been taxed to the limit. In several other sections of the state, the assigned quotas were quickly filled and some of them over-subscribed. The organization has launched a special fund-raising campaign for one of the greatest of all human's inhumanity to man. The rapidity and violence of the latest phase of the conflict intensified the problem too quickly to be met with the money and equipment already on hand.

Unless the Red Cross is successful in quickly obtaining the amount it has appealed for, the plight of millions of non-combatants in blood-soaked Europe will become even more acute. School children in this area have responded to the call immediately. Still only a little more than half of the city's quota to help meet the extraordinary need so far has been contributed. [133]

The quilts provided by the PTA in Turlock, California, were pieced and tied instead of quilted. *Courtesy of the Library of Congress*

Quilts were made and raffled, raising money to be directly donated to the Red Cross efforts, both on the home front and the battlefield. Wisconsin's Nekoosa branch of the South Wood County Chapter of the Red Cross raised a total of $242. They used $150 to furnish a sun room at Camp McCoy and $92 to meet the county quota for "soldiers kits," for servicemen leaving America for overseas duty. The original intention of the Chapter for making and raffling the quilt was to earn money for purchase of yarn. The national Red Cross organization furnished the needed yarn, so it was decided to divide the money for the above-listed purposes. [134]

The children of Greenville, Mississippi, were just a few of thousands who met the call for help meeting quotas of the Red Cross.

A quilt made by the little girls of the fifth grade of Central school is on exhibition at Nelms and Blum's. The quilt is to be sold to the highest bidder and the money presented to the Red Cross Society, as a small "bit" from these patriotic children. The design of the quilt is taken from the Red cross worn by Miss Babb. [135]

Just about a month prior to the bombing of Pearl Harbor, on November 1, 1941, in the *Clearfield Progress,* Clearfield, Pennsylvania, the call went out for sewing machines and workers to sew at the Trinity Methodist Church. Sewing, an age-old skill of women, was employed in both the wartime industries and in benevolent activities. With the request for additional machines came this offer:

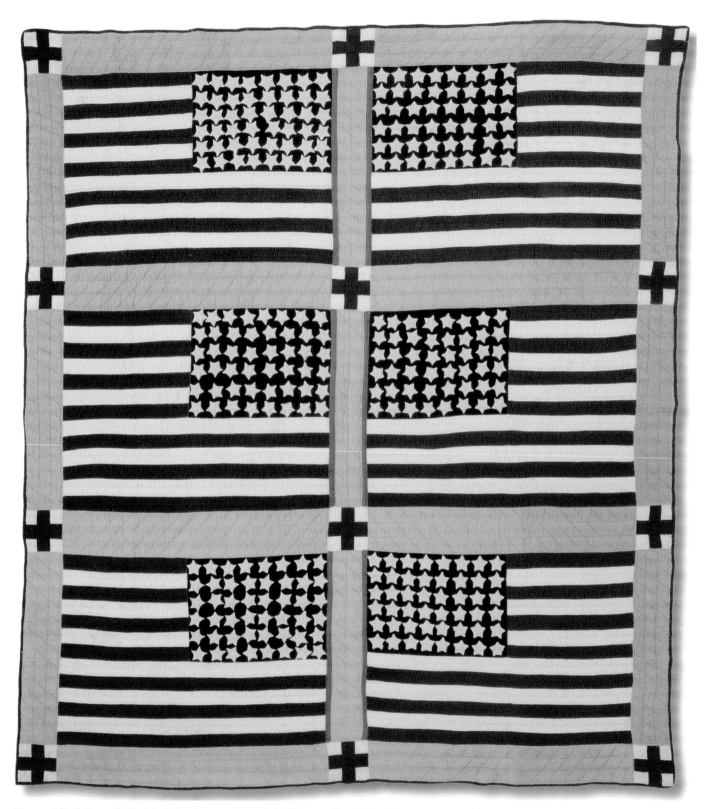

Flag and Red Cross Quilt. Made by the members of the Pleasant View Home Demonstration Club, Pleasant View, Oklahoma, 1942. Hand pieced and hand appliquéd, cotton, 86 inches x 76 inches. This quilt was made to raise funds for the Home Demonstration Club during World War II. *Courtesy of Cyndi Rennels*

The Sheboygan Press, Sheboygan, Wisconsin, Tuesday, December 17, 1940, page 10.

Red Cross Quilt. Quiltmaker unknown. Machine pieced, hand quilted, 61 inches x 81 inches, cotton. This highly recognizable symbol for the Red Cross organization was first adopted in 1864. During World War II, the American Red Cross provided extensive services to the U. S. military, its allies, and civilian war victims. It enrolled more than 104,000 nurses for military service, prepared 27 million packages for American and Allied Prisoners of War, and shipped more than 300,000 tons of supplies overseas.

The Red Cross will move the machines and keep them in good working order while they have the use of them. Very often workers have to wait their turn to use a machine at these meetings while, surely, there are some sewing machines in Clearfield which are not being used and which would enable the women to make many more garments in a day, those in charge said today. [136]

In June, 1942, Mrs. Estelle C. Patten, the Executive Secretary of the Fresno County Red Cross Chapter, Fresno, California, instructed the women in her chapter to "turn old scraps of fabric into national defense weapons." She went on to report "the Red Cross needs blankets and quilts badly." She encouraged women to use up their scraps to make quilts of any pattern for single or double beds. She recommended cotton, silk, and wool materials, but cautioned mixing the

The Kingsport Times, Kingsport, Tennessee, Thursday, July 8, 1943, page 5.

textiles in the same quilt. She also anticipated evacuees coming into the United States for refuge.[137]

In Kingsport, Tennessee, the Red Cross Chapter began its quilting project with a call for quilt pieces, completed quilts and quilts pieced. The suggested sizes were invalid, baby or regular bed size. Quiltmaking was just a portion of their contribution to the Red Cross. Between 1940 and 1942, they completed 52,000 sewn garments and approximately 500 knitted ones. Most of these items were sent overseas to Britain.[138]

The Watervliet Red Cross Chapter of Benton Harbor, Michigan, postponed their quiltmaking until a supply of materials arrived from the national organization. This Chapter made wool quilts for convalescing soldiers. Other groups were making quilts in the same area. "The Congregational Ladies' Aid Society is making four, the WSCS [139] of the Methodist church three; the Plymouth Guild two, and the American Legion Auxiliary two. In the Bainbridge district, a sewing group, in the charge of Mrs.

Byron Wise, has promised to make seven of the small quilts. All parts of the quilt, including blocks, and lining, are being furnished by the groups. Watervliet's quota is ten quilts, but that number is being exceeded."[140]

The Red Cross chairman of Moberly, Missouri, appealed to the softer side of the female corps in an article entitled "Never More Glamorous." He used flattery to enlist service at the local Red Cross Chapter. Volunteers raised $135 from the sale of quilts they made. The money helped meet their quota to construct 400 overseas kits distributed to soldiers as they deployed to war zones.

"Women are never more glamorous than when doing voluntary work," C. H. Longenecker, county Red Cross chairman, told the assembled women in a brief, inspirational talk. Mr. Longenecker, introduced by Mrs. Allen, quoted Winston Churchill's now famous statement "Never in the history of the world has so much been done for so many by so few."

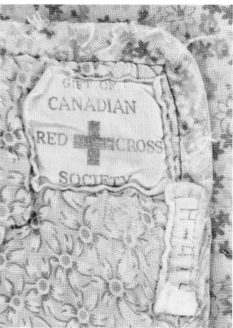

Canadian Red Cross Quilt. Quiltmaker unknown. Hand pieced, hand quilted, 56 inches x 72 inches, cotton. This scrappy, utilitarian Double Four Patch quilt was made in Canada and sent to England during World War II. Despite its humble construction and appearance, it served a noble cause aiding the British during and after the war. Like other Red Cross quilts, its historical importance was forever secured with the 1 in. x 1.25 in. tag sewn one corner (see detail image). Contemporary newspaper articles reported youth groups and school girls making thousands of quilts to be donated to the Red Cross. The Double Four Patch is an easy block for beginner quiltmakers.

U. S. Navy and Red Cross Child's Quilt. Quiltmaker unknown. Hand appliquéd, hand embellished, 39 inches x 52 inches, cotton toweling, cotton embroidery floss.
Courtesy of Polly Mello

He believed every woman who contributes her efforts to production work "feels grateful upon returning home after a day of voluntary service. I would like to give each lady an orchid. That being impossible, I give a mental orchid to each of you voluntary workers of the greatest organization in the world, the American Red Cross."[141]

The construction and donation of wool quilts were strongly encouraged by the Red Cross during World War II. This article from the *Denton Journal*, Maryland, reported a detailed account of the quiltmaking activities and the structure of the local chapter.

The Red Cross sewing has been progressing very satisfactorily during the summer months. A wool quilt has just been completed and has been on display this week in the window of A. W. Brumbaugh's Department store. The Red Cross asked for a quilt to be made from scraps of woolen material which people had on hand, to be cut and sewed to form a 3 inch square. The women of the different church and civic organizations of the town were asked to help with the project. The response was most gratifying and Mrs. E. J. Vandegrift, chairman of Red Cross sewing for Greensboro wishes to thank you everybody who so cheerfully gave of their time and labor to make the quilt. The following women acted as chairmen and worked most faithfully: Mrs. Clarence Jackson, for the W.S.C.S. of the Methodist Church, Mrs. Tom Thornton and Mrs. Clinton Edwards for the Baptist Church and Mrs. Byron Poore and Mrs. Harry Butler for the Greensboro Homemakers Club. Mrs. Beverly Goldsborough, of Holy Trinity Guild; Mrs. Charles Rich, of the Holiness Church, and Mrs. Alvin Smith, of the Adventist Church, gave their services. The chairman wishes to thank Mr. A. W. Brumbaugh for his kindness in giving space in his show window to display the quilt and also for the wool samples which

American Red Cross Quilt. Quilter unknown. Hand pieced, hand embroidered, hand tied, 38 inches x 48 inches, silk and cotton

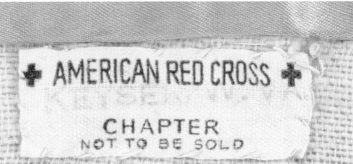

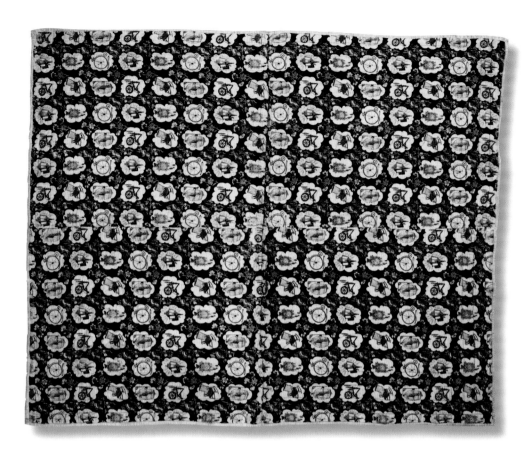

Canadian Red Cross Quilt.
Quiltmaker unknown. Hand
pieced, hand quilted, 63.5
inches x 72 inches, cotton. This
quiltmaker made thrifty use of
four feedsacks that were opened
up and sewn together to give the
look of a wholecloth quilt.

American Red Cross One Patch Quilt.
Quiltmaker unknown. Hand pieced, hand
tied, 50 inches x 50.5 inches, wool. This
simple, one-patch, utility quilt made of wool
suiting, was donated to the American Red
Cross. The 1 inch x 2 inch Red Cross tag sewn
on the back indicates that it was donated to
the Lane County Chapter of the Red Cross,
Eugene, Oregon during the War. This quilt
was recently purchased from Great Britain.

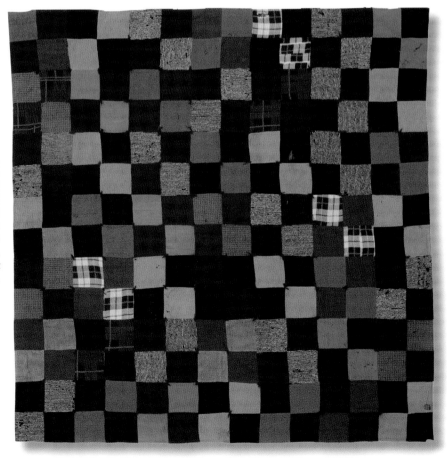

he furnished Mrs. Clarence Jackson from which over 100 squares were made. Also wish to thank Mr. Charles Wienke for printing the show card. The Homemakers Club made over 300 squares, the W. S. C. S. over 200 squares and the Baptist women over 140. The quilts measures 72x81 inches and contains 648 squares. It will be used for Foreign war Relief…[142]

Without the tiny cloth label stitched to a corner on the front or back of a quilt, the Red Cross quilts of World War II are indistinguishable from most of the utilitarian, everyday quilts made in the second quarter of the twentieth century. They are generally simply pieced blocks or strips. Feedsack fabrics are often used to create a wholecloth quilt, or cut-up and mixed with other prints of the era. These donation quilts were frequently tied or sparsely quilted. During World War II, women needed to dig deeply into their scrap bags when piecing quilts. Some may even be from another era. For instance, Mr. and Mrs. George Clay won a raffle quilt in 1918, made for fund raising during the last "Great War." In 1918, the quilt was sold and re-sold seven times before the Clays made the final bid. In 1942, Mr. and Mrs. Clay decided once again to donate the quilt for raffle in the present war.[143] The couple worked with "the Howard county chapter of the Red Cross to help carry on the work of World War 2." [144]

The Red Cross and Bundles for Britain quilts that survived, 65 years after being made and distributed to Britain and Europe, are now faded and worn. Few remain in unused or newly-made condition. After leaving the United States and Canada, one can only guess at their next stop during World War II. Hopefully, these quilts reassured both young and old with their bright designs. Or maybe they helped soothe a soldier with their warmth and comfort. Some of these quilts did survive the war; they remain records in fabric of the generous spirit of the American and Canadian home front's all-out effort for Victory.

The Changi Quilts

Newlyweds Ethel Rogers and Denis Mulvaney sailed into a brilliant sunset just off the coast of Singapore. Denis pined, "It is too beautiful. We're too happy. It can't last." The fateful day was December 7, 1941.[145] Little did they know, in the serenity of that lovely evening, just how prophetic his words would become.

Canadian Ethel Rogers was the daughter of a Presbyterian minister raised in Ontario and educated at the University of Toronto and McGill University. She applied the benefits of her education to become a teacher and later an international representative for the Red Cross. While on a world tour, Ethel met her British husband, Denis Mulvaney, a doctor in the Royal Army Medical Corps. As they began

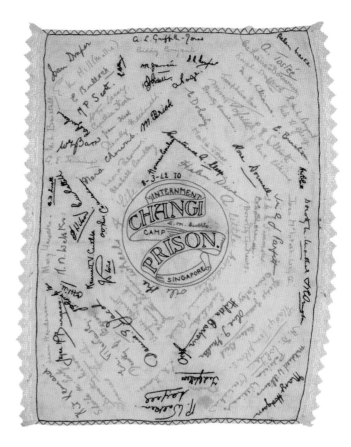

Embroidered signature cloth, made by Augusta Cuthbe, Changi Prison, 1942-1945. *Courtesy of the Australian War Memorial*

their seemingly made-in-heaven life together, the world around them deteriorated. With the capitulation of Singapore in 1941, they became separated and imprisoned for the next four years experiencing starvation, solitary confinement, and the indignities of life suffered and at the mercy of an enemy. Ethel was one of approximately 1,100 women and children from Australia, Canada, Britain, New Zealand, and the Netherlands trapped in Singapore at the beginning of World War II. All were sent on a grueling, 15-mile march through the jungle to the Changi Jail. Now separated from her beloved Denis, Ethel carried the few precious things left in her life: the clothes on her back, a patchwork quilt made by her mother, an extra dress, and her father's bible.[146]

Mary Thomas, a British woman on the Changi march recalled, as they neared the Changi prison:

> At last the grey walls and roofs of the prison appeared on a small hill to our right. We were hot and tired and glad to see them. As we drew near, some of the women felt a gesture of defiance was needed and they began to sing. We had left Katong singing *Tipperary* and we walked into Changi singing *There'll always be an England*…[147]

Proper nutrition and maintaining a willingness to live

were the two most pressing needs for the internees. Their sole source of food was buyaam soup made from a spinach-like weed and water. Ethel's weight went from 145 lbs. to 108 lbs. over those four years. During internment, she often forced herself to eat spiders, grasshoppers, and slugs for sustenance.[148]

The hardships experienced during wartime can sometimes make heroes of ordinary people. Ethel became a leader in Changi, petitioning the prison commandant endlessly for improved food and living conditions. For reasons unknown to Ethel, she was placed in solitary confinement for 120 days. On a day in August, 1945, she was released, not by her captors but by liberators. Ethel's recollection of her day of rescue was "a strange and unbelievable sight; the camp was ringed with clean, fresh looking Allied troops!"[149]

Today, few Asian historians acknowledge the massive number of women and children interred in Japanese prison camps. Three Changi quilts that Ethel and the women at Changi left us relate the indisputable proof of their status as female prisoners.

Ethel was the leading force in the creation of three quilts, completed between March and August, 1942. Provenance records indicate that the quilts were made "to alleviate boredom, to boost morale and to pass information to men in other camps that the women and children were alive."[150] To secure sanction from the commandant for their creation, Ethel devised a proposal to make quilts not just for the wounded British and Australian soldiers but also for injured Japanese soldiers. She distributed easily accessible materials of plain white cotton, flour sacks, and bed sheets to other female prisoners. Embroidery and appliqué were the most common forms of needlework they used in their quiltmaking. The skill levels of the women varied from practiced hands to roughly worked squares of amateurs. Many carefully stitched personal messages were communicated through the squares using floral motifs, a Victory V, reminiscences of hearth and homeland, and visual images of their imprisonment. The word for "prison" was forbidden by the commandant, so the stitches expressing this term had to be picked out of the blocks made by the inmates.

The imprisoned women who rendered their sentiments on the Changi quilts suffered continual fatigue, starvation, fear and the uncertainty of ever surviving the war or their incarceration. The quilts represented hope and despair at the same time: hope that their dour circumstances would soon end, and despair at being so far from their homelands, also under attack.

Blocks on the Australian quilt were embroidered with messages of love and hope, images of food unobtainable, kewpie children, the impossible living conditions of their cells, the Changi Prison, cottage gardens, Canadian Maple leaves, a ship with "Homeward Bound," Sir Francis Drake defeating the Spanish Armada, the mountains of New Zealand, the Scottish terrier – Jiminy Cricket, St. George slaying the dragon, depictions of flowers, birds and butterflies, maps of homelands in Scotland, Australia with kangaroo, the Malay Peninsula, Switzerland, England, a Scots piper, the Changi hairdresser's cell, two of the Seven Dwarfs from Disney's movie *Snow White*, and two interned children. Each quilt was made with 66 signed and embroidered squares, joined by turkey-red, chain-stitch embroidery. The cotton used on the borders was also used on the quilt backings. Each backing has a label inscribed with a similar label:

> Presented by the women of Changi internment camp 1942 to the wounded Australian soldiers with our sympathy for their suffering. It is our wish that on the cessation of hostilities that this quilt be presented to the Australian Red Cross Society. It is advisable to dryclean the quilt.[151]

The quilt that was made for injured Japanese soldiers was similar to the quilt made for Australian soldiers, but the 66 blocks were predominately embroidered with floral designs. There were a few block pictures with Japanese children and Mount Fuji. The back of the quilt was labeled:

> Presented by the women of the Changi internment camp 2602 (the number of the Japanese year corresponding with our 1942) to the wounded Nipponese soldiers with our sympathy for their suffering. It is our wish that on the cessation of hostilities that this quilt be presented to the Japanese Red Cross Society. It is advisable to dryclean this quilt.[152]

The quilt made for British soldiers has a block depicting the "Changi Hotel" and phrases that include: "It's a long way to Tipperary," "Hope Springs Eternal in the Human Breast," "Peace after war, Port after stormy seas, Rest after toil, All these do greatly please," and "God made the Earth and Sky for one + all, Man made these prison bars, But faith in England scales the highest wall, above it shines the stars."

The quilts were presented to the hospitals of Changi prison during the war. It is remarkable that they survived the hardships of war! Today, the two quilts made for the Australian and Japanese soldiers are exhibited in the Australian War Memorial, Campbell Act, Australia. The third quilt can be found at the British Red Cross Museum and Archives in Moorsfields, England. We honor the women quiltmakers of Changi prison, with their names transcribed here as proof of their suffering and hardship during World War II.

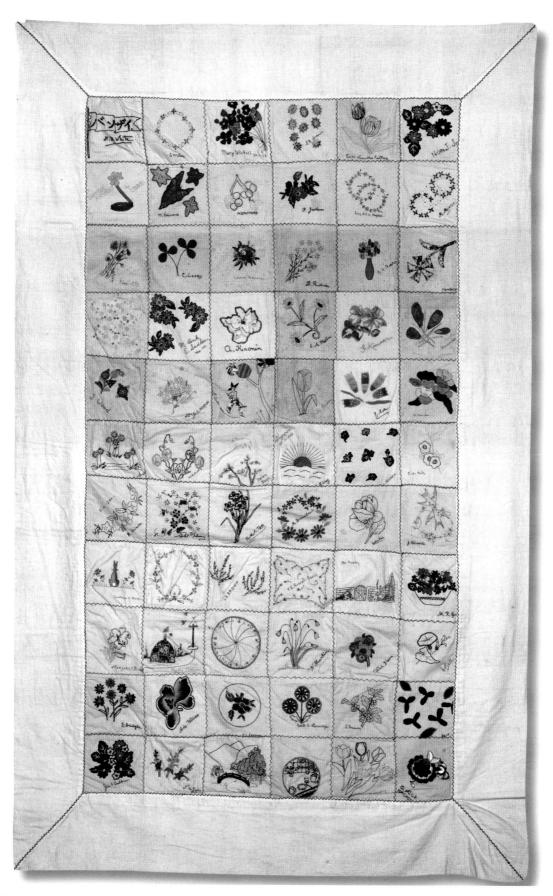

Japanese Changi Quilt, Made by the Female Prisoners of Changi Prison. *Courtesy of the Australian War Memorial*

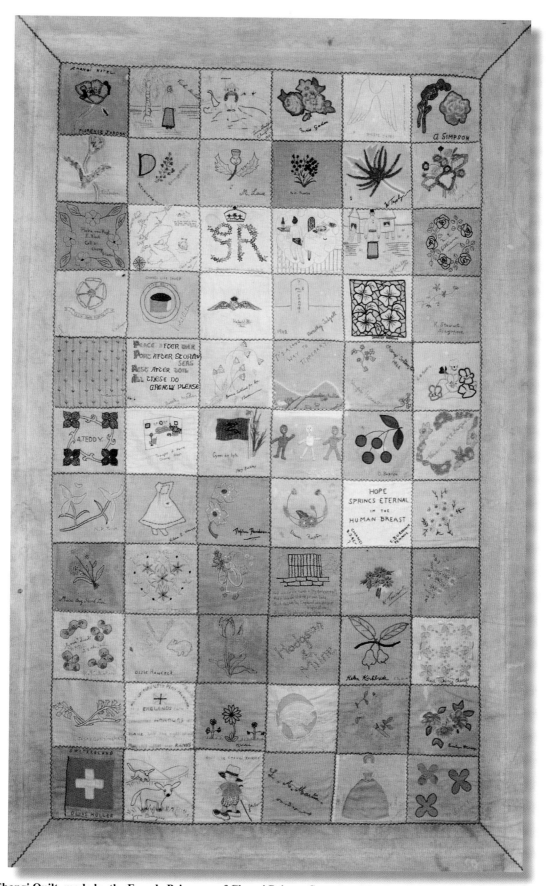

British Changi Quilt, made by the Female Prisoners of Changi Prison. *Courtesy of the British Red Cross Museum and Archives*

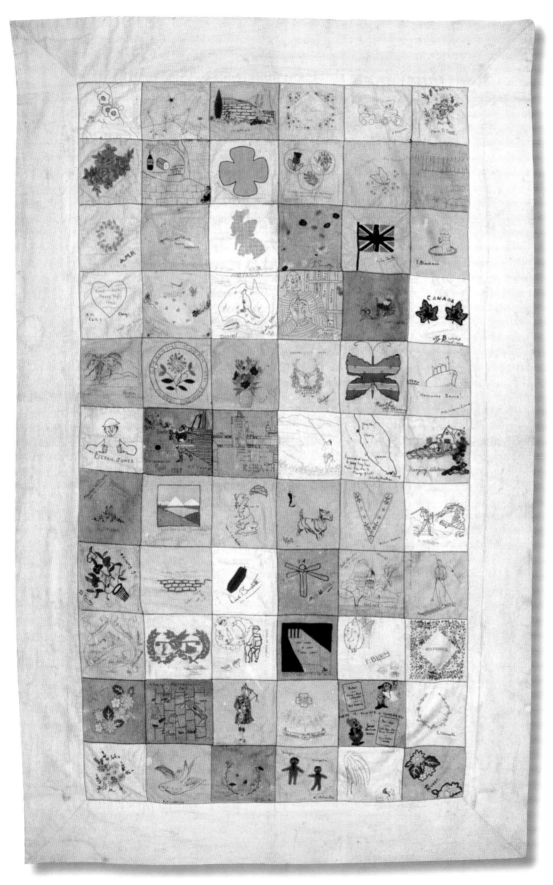

Australian Changi Quilt, made by the Female Prisoners of Changi Prison. *Courtesy of the Australian War Memorial*

Changi Quilt I - Australian

Row 1- E.M.Muir, Mary Thomas, I.D. Brown, May Watson 1942, S. Blackman, Mary P. Scott

Row 2- E. Gouch, E. Austen-Hofer, Mrs. Shorthouse, E.H.H. Murphy, N..oa? Barnes, Smallwood

Row 3 - A.M.P., Anne Rackham, J. McIvor and S. K. McKenzie, B. Smalley, A. LaCloche, E. Blackman

Row 4 - Violet von Hagt, F. E. Russell-Davis, Sheila Allen, Rodney Reilly, J. McCubbin, M. Burn and E. Mulvaney

Row 5 - Sue Williams, Geraldine Cogan, Nora J. Jones, Diana Logan, Martha McMorine, M. Elizabeth Ennis

Row 6 - Eileen Jones, H. G. Lacey, K. Heath, A. L. Griffith-Jones, Dorothy Mather, Marjorie Watson

Row 7 - Marion Williams, P. J. Mitchell, K. Kennard, S. G. Tompkins, Mary C. C. C. Hughes, M. Bell, Bridget Hergarth, V. McIntyre

Row 8 -. D. Corley, G. Gottleib, Valerie Burgin, Norah Burstall, M. A. Webster, Betty Bond, Joan Stanley Cray

Row 9 - Thumbs Up, J Tompkins, The Crypt, Helen Loxton, Judy Good, Irene Whitehead, J. H. Nealson, M. S. MacDonald, Helen Willis, Sheila, Joan MacIntosh-Whyte, Iris G. Parfitt, F. Bloom, Kay Francis

Row 10 - Lucy Fletcher, Ethne von Hagt, O. Sowerby, Katherine de Moubray, Iosbel Jenkins (R. A. M. C.), E. Oldworth

Row 11 - Harkness, D. Cornelius, S (or G) FR….., Mrs Uniake, Judy Good, Auget or Auger

Changi Quilt II – Japanese

Row 1- H. D. White, C McLeod, Mary Wickett, E. M. Francis, Edith Lascelles Rattray, Nora J. Jones

Row 2 - F. Bloom, M. Edwards, N. Stafford, P. Jackson, Mary C. C. C. Hughes, M. Morier

Row 3 - Rhoda Kitts, C. Lacey, Leonor Palomar, D. Ruthven, E. M. Pearson, Henderson

Row 4 - M. P. Scott, M. Rank, E. Sadler, A Kronin, L. A. Martin, G. Kinnear, Maunder

Row 5 - F. Wood, Mrs. G. S. Hooper, E. Austen-Hofer, Gladys Lindsay, R. Cutler, M. Sullivan

Row 6 - A. Evans, M. G. Clark, Helen Beck, E. King, V? W? Aitken, E. A. Moir

Row 7 - M Unaike, Ethel Mulvaney, Ruth K. Tan, M. Broadbent, Cynthia Kock, J. Edwards

Row 8 - Constance E. Renton, Eileen Jones, I. D. Brown, F. E. Russell-Davis, Pat Murphy, M. R. ?Agne(w)

Row 9 - Margaret Burns, Pauline Dickinson, V M H Patterson, N Martin, Nolah (or Norah) Dixon, M Bell

Row 10 - S. or (G.) Bridges, Ada H. (W)illies, A. L. Jamieson, Edith A. Loveridge, F. Greaves, Iris

Row 11 - J M S Cubbin, S de Jager, ?, K. M. Heath, B. Hegarty, Clarice Hancock

Changi Quilt III - British

Row 1 - Florence Jordan, Vicki Horton, Jane Davidson, Maie Gordon, Billie James, A. Simpson

Row 2 - E. L. Soutar, H. Crawshaw, M. Lowe, M.A. Martin, W. Taplyn, Nora J. Jones

Row 3 - Hebe von Hagt, Rona Cutler, M. Broadbent, Trudie v. Roode, J.E. Walton, M.E. Williams

Row 4 - N.M.Coopery?, Violet Aitkin, Helen Willis, Dorothy Tadgell, Dorothy Andrews, K. Stewart

Row 5 - Ann Courtenay, Dorothy Mather, J. Davidson, E. McCarthy, Winifred Harnett, E.H.H. Murphy

Row 6 - A. Teddy, (unsigned), Mary Buckley, M.M.G., O Barton, Vera A. McIntyre

Row 7 - M.P. Scott, Hilda E. Wemyss, Daphne Davidson, Eleanor Royston, E. Burnham, I.D. Brown

Row 8 - Mairi Ong, J.D.M.Summers, Marion Williams, Helen Beck, K. Toussaint, E. Aldworth

Row 9 - K. Nicholas, Ossie Hancock, Helen M. Dive, Hodgson & Milne, Helen Kirkbride, Lena Elkins

Row 10 - Janet Cunningham, N. Banks, M. Winters, J.W.Jefferies, M. Weiss, Evelyn Durege

Row 11 - Olive Muller, Joyce Burgess, G.Davies, L.A.Martin, W.Farmer, J. Kirby

Victory "V" Quilts

Quilts from the mid-twentieth century with embroidered, pieced or appliquéd Vs were not made for girls named Victoria. They were made during World War II to promote VICTORY. On January 14, 1941, the British Broadcasting Company broadcast the following message to the Low Countries of Europe — Belgium, the Netherlands and Luxemburg:

> I am proposing to you as a rallying emblem, the letter V, because V is the first letter of the words "Victorie: in French, and Frijheid" in Flemish: two things which go together, as Walloons and Flemings are at the moment marching hand in hand: two things which are the consequence one of the other, the victory which will give us back our freedom, the victory of our good friends the English. Their word for Victory also begins with V. As you see, things 'fit' all round. The letter V is the perfect symbol of Anglo-Belgian understanding.
>
> You have every interest in knowing how many among you want liberation. All the patriots of Belgium must have a rallying emblem; let them multiply this emblem around them; let them see it written everywhere; let them know that they are legion. Let the occupier, by seeing this sign, always the same, infinitely repeated,

understand that he is surrounded, encircled, by an immense crowd of citizens eagerly awaiting his first moment of weakness, watching for his first failure.[153]

The Victory sign of the index and middle finger slightly separated to form the shape of a V was popularized by Sir Winston Churchill during the war. On July 18, 1941, the following message was broadcast across the airwaves.

> The V sign is the symbol of the unconquerable will of the people of the occupied territories and of Britain; of the fate awaiting Nazi tyranny. So long as the peoples of Europe continue to refuse all collaboration with the invader, it is sure that his cause will perish and that Europe will be liberated.[154]

Victory Vs and slogans could be found everywhere during World War II. A Bundles for Britain poster read:

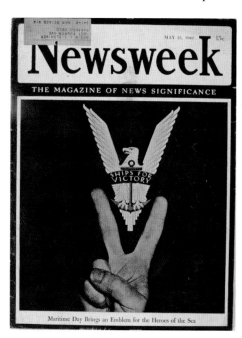

Maritime Day Brings an Emblem for the Heroes of the Sea

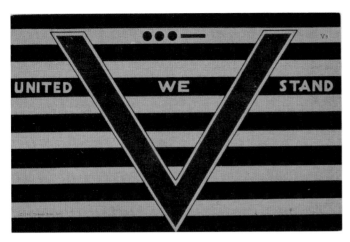

WHISTLE THE TUNE OF IT
USE IT AS A GREETING
TAP IT OUT IN CODE
PUT IT IN YOUR WINDOW
JOIN THIS CRUSADE FOR FREEDOM!
V IS FOR VICTORY! [155]

The symbol and slogans for Victory Vs were fully established when the United States formally declared war in December, 1941. Defense factory workers flashed the Victory V symbol as they passed one another at shift changes. There were V letters, Victory boats, Victory gardens, V bonds and V mail. Victory Vs and its Morse Code — three dots and a dash— were printed on buttons, match boxes, bobby pin containers, postage stamps, in newspapers, on posters, chalked graffiti-style on walls, and it was even sounded out in Beethoven's Fifth Symphony. The symbol for victory was everywhere in World War II.

Canadians began making Victory quilts in 1941. The Manyberries Community Chest decided, on August 9, 1941, to begin work on a Victory quilt.[156] They made the quilt to express patriotism and the hope for a successful outcome in the war effort, but their primary purpose was to help fellow Canadians. On December 6, 1941, the same newspaper reported,

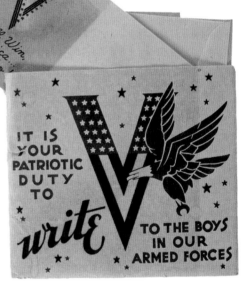

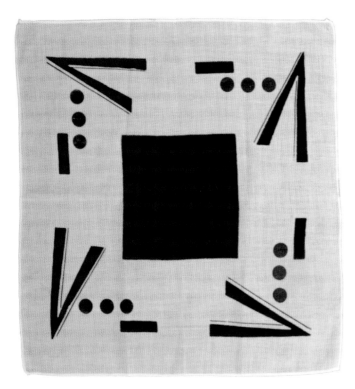

World War II handkerchief with Victory "V"s and Morse code for "victory."

"Tickets will be sold on the victory quilt being made by the ladies of the town. The proceeds are to be used to fill the children's Christmas stockings."[157]

Just five months after the bombing of Pearl Harbor, Victory was the motto of all Americans. This symbol was adopted by quiltmakers across the United States and incorporated into their quilts. Quilt patterns were designed and sold featuring Vs. Women were inspired by V designs on cards and in magazines and newspapers. On February 24, 1942, a quilting group from Maryland formed a Victory Club. The *Cumberland Evening Times* reported their activities.[158]

The women of Manheim have organized a Victory Club and will meet every Thursday to sew or knit for the benefit of the Red Cross and other war relief. They have donated a quilt which will be disposed of for the benefit of the Red

Near Right: *The Nashua Reporter*, **Nashua, Iowa, Wednesday, June 17, 1942. Page 1.**

Far Right: **Mrs. Albert Jackson was featured in the** *Ames Daily Tribune*, **of Ames, Iowa, on August 28, 1945, working on her Victory Quilt. The article reported that Mrs. Jackson began her quilt after Pearl Harbor and predicted that it would be completed when the war was over. She missed her prediction by only three days. The Vs on her quilt were made of bias tape and represented each state and territory.**

Cross. Mrs. L. M. Smith is president; Mrs. O. F. Bolyard, vice president; Mrs. Frank Fretwell, secretary; Mrs. D. A. McVicker, treasurer, and Mrs. Raphael Pyles, Mrs. C. B. Bishoff and Mrs. Victor Pyles, correspondents.

On May 22, 1942, it was printed in *The Chillicothe Tribune,* Chillicothe, Missouri,[159] "Red Cross met Tuesday afternoon at the Sturges hall. Thirteen members were present. The time was spent quilting on Mary McCarthy's Victory quilt and piecing on other quilts."

Mrs. Flora Amanda Gilbert a life-long member of the Church of Jesus Christ of Latter Day Saints was born in 1867 in Bountiful, Utah, and died on Christmas morning, 1955. She actively quilted for the Red Cross during World War II. During the war, while living in Pocatello, Utah, Flora made two Victory quilts. One she sold for $33 and donated the money to the USO. The other she gave to the Red Cross along with $40 donated by friends in support of her efforts.[160]

Victory quilts come in a multitude of designs and are both pieced and appliquéd. The most identified and exquisite Victory quilt was made by a Chicago, Illinois, quiltmaker, Bertha Stenge. Bertha was recognized as a "Champion Quilter" in a newspaper article in the *Florence Morning News*, Florence, South Carolina, on January 14, 1943. According to the article, Bertha began her ascent to quiltmaking fame eleven years earlier. By 1943, she had completed 20 quilts and won 34 prizes for her skill and artistic talent. Appliqué was Bertha's favorite method of quiltmaking; however, she also pieced quilts made with thousands of pieces. She was quoted in the *Florence Morning News* as saying, "The two things you need most in making quilts are plenty of patience and a warm iron."[161]

"V" FOR VICTORY FORMS DESIGN ON QUILT DONATED TO LOCAL RED CROSS

A small section of a beautiful red, white and blue "Victory Quilt" presented to the local chapter of the American Red Cross by Mrs. Harry Cortright is pictured above.

Being a bit too delicate to send to someone in the armed forces, the quilt will be disposed of and the proceeds will go into the Red Cross fund. It can be seen in the window at Chenoweth's Furniture store.

White forms the background for the quilt, with the letters and squares made in red and blue. The outside of the two dark strips forming the Vs are red and blue. The borders of the square are blue, with red squares in each corner. We forgot to measure them, but we would estimate the squares around the Vs to be about a foot across them.

Mrs. Cortright made the quilt entirely unassisted, and is to be congratulated both on her splendid handiwork, and for her generosity in giving it to the Red Cross.

Mrs. Jackson's Victory Quilt

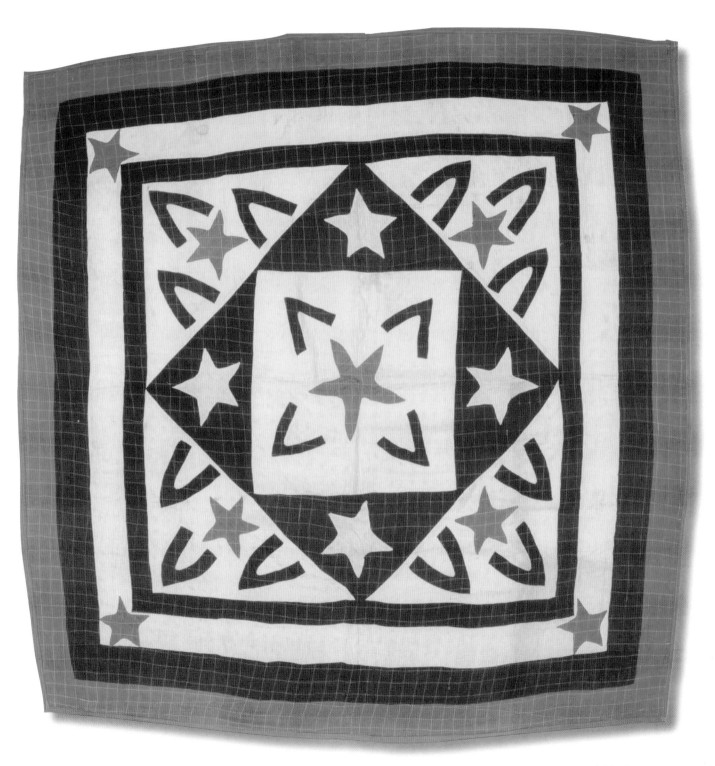

Victory Quilt with Stars. Quiltmaker unknown. Machine pieced, hand appliquéd, machine quilted, 73 inches x 73.5 inches, cotton.

Woman's Day magazine sponsored a national needlework competition in 1943. Bertha was the first-place winner for her quilt titled "Victory." Her patriotic quilt was described in the magazine as "a news report in patchwork."[162]

> Victory quilt, the grand prize winner, set the keynote with its triumphant American eagle ready to fly right out of the quilt's center, its stars for states, its oak leaves in memory of Mount Vernon, and the victory V spelled again and again in Morse code.[163]

In a Bertha Stenge retrospective, quilt historian Cuesta Benberry wrote for *Quilter's Newsletter Magazine,* June 1989:

> Those who lived during World War II know how potent and meaningful the V for Victory sign, popularized by Winston Churchill, was. People planted Victory Gardens and bought Victory Bonds; school children were encouraged to buy Victory Stamps and to collect old newspapers for Victory paper drives. Working around the clock in busy defense plants, incoming shifts of workers meeting outgoing shifts often greeted each other with the two-fingered V for Victory sign. With emotions engendered by the large trapunto quilted V for Victory motifs on her quilt, shown at the height of World War II, Bertha Stenge couldn't lose.

Bertha received the $1,000 prize and national acclaim for her extraordinary quilt justifiably acknowledged as the ultimate Victory quilt.

Bertha was born in 1891 in Alameda, California, to German Jewish immigrants, Mae and Frances Sheramsky.[164] In the 1910 United States Federal Census, the Sheramsky family was living on Taylor Avenue in Alameda. Bertha's father was a tailor with his own shop, and 18-year-old Bertha was listed as an artist with her own studio. Before Bertha married Bernhard Stenge, she furthered her career as an artist by attending the San Francisco College of Art.[165] Bernhard established a law practice in Chicago and settled there with Bertha and their three daughters.[166] At the time Bertha was making her incredible Victory quilt, her three girls were in their twenties allowing Bertha the freedom to devote her time and artistic

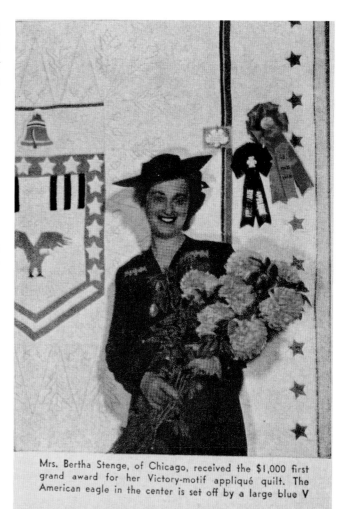

Mrs. Bertha Stenge, of Chicago, received the $1,000 first grand award for her Victory-motif appliqué quilt. The American eagle in the center is set off by a large blue **V**

WOMAN'S DAY

Famous Illinois quiltmaker, Bertha Stenge, received $1,000 and the first grand award for her Victory Quilt in the 1942 *Woman's Day* Quilt contest. This congratulatory photo appeared in the *Woman's Day* issue for February, 1943.

talents to develop her own style of quiltmaking. She never viewed herself as an artist working through the medium of quiltmaking. She bragged in the *Woman's Day,* "Prize-Winning Appliqué," article in 1943 that she "is a housewife, a grandmother, a woman who loves to make quilts."[167] Bertha Stenge's unique and original designs brought her national acclaim and distinguished her as one of the premier quiltmakers of the twentieth century. Her OPA quilt and her Four Freedoms quilt are also featured in this book.

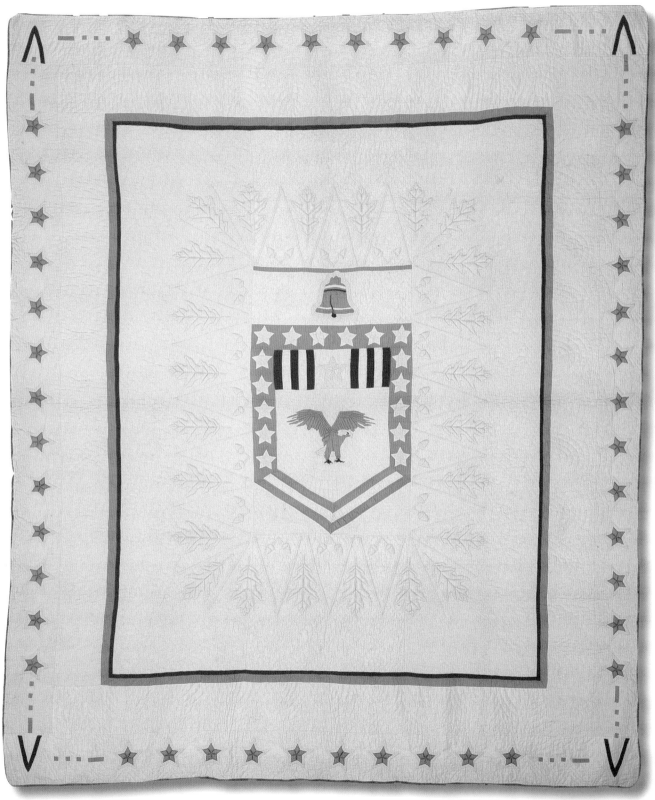

In the March issue of 1943, *Woman's Day* magazine, this Victory Quilt was proclaimed to be "like a news report in needlework." It featured oak-leaf quilting motifs, an eagle with its wings spread in a V formation, a patriotic shield, stars and Morse code for Victory. According to the article, this quilt could be made for $6.00 and the instructions were available upon request and a three-cent stamp. Designed and executed by Bertha Stenge, American, 1891-1957, U.S., Bedcover Entitled "Victory Quilt", 1942, Cotton, plain weave; pieced; appliquéd with cotton, plain weaves; embroidered with cotton in chain stitches; backed with cotton, plain weave; quilted with raised areas (trapunto), 240 x 204.2 cm. *Restricted gift of the Elizabeth F. Cheney Foundation and the Lloyd A. Fry Foundation; Christa C. Mayer Thurman Textile Endowment, 1995.391, The Art Institute of Chicago. Photography © The Art Institute of Chicago*

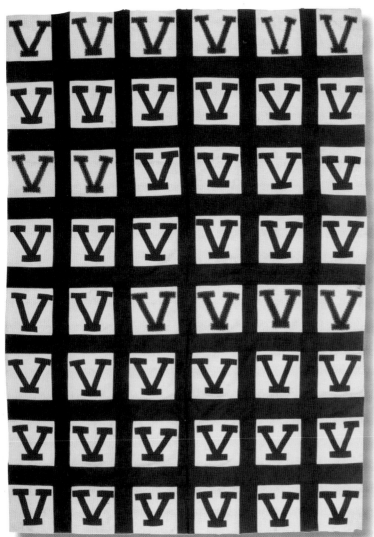

Kentucky Victory Quilt. Quiltmaker unknown. Hand appliquéd, machine assembled, hand quilted, 74 inches x 84 inches, cotton. The Victory symbol was popularized by Sir. Winston Churchill during the war. Victory Vs could be found everywhere, on posters, photographs, mail, and even on quilts from this era. This simple, appliquéd Victory quilt was purchased in Kentucky.

Child's Victory Quilt. Quiltmaker unknown. Machine pieced, hand tied, hand appliquéd, 35 inches x 55 inches, cotton. This humble quilt is made with remnants of shirting fabrics. The placement of the prints and the bold Vs repeat the symbol for Victory.

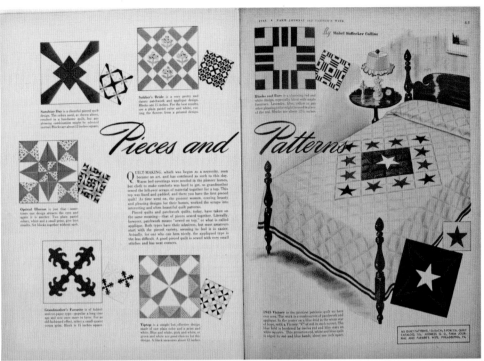

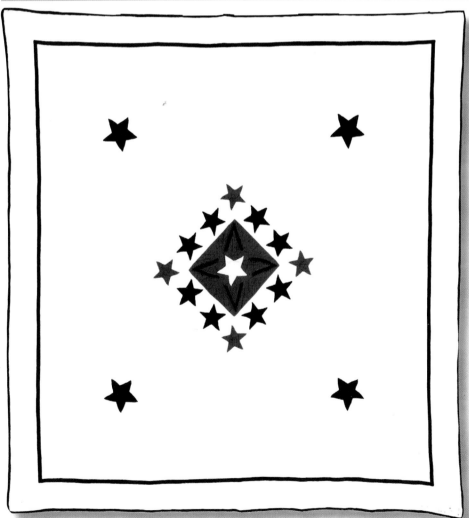

Victory Quilt. Quiltmaker unknown. Pattern Source is the *Farm Journal*, February, 1943. Machine pieced, hand appliquéd, hand quilted, 68 inches x 72.5 inches, cotton. As stated in *Farm Journal* magazine, "Victory is the prettiest patriotic quilt we have ever seen. The work is a combination of patchwork and appliqué. In the center on a blue field is the white star of hope, with a Victory "V" in red in each corner."

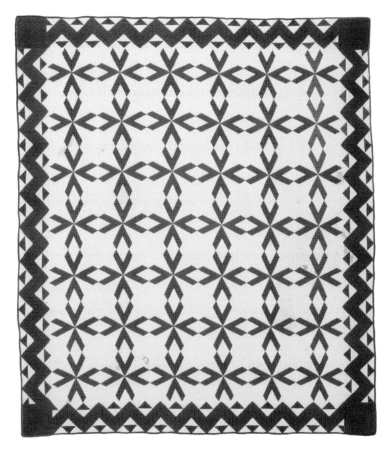

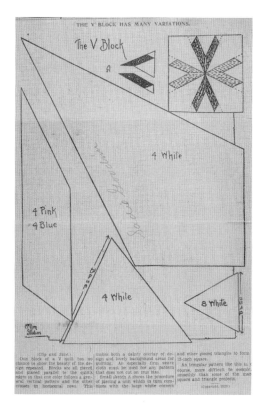

The V Block (McKim), originally published in
the *Kansas City Star* on October 23, 1929. It was
reprinted during the World War II years.

**Victory Quilt. Made by Nettie Williams, Williams, Indiana.
Quilted by the Ladies of the Williams Economic Club. Hand
pieced, hand quilted, 75 inches x 84.5 inches, cotton. The
Victory V blocks were set straight, with a Victory border
identical to the vertically set quilt owned by Sharon Waddell.**
Courtesy of Dee Williams

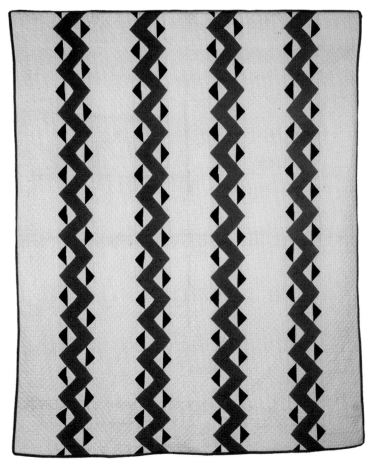

**Victory Quilt. Quiltmaker
unknown. Hand pieced, hand
quilted, 85 inches x 96 inches,
cotton. This vertically set Victory
quilt design was made identical
to the border on "The V Block"
quilt made by Nettie Williams
of Williams, Indiana.** *From the
collection of Sharon Waddell.
Photography by On Location
Poughkeepsie, New York*

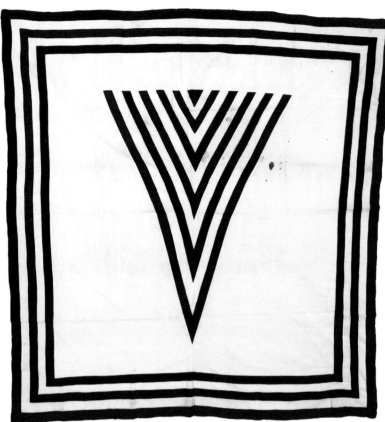

Victory "V" Quilt Top.
Machine pieced, 67.5
inches x 72.5 inches,
cotton.

The Nashua Reporter,
Nashua, Iowa,
Wednesday, June 10,
1942, page 4, and *The
Billings Gazette*, Billings,
Montana, Thursday,
August 6, 1942, page 8.

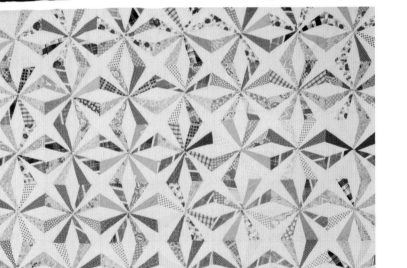

*The Kingsport
Times*, Kingsport,
Tennessee, Sunday,
November 8, 1942,
page 3.

**Victory Quilt/Endless Chain. Quiltmaker unknown.
Hand pieced, hand quilted, 65 inches x 76 inches,
cotton. This Laura Wheeler pattern was sold through
newspapers across the United States in 1942. It
continued to be featured in newspapers throughout the
War, being referred to as a Victory Quilt. The directive
in the ad states,**

*Get out your scraps, get some from all your
friends, and have a gay time piecing this quilt.*

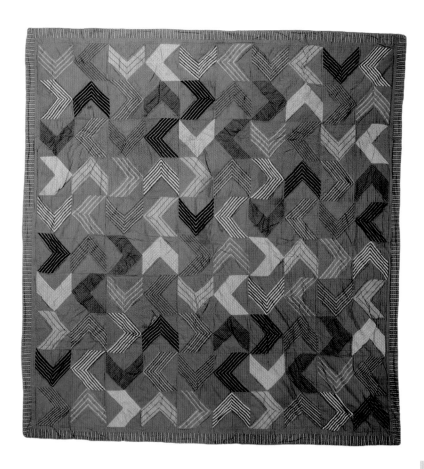

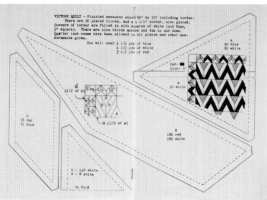

Victory "V" Quilt. Quiltmaker
unknown. Machine pieced, hand
quilted, 79 inches x 84 inches,
cotton. During World War II, the
"V" for Victory image was an
important symbol. Quiltmakers used
traditional quilt patterns, such as
Flying Geese, to create quilts that
emphasized the "V" symbol. This
quiltmaker used scraps of shirting to
make her Victory quilt.

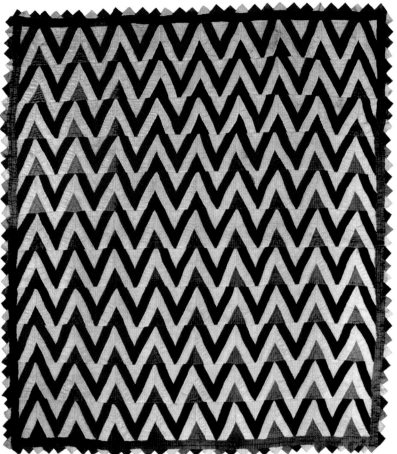

Victory Quilt, Hand pieced, hand quilted, 87 inches x
96 inches, silk. This quilt was made from a published
pattern in *Workbasket* during World War II.

162

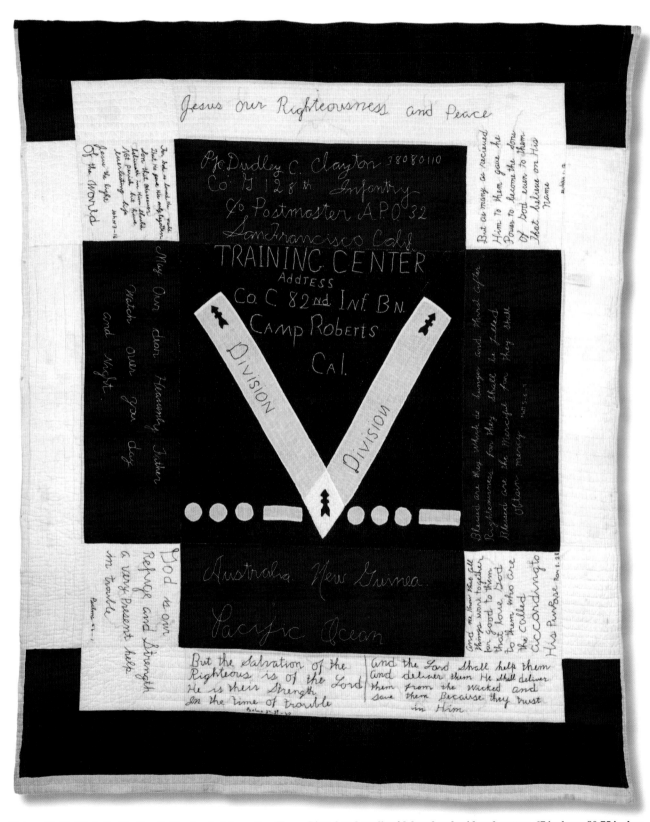

Victory Quilt. Made for Dudley C. Clayton by his mother. Texas. Pieced and appliquéd, hand embroidered, cotton. 67 inches x 80.75 inches. Dudley C. Clayton was born in 1919 and enlisted in the Army at Camp Wolters, Texas, on Hanuary 6, 1942. His mother made this patriotic red, white and blue quilt to record his military service. She displayed her commitment to her faith with embroidered passages from the Bible and her hope for our country's success in the war with her Victory V. *Courtesy of Abby Aldrich Rockefeller Folk Art Museum, Williamsburg, Virginia*

The Hatfield and McCoy Victory Quilt

The photograph shown was taken during World War II at quilting bee with members of the famous Hatfield and McCoy families, from Virginia and Kentucky. Held at the home of Frank McCoy in 1944, the families' quilters finished a patriotic quilt to honor their loved ones who were fighting the wars in the Europe and the Pacific theaters. The two upper stars of the quilt represented the famous feuding heads of each family, from the Civil War era. Anderson "Devil Anse" Hatfield of West Virginia joined the Confederate forces. Harmon McCoy of Kentucky became a Union soldier; he was slain during the Civil War. (The families began this legendary feud in the 1870s, as a dispute over a hog and the romantic relationship of Johnson "Johnse" Hatfield and Roseanna McCoy.) The two stars at the bottom of the quilt represent sons fighting in World War II. Woodrow McCoy served his country returning at the war's end. Anderson Hatfield joined the U. S. Navy; he died and was buried in Egypt.[168] "The

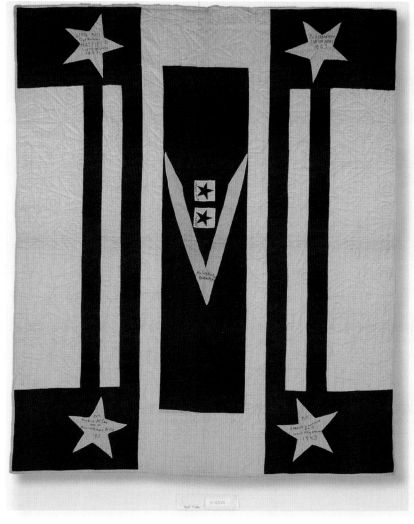

Members of the famous feuding families, the Hatfields and the McCoys, were featured in *Life* magazine, on May 22, 1944, quilting together on a Victory Quilt.

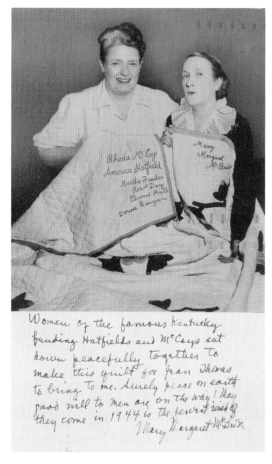

1944. The Hatfield and McCoy Victory Quilt. Made by America Hatfield and Rhoda McCoy, Kentucky. Hand pieced, hand quilted, 76 inches x 92 inches, cotton. *Courtesy of the Ohio History Society*

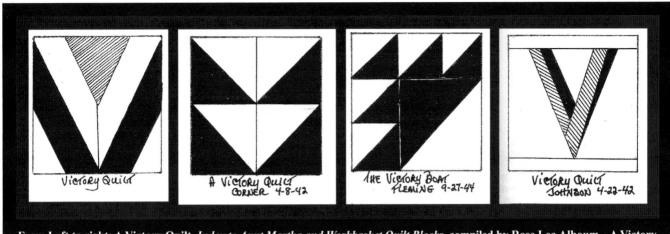

From Left to right: **A Victory Quilt,** *Index to Aunt Martha and Workbasket Quilt Blocks,* **compiled by Rose Lea Alboum. A Victory Quilt,** *Index to The Kansas City Star,* **compiled by Rose Lea Alboum. The Victory Boat,** *Index to The Kansas City Star,* **compiled by Rose Lea Alboum. Victory Quilt,** *Index to The Kansas City Star,* **compiled by Rose Lea Alboum.**

Hatfield and McCoy Victory Quilt" was later given to Jean Thomas, a friend of both families, in 1945, who chose the Ohio Historical Museum for the quilt's new home.

The process of making this quilt became a momentous occasion that was featured in *Life Magazine* on May 22, 1944, in an article called "Life Visits the Hatfields and the McCoys." In addition, the following ballad was written by neighbors from Kentucky and West Virginia:

> I've been down to the quiltin', folks,
> A Victory quilt, they say;
> At Granny Hatfield's old log house
> Across on Tadpole way.
>
> And Rhoda, Bud McCoy's good wife
> With Martha Hatfield, too,
> Made up the quilt of calico
> With old red, white and blue.
>
> One big star stands for Devil Anse.
> Who led the rebel clan;
> Another star – Harmon McCoy
> A faithful Union man.
>
> Woodrow McCoy, another star,
> For many victories won,
> He was a proud and noble lad,
> America Hatfield's son.
>
> The last big star, a Hatfield Boy,
> Old Tolbert's pride was he;
> The small stars, Ace and Anderson
> Who fought across the sea.
>
> This Victory quilt to honor them
> We'll place within a shrine,
> With Roosevelt's name and noble deeds
> On history's page to shine.[169]

Victory Garden Quilts

On February 8, 1943, the *Maryland News* in Frederick, promoted the planting of Victory Gardens. "Food is a weapon in the war we are fighting…..By growing a Victory Garden you can help the country build up its stockpile of food for war uses. You can make it easier for our own fighting men and our fighting Allies to get the food they need to keep driving against the Axis aggressors. You can help build the stockpile

higher for the campaigns yet to come and for the countries being re-occupied—food that must be ready to back up each drive. By growing a Victory Garden you can help save vital metals used for canning. The food you eat from your garden will reduce the amount needed from cans and will supplement the supplies of canned food that will be available under rationing."

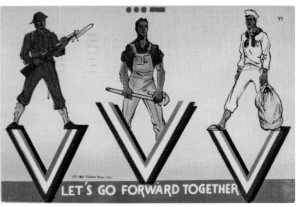

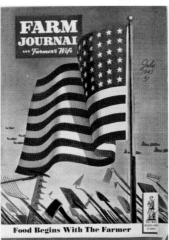

40,000 Victory Gardens for the upcoming growing season of 1944. There were 38,870 food-producing gardens the previous year in 1943. The local food council reported, "The need for home-grown food will be greater than ever, the council said, advising increased crops of peas, cabbage, lima beans, carrots and onions.[170]

Besides newspapers nationwide, free pamphlets were printed by the government to promote food production for the home in Victory Gardens. The family was frequently featured holding their garden tools like weapons.

Many of the designs and slogans appearing in the advertising literature were also interpreted in quilts during the World War II years. Although most textile production was directed to battlefront needs, there was a small amount of production for home decoration and clothing industries. *The Zanesville Signal*, Zanesville, Ohio, printed this account of a fashion show in Los Angeles, California on March 25, 1943. The World War II actress and swimming starlet, Esther Williams was chosen to model clothing made with Victory Garden colors. The scraps of these earthy Victory Garden colors were incorporated in World War II quilts.

Early in the war, experienced volunteer gardeners were enlisted to speak at garden clubs, Red Cross meetings, and state sponsored meetings to advise novices in planting their home victory gardens. By 1943, most United States industries had converted their efforts to the production of war equipment and munitions. Farmers cultivated their crops for war food and fibre production. Even the smallest plots of land were pressed into the service for the country. On February 25, 1943, the *Berkshire Evening Eagle*, Pittsfield, Massachusetts, specifically outlined the reasons to plant Victory Gardens at home. "Everybody who has a suitable piece of fertile ground can make an important contribution to the national food program and help win the war by growing a home vegetable garden in 1943." This promotion went out to farm families, city dwellers, suburban and town residents, school children and community plot holders. The following reasons supported home food production:

1. Help to build the stockpiles higher for the campaigns yet to come and for the countries being re-occupied.

2. Help to save vital metals used for canning.

3. Help to supplement the supplies of canned food that will be available under rationing.

4. Ease the burdens of our transportation systems by cutting down the amount of food that must be shipped.

5. Make all the people healthier and stronger.

As World War II progressed, growing Victory Gardens, also known as 'V' Gardens, was an overwhelming success. *The Clearfield Progress*, Clearfield, Pennsylvania, April 20, 1944, reported, "Last year's Victory Gardens grew 8,000,000 tons of food, an average of two-fifths of a ton each." The New York area of White Plains set a goal of

Fashions are getting down to earth, at least as far as color is concerned. A whole palette of fresh exciting hues called "Victory Garden Colors" was featured at a recent Los Angeles spring style showings. They vary from the true shades of vegetables—so real they look edible—to softer tones, just as true, but grayed down. The latter lend themselves admirably to contrasts and combinations, and the whole Victory Garden Color range is a "natural" for sportswear. There are four different greens—Chard, Carrot Leaf, Blue Grass and Celery. The two reds are Rhubarb and Tomato. Then there are plum Royal, a brilliant blue: Butter Bean yellow: Potato Tan, a new luggage tone: Parsnip Tan, a new beige: Cantaloupe Beige, warmer than Parsnip: and Turnip Brown. Four pastels finish up the Victory Garden array: a delicate pink called Peach Blossom: a rosier tone called Cherry Blossom: Berry Blue, which is like faded blueberries and Squash Gray."

West Paints Style Pictures

In typical "Victory Garden" color is this new West Coast-designed slack suit of Carrot Top green macomba cloth, worn by screen actress Esther Williams. It is less strictly tailored than such garments have been in the past, the sunrayed stitching from jacket pockets to shoulder giving it a handmade look.

Victory Gardens were part of the home front's nationwide effort to fight the war. Victory Garden quilts survive as artifacts recalling the tremendous efforts of everyday Americans to battle the war in their own backyards. The following poem printed in the *Sunday Times Signal*, Zanesville, Ohio and the *Dixon Evening Telegraph*, Dixon, Illinois best expresses the drive of Victory gardeners:

The Zanesville Signal, **Zanesville, Ohio, March 25, 1943.**

The Flag is Over The Plow

Do you feel, young man, the only way
To serve the land you love
Is to shoulder a gun and march away
With the stars and stripes above?

More than troops and ships and camps are marked
With the cloth of sacred vow.
You may not see it wave as you work
But the flag is over the plow.

There's another army must march today
As strong as the one afield.
Millions of men must face the earth
And make the land to yield;

An unfed army of fighting men
Is no force to face the Huns
To free the world of this hellish horde
Takes more than planes and guns.

If plows, perhaps, were put in line,
If the bugle call would sound,
If band would play, and colors rise
In services profound;

If tractor on tractor could move away
To music that quickens feet
There might be patriotism then
In corn and hay and wheat.

But there are no drums, no bands that play,
No buddies there in line,
He works alone in the field of his
As I work alone in mine;

It is very humble the work we do,
But we must remember somehow,
As much as it flies at the battle front,
The flag is over the plow! [171]

Victory Garden Quilt

On December 17, 1904, seventeen-year-old Mariska Mihalovits departed Hamburg, Germany, with her nineteen-year-old sister, Erzebeth. Most likely, the two traveled by train from their home in Otelek,[172] Hungary, to the port on the North Sea. Mariska and Erzebeth endured fourteen days at sea, traveling in steerage. Their ship, *Pretoria,* made stops at Boulogne-sur-Mer in northern France and at Dover, England, before making its long journey across the Atlantic Ocean, arriving in New York City on December 30, 1904.[173, 174]

Mariska assimilated quickly to her new country and surroundings. She changed her given name to Mary, the English equivalent of Mariska. Residing in Chicago, Illinois,

her first job was as a house servant. In the 1910 Federal Census, she was recorded as English-speaking and married to Stephen Gasperik, also a Hungarian by birth. Early in his career, Stephen was a milk dealer who developed his business into grocery store ownership by 1920. Mary worked in the store as a clerk. Their young family was living on Cottage Grove Avenue in 1917, when Stephen signed up for the draft to fight in World War I, at age 35.[175]

Raising two sons and a daughter, and working alongside her husband in their store, did not allow Mary the free time to actively pursue quiltmaking until she was 45 years old. She quickly developed her talent and personal creative style, making approximately 80 quilts in the second half of her life.[176] (The entire collection of Mary Gasperik's quilts can currently be viewed on the Internet at The Quilt Index.org)

Hungary was Mary's homeland. Historically, in most Eastern European countries, the favorite needlework tradition was decorative embroidery on costumes, altar clothes, and ceremonial textiles. Embroidery, by definition, is the ornamentation of fabric using needlework. Mary ornamented her quilts with her appliqué skills, creating countless original layouts inspired by published designs. The largest percent of her quilts were appliqué quilts. "Victory Garden" was the exception, with hundreds of small, pieced hexagons in a "Flower Garden" setting.

Although Mary left this world without sharing the meaning of her quilt design, the two stars in the center of the quilt may represent the service of her two sons, Stephen and Elme, who were both enlisted in World War II.[177,178] To further embellish her quilt, Mary appliquéd a wreath on both sides of the quilt, replicating the wreaths found on the Hungarian flag. Her placement of "Victory Vs" at the four corners displayed a hopeful and winning spirit for her adopted nation in a time of war.

Mary Gasperik, Chicago, Illinois. *Courtesy of Susan Salser*

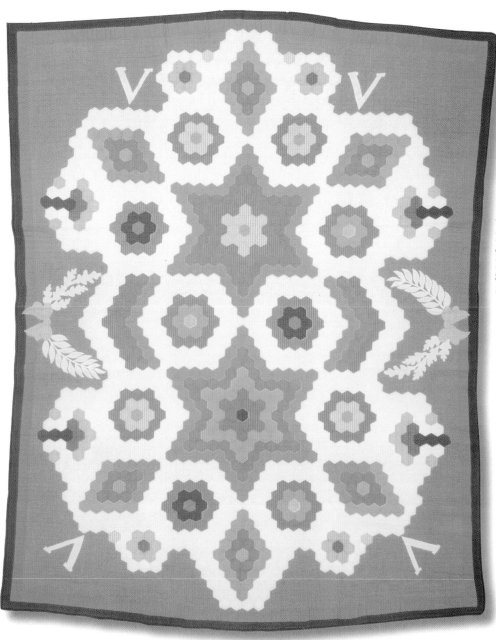

Victory Garden. Made by
Mary Gasperik (1888-1969),
Chicago, Illinois. Hand pieced,
hand appliquéd, hand quilted,
84 inches x 98 inches, cotton.
Courtesy of Charlene Shipp

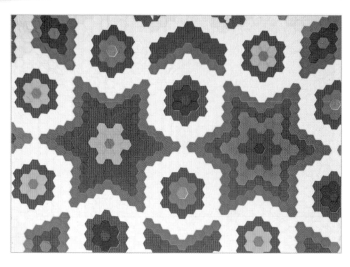

The Rainbow Block Company Victory Quilt

*"What's at the end of a Rainbow?
A collector's dream—A Rainbow Quilt Design."* [179]

William Pinch began his successful career designing and providing appliqué and embroidery patterns in the 1920s. The designs were stamped onto square white fabric measuring 18 inches. Baskets and bouquets, vining flowers and leaves, birds nesting and in flight, snowflakes, butterflies, Kewpies and Sunbonnet girls were some of his popular patterns. Following a trend that originated in the 1930s, Pinch created his own theme quilts. State flowers and birds, and Biblical quilts were among his most sought-after designs. The Rainbow Block Company sold patterns to Woolworth's, S. W. Kresge and other 5 & 10 Cent stores until the 1960s. [180]

During World War II, Victory quilts were made in pieced and appliquéd designs. William Pinch published his version of a Victory quilt to be completed in embroidery. It featured flowers, symbols of peace, and Victory Vs. It became one of most popular Victory quilt designs of the World War II era.

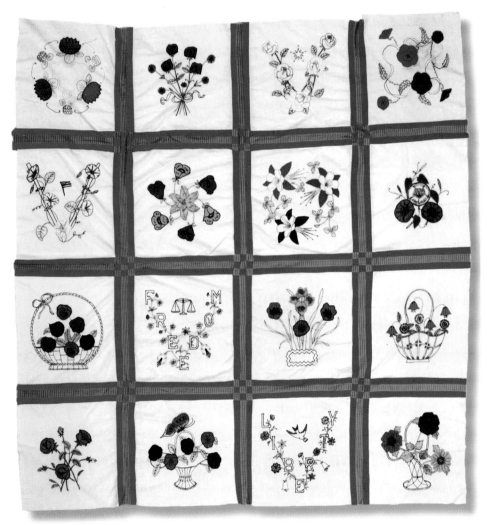

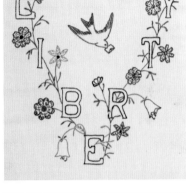

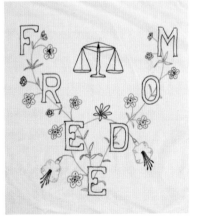

Victory Garden Quilt. Quiltmaker unknown. Machine pieced, hand embroidered, hand quilted, 75 inches x 100 inches, cotton. The Rainbow Quilt Block Company, of Cleveland, Ohio, published these embroidery patterns of Victory Vs.

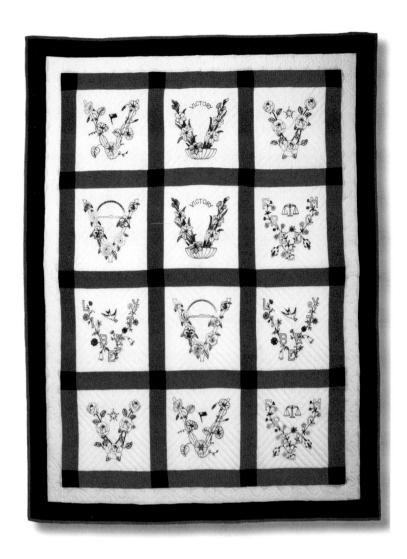

Victory Garden Quilt. Quiltmaker unknown. Machine pieced, hand embroidered, hand quilted, 75 inches x 100 inches, cotton. The Rainbow Quilt Block Company, of Cleveland, Ohio, owned by William Pinch, published these embroidery patterns of Victory Vs. The quiltmaker repeated the victory design in her quilting.

The Victory Quilt
No. 231-H

This Patriotic Victory Quilt No. 231-H is different in design from all other quilts, because of the V formation, and it is very attractive. There are six symbolistic patterns in outline and requires two of each design for a quilt. Notice the dove with the letter of peace, while the cosmos and flowers beautify the word LIBERTY. Our American beauty rose surrounds the star of hope. The jar of gladiolas depicts joy when victory is assured. Forget-me-nots grace our sacred word of FREEDOM. Morning glories express the glory as our flag rises supreme, and the lovely pansies symbolize victory, while the rainbow gives promise of peace. Work letters and rose stems in brown, and flowers as shown. Rainbow lines from top down, orchid - blue - green - yellow - orange and red. 15 skeins of floss needed — one each of violet, orchid, orange, yellow, pink, rose, red, dark blue and light blue, two of brown, and 4 of green. Use four and a half inch strips for border. 11 yards of white, 13 yards of blue, and 16 yards of rose. Size 90 x 100 inches.

You have the privilledge of choosing the colors of your applique for quilt blocks for any dozen of the same design, or all over special tops. Pink - rose - deep rose - light blue - dark blue - light or dark yellow - orchid - violet - peach - appricot - orange - gold - rust or red.

C+S

WILLIAM PINCH
4915 Wichita Ave. Cleveland, Ohio 44109

Vegetable Head Victory Gardeners, to be embroidered on tea towels.

The Amarillo Daily News, Amarillo, Texas, Friday Morning, March 18, 1943, page 13.

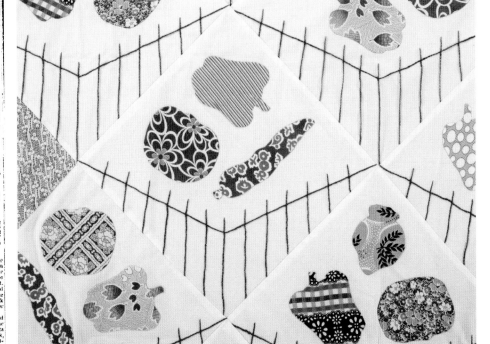

Detail of a newly made Victory Garden quilt using vintage fabrics.

Quilts and Published Patterns during World War II

The fabrics used in World War II quilts were often a mix of 1920s and 1930s scraps, as thrifty women reached into their scrap bags for their quiltmaking. World War II quilts made without patriotic designs, military insignia, or red, white and blue color themes are not easy to date to the war years.

Many of the quilts presented in this book feature patterns published between 1940 and 1945. This chapter also could be called "World War II Quilts Yet to Be Found." It concentrates on quilt patterns and articles reporting quilts made during the World War II years but not yet found.

The *Mason City Globe-Gazette,* Mason City, Iowa, on March 27, 1942, detailed Mrs. Ethel Sampson's construction of a Crazy Quilt. The article, titled "Famous Names Lend Help for Crazy Quilt," continues:

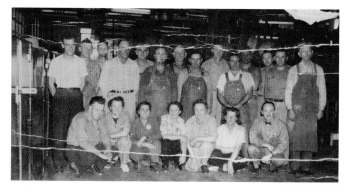

This group picture includes quilter Kathryn Elizabeth Pickering Say, botom row, second on the right.

CHICAGO,—President Roosevelt's necktie, the Dionne quintuplets' diapers, the late Jane Addams' dress cloth, a piece of one of Mae West's gowns—sew them all together and you have a section of Mrs. Ethel Sampson's "historical crazy quilt." Ten years ago, Mrs. Sampson who lives in Evanston, Ill., got the idea of making a crazy quilt out of personal clothing of the world's great.

She began by writing letters to celebrities all over the world, and received a surprisingly large number of responses. Neckties were the greatest number of items donated to the quilt. Among the donors were Vice President Henry Wallace, Douglas (Wrong-Way) Corrigan, former Chief Justice of the Supreme Court Charles Evans Hughes, Charlie McCarthy, the late Senator William Borah and Haille Selassie. The late Amelia Earhart sent a collar and Shirley Temple sent a piece of a dress. Mrs. Simpson has letters to prove that each item is the genuine article. She plans to keep right on acquiring more material and enlarging her quilt. Her latest request went to Gen. Douglas MacArthur.[181]

Although this American Famous Names quilt cannot currently be located, in its time it was reported about in newspaper and magazine articles across the nation, including *The New Yorker.*[182,183]

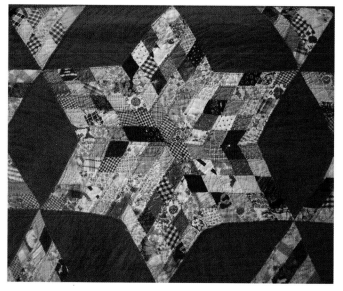

This is a detail of a Lone Star Scrap quilt made by Kathryne Elizabeth Pickering Say (1900-2002), of Wilsey, Kansas. She is pictured nearby. She worked as a riveter from 1943 to 1945, at the Beechcraft facility at Delavan Air force Base, in Delavan, Kansas. She used scraps from her dresses, curtains and other household textiles. *Courtesy of Mary Wilson Kerr*

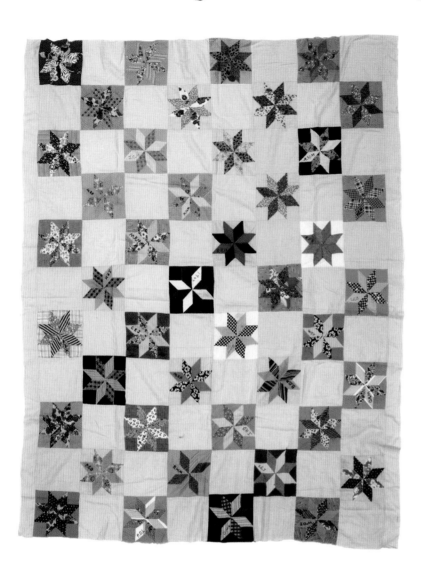

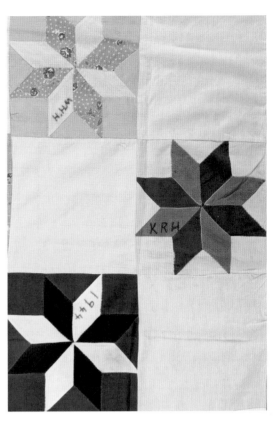

Eight-Point Star Quilt Top. Dated 1944. Initialed by multiple Connecticut quiltmakers. Hand and machine pieced, hand embroidered, 61.5 inches x 74 inches, cotton. The Eight Point Star is an ageless quilt pattern. Without the red, white and blue dated star in the center of this quilt. This quilt top would be dated to the 1920s-1930s.

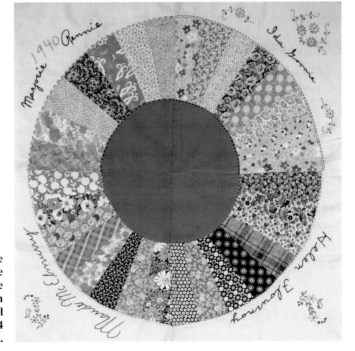

The embroidered date, 1940, and the blue and white sailor fabric in the upper left corner of this Dresden Plate block, make this block a World War II artifact. Maude McElmurry, Ida Gorrie, and Marjorie Rennie lived in Lane County and Polk County, Oregon. The 1930 Federal Census indicates these ladies were between the ages of 44 and 53 years of age when they made the quilt block.

Patriotic colors and nautical images date
this fabric to the war years.

Sometimes, the backing of a quilt or the foundation upon which it was pieced give the
best clues to identify a quilt's date. These blocks, constructed by strip-piecing, were
made with fabrics from the second quarter of the twentieth century. The newspapers
and magazines used for the foundation piecing date from the World War II years.

This feedsack fragment is easy date to the
World War II era, with its Victory Vs.

A feedsack was originally printed with red
and blue candles alight with hope for peace
during the war years.

174

Yankee Pride. Quiltmaker unknown. Hand and machine pieced, hand quilted, 76.5 inches x 72.5 inches, cotton.

This patriotic feedsack, from Iowa, was printed with soldiers, an imposing V, and the Morse Code encryption for "Victory."

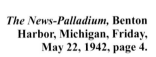
The News-Palladium, Benton Harbor, Michigan, Friday, May 22, 1942, page 4.

Texas Trellis Quilt, made by Mrs. H. L. Lawrence for her son, George Raymond (Buddy), and his wife, Goldie Wilson Lawrence. They were married on November 2, 1941, and their son, Buddy, Jr,. was born on January 10, 1943, while his father was overseas. His father saw him only once before he was killed at Normandy in 1944. The pattern for Texas Trellis was published by the *Kansas City Star* on July 28, 1943. Without the family provenance, it could not have been identified as a World War II quilt.
Courtesy of Mary Wilson Kerr

Mountain Mist® Quilts

A Chronicle of Our Employees in the Uniform Services during World War II was published by The Stearns and Foster Company, manufacturers of Mountain Mist® batting for quilts.[184] The account was printed as a hardbound book. It included letters from employees who were called to the battlefield, memorials to "Gold Star" employees who were killed in the war, encouragement to buy war bonds and stamps, give blood, and to comply with rationing regulations and price ceilings.[185] The book expressed, with words and design, the pride of this American company's sacrifice and contribution to the war effort. Mountain Mist®, a Cincinnati, Ohio, company designed quilt patterns and printed them on the inside wrappers of batting, to encourage women to purchase their products. Mountain Mist® products and quilt designs were fundamental to the quilt world during the twentieth century. "Mountain Mist® is a registered trademark now owned by Polyester Fibers, LLC."

Early in the war, as our nation's men went off to foreign lands, Mountain Mist® featured quilt patterns that evoked patriotism and warm feelings of hearth and home. Some of the most popular were the new designs for 1941: Country Garden, April Showers, Bluebird to Happiness, Apple Blossoms, Maple Leaf, and Patriot's Pride.

Later in the war, and perhaps in honor of their own employees on the battlefront, Mountain Mist® released patterns to honor the Army, with "Wings Over All," and the Navy, with "Sea Wings to Glory." They were both published in 1943.[186, 187]

During the last years of the war with the shrinking availability of goods for quiltmaking, Mountain Mist® wisely provided patterns to encourage women to use up their scraps. Crazy Pieces and Crossword Puzzle were published in 1944, and Odds and Ends in 1945.[188, 189] The women, through necessity due to shortages of fabric, dug deep into their scrap bags as the war progressed. Mountain Mist® responded with appropriately designed patterns for quilts with hundreds of small pieces. Even in their ads, the company called upon quiltmakers to "use of your scraps to piece or patch."[190]

Patriot's Pride, a pattern by Mountain Mist®, 1941.

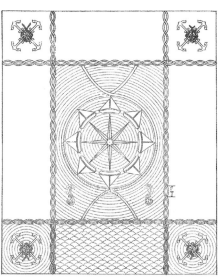

Sail Ho, a pattern by Mountain Mist®, 1940.

Crossword Puzzle, a pattern by Mountain Mist®, 1944.

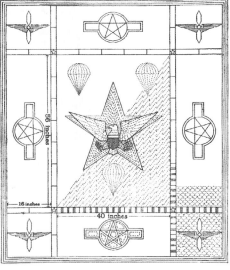

Wings Over All, a pattern by Mountain Mist®, 1943.

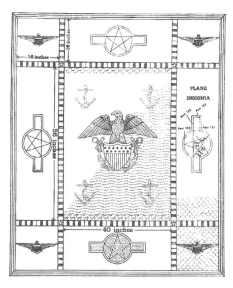

Sea Wings to Glory, a pattern by Mountain Mist®, 1943.

Country Gardens Quilt. Quiltmaker unknown. Machine pieced, hand quilted, 73 inches x 96 inches, cotton.

Country Gardens, a pattern by Mountain Mist®, 1941.

Near Right: Odds and Ends, a pattern by Mountain Mist®, 1945.

Far Right: Crazy Pieces, a pattern by Mountain Mist®, 1944.

Kansas City Star Quilts

Published in the center of the country, *The Kansas City Star* has led the way in quilt pattern design since 1928.[191] During World War II, traditional quilt patterns were submitted to *The Star* by women from across the Midwest and South, and they were renamed with titles reflecting the patriotism of the country.

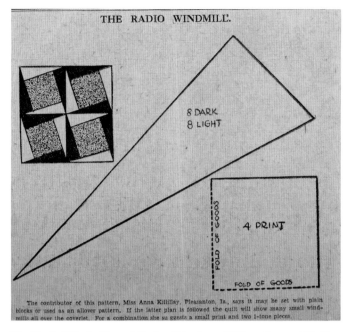

The Radio Windmill, contributor Miss Anna Killian, *Kansas City Star.*

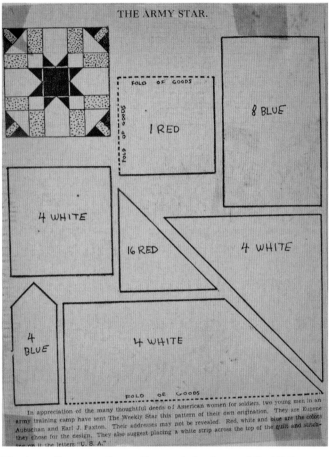

The Army Star, contributors Eugene Aubuehan and Earl J. Paxton, *Kansas City Star.*

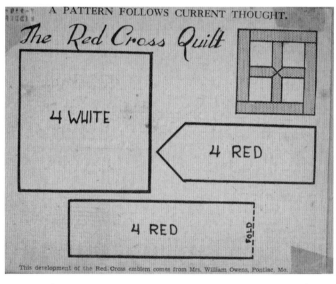

The Red Cross, contributo Mrs. William Owen, *Kansas City Star.*

Whirling Star, a pattern published in April, 1941, attributed to Mrs. Herrick from Hazel Valley, Arkansas. She suggested making this star in red, white and blue and renaming it "Patriotic Star." it is featured in the *Index to The Kansas City Star*, compiled by Rose Lea Alboum.

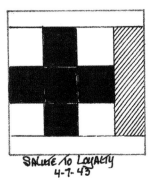

Salute to Loyalty, featured in the *Index to The Kansas City Star*, compiled by Rose Lea Alboum.

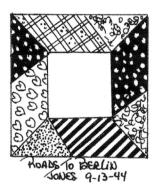

Roads to Berlin, featured in the *Index to The Kansas City Star*, compiled by Rose Lea Alboum.

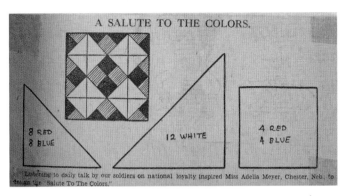

A Salute to the Colors (Meyer) pattern, *Kansas City Star*, May 6, 1942.

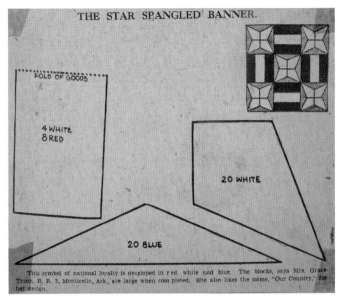

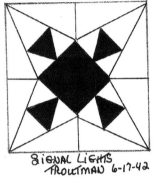

Signal Lights, featured in the *Index to The Kansas City Star*, compiled by Rose Lea Alboum.

SIGNAL LIGHTS TROUTMAN 6-17-42

The Star Spangled Banner, published September, 1941. Mrs. Grace Tyson, Monticello, Arkansas, created the block in red, white and blue. She chose the name "Our Country" for her new design.

Ladies Home Journal

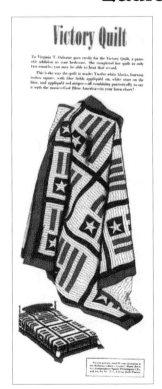

Ladies Home Journal featured this pattern in April, 1944. The quilt was designed and made by Virginia Osborne, who called it "Victory Quilt." Her message to all was, "God Bless America!"

Cowboy Star Quilt, *Morning Herald*, Uniontown, Pa. December 26, 1942, p. 2.

Victory Star, *Marion Star*, Marion, Ohio, September 25, 1942.

This quilt pattern appeared in the July, 1942 issue of *American Home* magazine. The article begins with: "Back we go, with heads high and hearts honestly happy, to wearing cotton stockings and riding bicycles; to raising our own greens and saving our bacon grease; to practicing Poor Richard's thrift – we've done it before, and we're doing it again. Best of all we like doing it. Along with this wave of reclaiming our lost virtues, interest is rapidly mounting in a treasured pastime of American women, quilting. The quilt "Wings for Victory," was designed by Mary Dyer. The motifs are simple, the Victory V and the Army Air Corps Insignia.

Patterns from Newspapers

Laura Wheeler and Alice Brooks

Quilt patterns published in newspapers during World War II are featured throughout this book. There were thousands of patterns issued and reissued to encourage women to continue popular needlework skills. As the war progressed, quiltmakers were wisely urged to use their fabric scraps.

On July 15, 1942, quilt pattern # 387, by Laura Wheeler, was published with the following encouraging words:

> Scrap quilts conserve materials! And the more varied your scraps, the prettier your quilt will be! And the Star of the East blocks add up quickly![192]

"Nosegay Quilt" pattern # 254, made a come-back on February 13, 1942 in the same paper, with these words:

> In these times of constant strain and worry, there's a blessed comfort to be had in working with your hands. More and more smart modern women are finding needlework as an outlet for emotional tension. This quilt is a perfect way use up the colorful odds and ends in your scrap bag.[193]

And below, in July 28, 1942, the *Monessen Daily Independent*, Monessen, Pennsylvania, featured as an 'Old Time Favorite,' 'Friendship Fan' #396, these words accompany the pattern:

> Be economical! Don't let those scrap prints lie idle. Place them together into this quilt, Friendship Fan – an old-time favorite that's as colorful as it is easy to make![194]

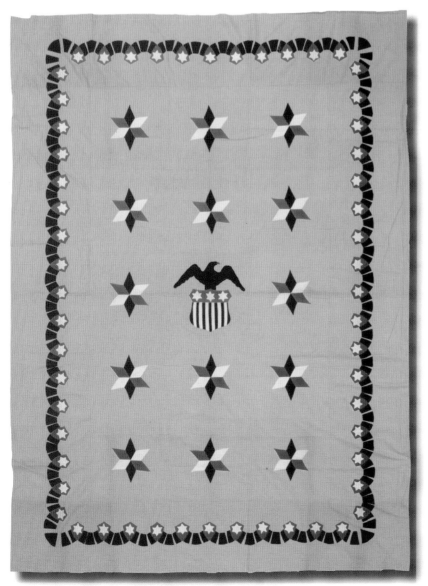

A pattern featured in the *Index to The Farm Journal* and *The Farmer's Wife Quilt Blocks*, compiled by Rose Lea Alboum.

A pattern featured in the *Index to The Farm Journal* and *The Farmer's Wife Quilt Blocks*, compiled by Rose Lea Alboum.

Liberty Quilt, quiltmaker unknown. Hand appliquéd, machine pieced, hand quilted, 84.5 inches x 90 inches, cotton. Published by *Farm Journal and Farmer's Wife*, in 1943.

Farm Journal Quilts

Once a year, throughout World War II, Farm Journal Magazine featured quilt patterns. The magazine, first published in Philadelphia, Pennsylvania, was in circulation since March, 1877. Its founder, Wilmer Atkinson, was a Quaker and the families of rural America received this magazine.[195]

The magazine published patterns for quiltmaking in the February issue each year, and in pamphlets available with magazine orders. Patriotism was a major focus in the magazine's quilt designs during the war years. The Farm Journal patterns named Liberty, Victory and Red, White and Blue were extremely popular. Many quilts were made with these designs, showing the loyalty and support for our country during World War II.

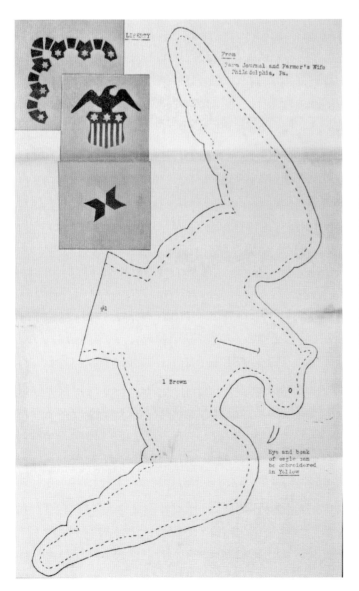

Farm Journal, February, 1945, page 54.

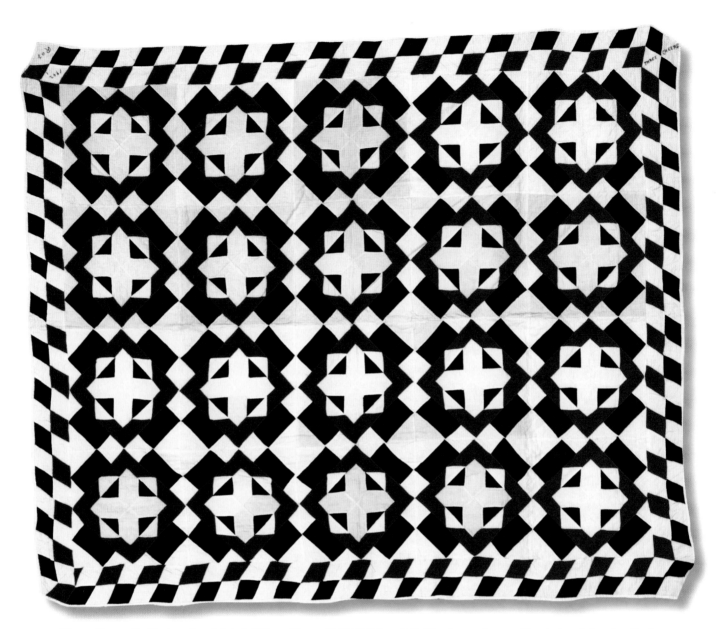

Three Cheers Quilt, signed and dated, "Three Cheers 1942-1943 Roy." Quiltmaker unknown. Hand pieced, hand quilted, 61.5 inches x 84.5 inches, cotton. This pattern was published by *Farm Journal* in 1941.

Detail of Three Cheers Quilt.

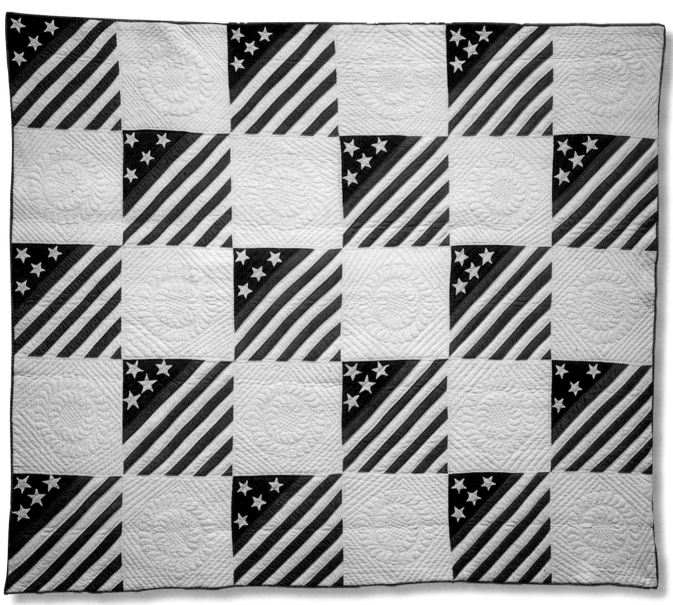

Red, White and Blue Quilt, quiltmaker unknown. Hand pieced, hand quilted, 95 inches x 75.5 inches, cotton. The pattern was featured in *Farm Journal*, February, 1945. *Courtesy of the New England Quilt Museum.*

Notes

Preface

1 "Relief Society Announces Work Meeting," *Soda Springs Sun*. Soda Springs, Idaho. January 8, 1942: 5

2 "The Greatest Generation" coined by Tom Brokaw. *The Greatest Generation*. Random House. 2005

3 Bundles for Britain was founded by the British War Relief in early 1940, to provide non-military aid to the British people.

Chapter 1: In A Time of War

4 Roosevelt, Franklin Delano. Pearl Harbor Speech. December 8, 1941.

5 "WE, THE WOMEN." *Edwardsville Intelligencer*. Edwardsville, Illinois. November 12, 1941: 3.

6 *Denton Journal*. Denton Maryland. June 6, 1942: 1

7 http://www.rosietheriveter.org/index.htm; accessed on 2 Jan. 2010.

8 "FASHION FAVORS QUILTING." *Ironwood Daily Globe*. Ironwood, Michigan. September 29, 1942: 6.

9 "FASHION FAVORS QUILTING." *Ironwood Daily Globe*. Ironwood, Michigan. September 29, 1942: 6.

10 "On the Family Front." *The Lowell Sun*. Lowell, Massachusetts. September 24, 1942: 20.

11 *Troy Record*, Troy, New York. October 15, 1943: 24.

12 *The Dothan Eagle*. Dothan, Alabama. October 14, 1943: 7.

13 *The Dothan Eagle*, Dothan, Alabama. June 16, 1943: 6.

14 This observation is based on the thousands of articles about quiltmaking in newspapers across the United States, found in online data bases such as Ancestry.com and other newspaper data bases available through libraries, museums and universities.

15 *Times Record*, Troy, New York. March 22, 1943: 14 and Portsmouth Herald. Portsmouth, New Hampshire. April 30, 1943: 10.

16 *Lethbridge Herald*. Lethbridge, Alberta, Canada. March 17, 1943: 11.

17 "Newspapers Are Lauded By O'Connor In Scrap Drive." *Denton Journal*. Denton, Maryland. October 17, 1942: 4.

18 Connecticut Quilt Search Project. *Quilts and Quiltmakers Covering Connecticut*. Atglen. Schiffer Publishing LTD: 176.

19 Poem about Ruth Snow Bowen was provided courtesy of The Windham Textile & History Museum, Willimantic, CT.

20 "Gracie Allen's Alman(i)ac." *The Zanesville Signal*. Zanesville, Ohio. October 19, 1943: 8.

21 "Gracie Allen's Alman(i)ac." *The Zanesville Signal*. Zanesville, Ohio. October 19, 1943: 8.

22 "No Need to Put Your Home in 'Mourning' for Blackout." *Evening Times*. Cumberland, Maryland. January 29, 1942: 6.

23 "Star of the East # 387." *The Daily Independent*. Monessen, Pennsylvania. July 15, 1942: 3.

24 "Nosegay Quilt #254." *The Daily Independent*. Monessen, Pennsylvania. February 13, 1942: 3.

25 "Friendship Fan #395." *The Daily Independent*, Monessen, Pennsylvania, July 28, 1942, 6.

Chapter 2: Franklin Delano Roosevelt

26 http://en.wikipedia.org/wiki/Four_Freedoms; accessed on 2 Jan. 2010.

27 V-E Day, August 15, 1945 and V-J Day, September 2, 1945 are universally recognized as the end of World War II in the European and Pacific theaters respectively.

28 Information about Hermina Gervais Giroux was provided by her granddaughter, Sue McGuire, Vermont.

29 Joseph P. Lash. *Eleanor and Franklin*. New York: W.W. Norton and Company, Inc., 1971, 654.

30 Connecticut Quilt Search Project, *Quilts and Quiltmakers Covering Connecticut*. Atglen: Schiffer Publishing, LTD., 2002, 140.

31 http://www.gwu.edu/~erpapers/documents/speeches/doc026453.cfm; accessed on 2 Jan. 2010.

32 http://en.wikipedia.org/wiki/Fala_(dog); accessed on 2 Jan. 2010.

33 President Roosevelt named his dog after a famous Scottish ancestor, John Murray of Falahill.

34 "Fala Sits In on So many Conferences That He's Beginning to LOOK Like a Statesman!" *The Zanesville Signal*. Zanesville, Ohio. October 9, 1941: 6.

35 *Dunkirk Evening Observer*. Dunkirk, New York, April 7, 1942: 1.

Chapter 3: Children, Wives, Mothers, and Grandmothers of World War II

36 "Newsy Items About Events At Caroline High School." *Denton Journal*. Denton, Maryland. October 17, 1942: 4.

37 Rae, Janet and the British Quilt Heritage Project. *Quilt Treasures of Great Britain*. Nashville, Tennessee: Rutledge Hill Press, 1995: 157.

38 *Mason City Globe-Gazette*. Mason City, Iowa, March 5, 1942: 15.

39 *The Kingsport Times*. Kingsport, Tennessee. January 15, 1943: 3.

40 Willard Boyles, Secretary of Victory Leaders Bands, "Letter from The Church of God," Cleveland, Tennessee, September 21, 1943 in the archives of the Franklin D. Roosevelt Library and Museum, Hyde Park, New York.

41 Mackey, Albert. *An Encyclopedia of Freemasonry and Its Kindred Sciences*. Chicago: The Masonic History Company, 1924: 686. "An old heraldic writer, quoted by Sloane-Evans (Gram. Brit. Her., 153), thus gives the symbolic import of the shield: "Like as the shield served in the battle for a safe-guard of the body of soldiers against wounds, even so in time of peace, the same being hanged up, did defend the owner against the malevolent detractions of the envious."

42 Alboum, Rose Lea. *Index to the Ladies Art Company Quilt Designs*. West Halifax, Vermont: 2006: #420.

43 "1943 Minutes of the General Assembly, September," Linda Humberd, Human Resources Department, Church of God of Prophecy. Cleveland, Tennessee.

44 *White Wing Messenger*, Church of God of Prophecy, Cleveland, Tennessee.

45 Willard H. Boyles, "Letter from The Church of God," Cleveland, Tennessee, August 28, 1943 in the archives of the Franklin D. Library and Museum, Hyde Park, New York.

46 "Letter from Major General Edwin M. Watson," U. S. Army, Secretary to President Roosevelt. August 31, 1943 in the archives of the Franklin D. Roosevelt Library and Museum, Hyde Park, New York.

47 Document Facsimiles Descriptions. Franklin D. Roosevelt Presidential Library and Museum. April 11, 1944.

48 Document Facsimiles Descriptions. Franklin D. Roosevelt Presidential Library and Museum. April 11, 1944.

49 *Wisconsin Rapids Daily Tribune*. Wisconsin Rapids, Wisconsin. July 14, 1944: 5.

50 *Salisbury Times*, Salisbury, Maryland. September 2, 1944: 3.

51 "WE, THE WOMEN." *Edwardsville Intelligencer*. Edwardsville, Illinois. November 6, 1941: 3.

52 *The Dothan Eagle*. Dothan, Alabama. June 16, 1943: 6.

53 *The Dothan Eagle*. Dothan, Alabama. June 15, 1943: 7.

54 *Denton Journal*. Denton, Maryland. December 5, 1942: 2.

55 *1930 United States Federal Census*, Oklahoma, Woods County, Patterson Township.

56 http://en.wikipedia.org/wiki/United_States_Coast_Guard; accessed on 2 Ja. 2010.

57 http://en.wikipedia.org/wiki/World_War_II_casualties; accessed on 2 Jan. 2010.

58 Biography information provided by Delaine Gately, Gig Harbor, Washington.

59 Howard, Judith. *Centennial Stitches: Oklahoma History in Quilts*. Oklahoma City, Oklahoma. Dorcas Publishing. 2007: 44.

60 http://www.geocities.com/Pentagon/8967/?200923. Knowles, Jesse. "The Bataan Death March." Stanza #1; accessed on 2 Jan. 2010.

61 *U.S. Veterans Gravesites, ca. 1775-2006*. National Cemetery Administration.

62 *U.S. World War II Army Enlistment Records, 1938-1946.* National Archives and Records Administration.

63 http://www.home.pacbell.net/fbaldie/In_Retrospect. html. Maj. Richard M. Gordon (USA Ret.) Bataan, Corregidor, and the Death March: In Retrospect; accessed on 2 Jan. 2010.

64 http://www.geocities.com/Pentagon/8967/?200923. Knowles, Jesse. "The Bataan Death March." Stanza #8.

65 "Official army-navy text of Jap atrocities." *The Nebraska State Journal.* Lincoln, Nebraska. January 28. 1944: 2.

66 *Fifteenth Census of the United States: 1930. Denver, CO.* Election District H, 34A. Department of Commerce – Bureau of the Census.

67 http://cybersarges.tripod.com/bluestarflgs. htmlBlueStarFlag; accessed on 2 Jan. 2010.

68 *1930 Federal Census of the United States, Ohio, Muskingum, Jefferson township, Dresden village,* Sheet number 8B.

69 *Times Recorder and Signal,* Sesquicentennial Edition. Zanesville, Ohio. October 5, 1949: 6.

70 *The Zanesville Signal.* Zanesville, Ohio. July 12, 1944: 2.

71 *The Zanesville Signal.* Zanesville, Ohio. July 12, 1944: 2.

72 *Times Record.* Troy, New York. December 21, 1943: 3.

73 *Oelwein Daily Register.* Oelwein, Iowa. March 3, 1944: 4.

74 *Oelwein Daily Register.* Oelwein, Iowa. March 16, 1942:5.

75 Bassett, Lynne Zacek. "Of Patriotism and a Family Quilt." Notes provided from an article written for *Pieceworks Magazine.*

76 Bassett, Lynne Zacek. "Of Patriotism and a Family Quilt." Notes provided from an article written for *Pieceworks Magazine.*

77 Bassett, Lynne Zacek. "Of Patriotism and a Family Quilt." Notes provided from an article written for *Pieceworks Magazine.*

Chapter 4: Symbols of a Country at War Expressed in Quiltmaking

78 Boston, Massachusetts. *Passenger Lists of Vessels Arriving at Boston, Massachusetts, 1891-1943.* Micropublication T843. RG085. Rolls # 1-454. National Archives, Washington, D.C.

79 *1920; Census Place: Boston Ward 20, Suffolk, Massachusetts:* Roll: T625_738: Enumeration District: 487; Image: 620.

80 1930; *Census Place: Watertown, Middlesex, Massachusetts*; Roll: 931; Page: 15B; Enumeration District: 516; Image: 258.0.

81 Boston, Massachusetts. *Passenger Lists of Vessels Arriving at Boston, Massachusetts, 1891-1943.* Micropublication T843. RG085. Rolls # 1-454. National Archives, Washington, D.C.

82 Welthea Blanche Thoday. *Quilting Journal of Welthea Thoday,* 1995, National Museum of the American History, Washington D.C.

83 Fylfot – An ancient symbol well known among Heralds. It is sometimes known as the crux dissimulate, found in the catacombs of Rome, and forms one of the symbols of the degree of Prince of mercy, Scottish Rite System. It is a form of the "Swastika." (See Jaina Cross.)

84 http://ancienthistory.about.com/od/ancientart/f/ swastika.htm; accessed on 2 Jan. 2010.

85 Millett, Ruth. "Busy Bodies Will Start Bad Feeling." *Ironwood Daily Globe.* Ironwood, Missouri. August 29, 1942: 6.

Chapter 5, Flags, Banners, Stars and Our Country's Military

86 *Oelwein Daily Register.* Oelwein, Iowa. January 7, 1942: 4.

87 "Raised Flag July 4, 1777." *Oelwein Daily Register,* Oelwein, Iowa. November 3, 1943: 5.

88 *Oelwein Daily Register.* Oelwein, Iowa. January 7, 1942: 4.

89 *Denton Journal.* Denton, Maryland. June 13, 1942: 2.

90 http://www.usflag.org/history/the50starflag.html.

91 Written in Memory of Harry B. Rann who was killed in France on July 20, 1944, by his parents and grandparents. *Daily Review.* Decatur, Illinois. July 20, 1944: 6.

92 *Denton Journal.* Denton, Maryland. November 12, 1943: 4.

93 *Sunday Times Signal.* Zanesville, Ohio. March 21, 1943: 7.

94 Advertisement from Robert Frank Needlework Supply Co., Kalamazoo, Michigan, during World War II.

95 Advertisement from Robert Frank Needlework Supply Co., Kalamazoo, Michigan, during World War II.

96 http://www.nrotc.org/blue.star.mem.hwy.htm; accessed on 2 Jan. 2010.

97 The words engraved on Service Plaques on the Blue Star Memorial Highway that stretches from the Atlantic Ocean to the Pacific Ocean.

98 *Denton Journal*. Denton, Maryland. October 17, 1942: 5.

99 *The Lethbridge Herald*. Lethbridge, Alberta, Canada. July 12, 1943: 9.

100 The information and names from the Honor Roll Banner of the First United Methodist Church of Knoxville, Tennessee, was provided by Joe Vogt, Church Historian.

101 The names of the men on this quilt were researched using the 1930 Federal Census. Although not all of the men were located, the majority were found to be living in Clay County and Montague County, Texas.

102 http://en.wikipedia.org/wiki/Newport,_Texas; accessed on 2 Jan. 2010.

103 *Ada Weekly News*. Ada, Oklahoma. November 30, 1944: 8.

104 This conclusion is based on five years of research conducted in hundreds of online newspapers listed in data bases through universities, libraries and services, such as Genealogy.com and Ancestry.com.

105 Provenance provided by Lyman A. Chapman, Lasalle, Quebec, Canada.

Chapter 6: Quilting Groups of World War II

106 *Northwest Arkansas Times*. Fayetteville, Arkansas. June 3, 1944: 6.

107 *The Clearfield Progress*. Clearfield, Pennsylvania. April 22, 1942: 9.

108 *Mason City Globe-Gazette*. Mason City, Iowa. January 22, 1942: 9.

109 *Mason City Globe Gazette*. Mason City, Iowa. October 26, 1942: 4.

110 *Mason City Globe Gazette*. Mason City, Iowa. February 5, 1943: 5.

111 *Mason City Globe Gazette*. Mason City, Iowa. May 25, 1944:14.

112 *Monitor-Index*. Moberly, Missouri. August 7, 1942: 3.

113 *Abilene Reporter News*. Abilene, Texas. May 29, 1942: 14.

114 *Daily Globe*. Ironwood, Michigan. March 6, 1943: 6.

115 *Tucson Daily Citizen*. Tucson, Arizona. July 8, 1942: 4.

116 *The Kingsport Times*. Kingsport. Tennessee. February 15, 1943: 5.

117 O.E.S. stands for Order of Eastern Star.

118 *The Lethbridge Herald*. Lethbridge, Alberta, Canada. March 17, 1943: 11.

119 April 14, 1863, *Records from the Secretary's Book of the Ladies Benevolent Society of Northfield, 1842-1865*, Litchfield Historical Society, Litchfield, Connecticut.

120 The Connecticut Quilt Search Project, *Quilts and Quiltmakers Covering Connecticut*, Schiffer Publishing Ltd., Atglen, PA, Pages 116-117.

121 *Lima News*, Lima, Ohio, March 31, 1942, Page 12.

122 *Wisconsin Rapids Daily Tribune*, Wisconsin Rapids, Wisconsin, February 21, 1942: 6.

123 *Wisconsin Rapids Daily Tribune*, Wisconsin Rapids, Wisconsin, September 10, 1942: 8.

124 *Wisconsin Rapids Daily Tribune*, Wisconsin Rapids, Wisconsin, September 16, 1942: 9.

125 Walter Hynd, *Liberty,* a statement taking place during extensive interviews with Air Marshall William A. Bishop.

126 http://www.archives.gov.on.ca/english/exhibits/eatons-windows/royalty.htm; accessed on 2 Jan. 2010.

127 http://www.archives.gov.on.ca/ENGLISH/exhibits/eatons/parade.htm; accessed on 2 Jan. 2010.

128 *The Lethbridge Herald*, Lethbridge, Alberta, Canada, May 7, 1943: 8.

129 *The Lethbridge Herald*, Lethbridge, Alberta, Canada, May 7, 1943: 8.

Chapter 7: Wartime Quiltmaking for the Red Cross

130 *Fresno Bee Republican*. Fresno, California. January 13, 1942: 4.

131 "The Heritage Search of the Quilter's Guild." *Quilt Treasures of Great Britain*. Nashville, Tennessee: 164

132 *The Lethbridge Herald.* Lethbridge, Alberta, Canada. February 25, 1943: 6.

133 *The Charleston Daily Mail.* Charleston, West Virginia. June 5, 1940: 17.

134 *Wisconsin Rapids Daily Tribune.* Wisconsin Rapids, Wisconsin. October 27, 1942: 7.

135 *Delta Democrat Times.* Greenville, Mississippi. May 12, 1942: 2.

136 *Clearfield Progress.* Clearfield, Pennsylvania. November 1, 1941: 8.

137 *Fresno Bee Republican.* Fresno, California. January 13, 1942: 4.

138 WSCS represents Women's Society of Christian Service.

139 *The News-Palladium.* Benton Harbor, Michigan. February 12, 1942: 20.

140 The *Kingsport Times.* Kingsport, Tennessee. April 9, 1942: 2.

141 *Moberly Monitor-Index.* Moberly, Missouri. September 16, 1942: 5.

142 *Denton Journal*, Denton, Maryland, November 4, 1945: 6.

143 *Mason City Globe-Gazette*, Mason City, Iowa, March 7, 1942: 13.

144 *Mason City Globe Gazette*, Mason City, Iowa, February 21, 1942: 10.

145 Mulvaney, Ethel Rogers. "Prisoner of War." *Manitoulin Expositor.* September 15, 2001.

146 Mulvaney, Ethel Rogers. "Prisoner of War." *Manitoulin Expositor.* September 15, 2001.

147 Archer, Bernice. *The Internment of Western Civilians under the Japanese 1941-1945: A Patchwork of Internment.* Hong Kong University Press. 2008: 125.

148 Mulvaney, Ethel Rogers. "Prisoner of War." *Manitoulin Expositor.* September 15, 2001.

149 Mulvaney, Ethel Rogers. "Prisoner of War." *Manitoulin Expositor.* September 15, 2001.

150 http://www.awm.gov.au/encyclopedia/quilt/history. asp; accessed on 2 Jan. 2010.

151 http://www.awm.gov.au/encyclopedia/quilt/history. asp; accessed on 2 Jan. 2010.

152 http://www.awm.gov.au/encyclopedia/quilt/history. asp.

Chapter 8: Victory "V" Quilts

153 Rolo, Charles J. "V for Victory," *Radio Goes to War The Fourth Front.* New York. 1942: Chapter XIV.

154 http://www.postalmuseum.si.edu/symposium2008/ DeBlois-Harris-V_for_Victory-paper.pdf; accessed on 2 Jan. 2010.

155 http://www.postalmuseum.si.edu/symposium2008/ DeBlois-Harris-V_for_Victory-paper.pdf; accessed on 2 Jan. 2010.

156 *The Lethbridge Herald*, Lethbridge, Alberta, Canada, August 20, 1941: 20.

157 *The Lethbridge Herald*, Lethbridge, Alberta, Canada, December 6, 1941: 22.

158 *The Cumberland Evening Times*, Cumberland, Maryland, February 24, 1942: 12.

159 *The Chillicothe Constitution Tribune*, Chillicothe, Missouri, May 22, 1942: 4.

160 *Idaho State Journal*, Pocatello, Idaho, December 27, 1955: 16.

161 Dorothy Roe, "How To Piece A Quilt," *Florence Morning News*, Florence, South Carolina, January 14, 1943: 2.

162 *Woman's Day*, March, 1943: 24.

163 Margaret Lukes Wise, "Prize-Winning Needlework," *Woman's Day*, February, 1943: 22-25.

164 *1910 United States Federal Census, California, Alameda, Alameda,* Ward 6, District: 12.

165 http://www.museum.state.il.us/ismdepts/art/ collections/daisy/biography.html; accessed on 2 Jan. 2010.

166 *1920 United States Federal Census, Illinois, Cook County, Chicago City*: 22.

167 *Woman's Day*, March, 1943: 24.

168 Benberry, Cuesta. "Hatfield-McCoy Victory Quilt," *Quilter's Journal*, Vol.2, No.4 Edited by Joyce Gross, Mill Valley, California, Fall, 1979: 6-7.

169 Benberry, Cuesta. "Hatfield-McCoy Victory Quilt," *Quilter's Journal*, Vol.2, No.4 Edited by Joyce Gross, Mill Valley, California, Fall, 1979: 6-7.

170 *Times Record*, Troy, New York, February 24, 1994: 13.

171 *Dixon Evening Telegraph*, Dixon, Illinois, July 15, 1944, and *Sunday Times Signal*, Zanesville, Ohio, August 29, 1943.

172　According to Mary Gasperik's granddaughter, Susan Salser, "In 1904, Otelek was part of Transylvania when it was a part of the Austro-Hungarian empire."

173　Staatsarchiv Hamburg. *Hamburg Passenger Lists, 1850-1934* [database on-line]. Provo, UT, USA: The Generations Network, Inc., 2008. Original data: Staatsarchiv Hamburg, *Bestand: 373-7 I, VIII* (Auswanderungsamt I). Mikrofilmrollen K 1701 - K 2008, S 17363 - S 17383, 13116 – 13183: Staatsarchive Hamburg, *373-7 I, VIII A 1,* Band 161, Seite 2406(Mikrofilm Nr. K_1786.

174　Ancestry.com. *New York Passenger Lists, 1820-1957* [database on-line]. Provo, UT, USA: The Generations Network, Inc., 2006. Original data: *Passenger Lists of Vessels Arriving at New York, New York, 1820-1897;* (National Archives Microfilm Publication M237, 675 rolls); Records of the U.S. Customs Service, Record Group 36; National Archives, Washington, D.C. Year: 1904; Microfilm serial: T715; Microfilm roll: T715_525; Line: 4.

175　*Registration Location: Cook County, Illinois*; Roll: 1493568; Draft Board: 21.

176　http://www.quiltindex.org/gasperikessay.php, accessed on 2 Jan. 2010.

177　National Archives and Records Administration. *U.S. World War II Army Enlistment Records, 1938-1946*

178　National Cemetery Administration. *U.S. Veterans Gravesites, ca.1775-2006.*

179　A statement provided by Verna Pinch in recollection of her father, William Pinch, and his successful quilt pattern and embroidery design business.

180　Alboum, Rose Lea. *Index to the Rainbows,* West Halifax, Vermont, 2006.

Chapter 9: Quilts and Published Patterns during World War II

181　*Mason City Globe-Gazette*, Mason City, Iowa. March 27, 1942: 14.

182　Gibbs, Wolcott. *The New Yorker.* May 16, 1942: 9.

183　"Famous Names Lend Help for a Crazy Quilt." *The Lowell Sun.* Lowell, Massachusetts. May 12, 1942: 23.

184　*A Chronicle of Our Employees In The Uniform Services during World War II.* Stearns and Foster Company. Cincinnati, Ohio. Provided by Linda Pumphrey.

185　*A Chronicle of Our Employees In The Uniform Services during World War II.* Stearns and Foster Company, Cincinnati, Ohio. Provided by Linda Pumphrey.

186　*Catalog of Mountain Mist Quilts.* The Stearns Technical Textiles Company, Cincinnati, Ohio.

187　Waldvogel, Merikay. "Mountain Mist Patterns." *Uncoverings,* 1995, (The American Quilt Study Group): 136.

188　*Catalog of Mountain Mist Quilts.* The Stearns Technical Textiles Company, Cincinnati, Ohio.

189　Waldvogel, Merikay. "Mountain Mist Patterns". *Uncoverings,* 1995, (The American Quilt Study Group): 136.

190　*Farm Journal Magazine,* March, 1945.

191　Brackman, Barbara. *Encyclopedia of Pieced Quilt Patterns.* American Quilter's Society. Paducah, Kentucky. 1993: 524.

192　"Star of the East, Laura Wheeler Pattern #387," *Monessen Daily Independent,* Monessen, Pennsylvania, July 15, 1942: 7.

193　"Nosegay Quilt, Laura Wheeler Pattern #254," *Monessen Daily Independent,* Monessen, Pennsylvania, February 13, 1942: 3.

194　"Friendship Fan, Laura Wheeler Pattern #396," *Monessen Daily Independent,* Monessen, Pennsylvania, June 28, 1942: 5.

Bibliography

and Books Featuring WWII Quilts

Adams, Barb and Alma Allen. *Women of Grace & Charm: A Quilting Tribute to the Women Who Served in WWII.* Kansas, Missouri: Kansas City Star Books, 2003.

Alboum, Rose Lea. *Index to The Aunt Martha and Workbasket Quilt Blocks.* West Halifax, Vermont, 2007.

_____, *Index to The Farm Journal and The Farmer's Wife Quilt Blocks.* West Halifax, Vermont, 2004.

_____. *Index to Home Arts Studio Quilt Designs.* West Halifax, Vermont, 2006.

_____. *Index to The Ladies Art Company Quilt Designs.* West Halifax, Vermont, 2006.

_____. *Index to The Laura Wheeler Quilt Blocks.* West Halifax, Vermont, 2004.

_____. *Index to The Kansas City Star.* West Halifax, Vermont, 2005.

_____. *Index to The Quilt Designs of Alice Brooks.* West Halifax, Vermont, 2005.

_____. *Index to The Rainbows.* West Halifax, Vermont, 2006.

_____. *The Smaller Offerings Index Two.* West Halifax, Vermont, 2006.

Atkins, Jacqueline Marx. *Shared Threads: Quilting Together - Past and Present.* New York: Museum of the American Folk Art. 1994. pp. 9, 72.

Atkins, Jacqueline, Editor. *Wearing Propaganda: Textiles on the Home Front in Japan, Britain, and the United States, 1931-1945.* New Haven, Connecticut: Yale University Press, 2005.

Bassett, Lynne Zacek and The Massachusetts Quilt Documentation Project. *Massachusetts Quilts: Our Common Wealth.* Hanover and London: University Press of New England, 2009. pp. 262, 263.

Bird, William L. and Harry R. Rubenstein. *Design for Victory.* New York: Princeton Architectural Press, 1998.

Bishop, Robert and Carter Houck. *All Flags Flying: American Patriotic Quilts as Expressions of Liberty.* New York: E. P. Dutton, 1986. pp. 43, 44.

Bolles, Paul F. *Presidential Anecdotes.* Oxford University Press, 1996.

Brackman, Barbara, Jennie Chinn, Gayle Davis, Terry Thompson, Sara Reimer Farley, Nancy Hornback, and the Kansas Quilt Project. *Kansas Quilts & Quilters.* Lawrence, Kansas: University Press of Kansas, 1993. pp. 48, 49.

Clotworthy, William. *Homes and Libraries of the President.* The McDonald & Woodward Publishing Company, 2008.

Colman, Penny. *Rosie the Riveter.* New York: Crown Publishers, 1995.

Connecticut Quilt Search Project. *Quilts and Quiltmakers Covering Connecticut.* Atglen, Pennsylvania: Schiffer Publishing, Ltd. 2002. pp. 140, 148-151.

Crews, Patricia Cox and Robert C. Naugle. *Nebraska Quilts & Quiltmakers.* Lincoln, Nebraska: University of Nebraska Press. pp. 132, 133, 222-224.

Florence, Cathy Gaines. *Collecting Quilts: Investments in America's Heritage.* Paducah, Kentucky: American Quilter's Society. pp. 78, 110.

Gilbert, Jennifer. *The New England Quilt Museum Quilts.* Lafayette, California: C&T Publishing, Inc. 1999. p. 53.

Grosz, Hanus and Kristen. *Kindertransport Memory Quilt.* Upton, New York: KTA National Office, 2000.

Horton, Laurel and The American Quilt Study Group. *Quilting in America: Beyond the Myths.* Nashville, Tennessee: Rutledge Hill Press, 1994. pp. 105-111.

Howard, Judy. *Centennial Stitches: Oklahoma History of Quilts.* Oklahoma City, Oklahoma: Dorcas Publishing, 2007. p 44.

Laury, Jean Ray and California Heritage Quilt Project. *Ho for California! Pioneer Women and Their Quilts.* New York: E.P. Dutton, 1990. pp. 145, 149.

Mackey, Albert and Edwin L. Hughan. *An Encyclopedia of Freemasonry and its Kindred Sciences*, Volumes I & II. Chicago: The Masonic History, 1924.

McDonald, Deidre and The Heritage Search of the Quilters' Guild. *Quilt Treasures of Great Britain's: The Heritage Search of the Quilter's Guild.* Nashville, Tennessee: Rutledge Hill Press, 1995, pp. 157-161, 163.

Minnesota Quilt Project. *Minnesota Quilts: Creating Connections with Our Past.* Stillwater, Minnesota: Voyageur Press, Inc., 2005. pp. 42, 43.

Oklahoma Quilt Heritage Project. *Oklahoma Heritage Quilts.* Paducah, Kentucky: American Quilter's Society, 1990. p. 110.

Paullus, Vickie and Linda Pumphrey. *Mountain Mist® Blue Book of Quilts.* Stearns Technical Textiles Company, 1996.

Powell, Julie. *The Fabric of Persuasion: Two Hundred Years of Political Quilts.* Chadds Ford, Pennsylvania: Brandywine Museum, 2000. p. 34.

Rae, Janet and the Heritage Search of the Quilter's Guild. *Quilt Treasures of Great Britain.* Nashville, Tennessee: Rutledge Hill Press, 1995. pp. 14, 15, 155–164.

Robson, Scott and McDonald. *Old Nova Scotian Quilts.* Halifax, Nova Scotia: Nimbus Press, 1995. p. 97.

Rolfe, Margaret. *Australian Quilt Heritage.* Rushcutters Bay, Australia: J.B. Fairfax Press Pty Limited, 1998. pp.72-75.

Rubin, Stella. *Treasure or Not? How to Compare & Value American Quilts.* London, England: Octopus Publishing Group Ltd, 2001. p. 66.

Shih, Joy. *Forties Fabrics.* Atglen, Pennsylvania: Schiffer Publishing Ltd, 1997.

Siedlecki, Janusz Nel, Krystyn Olszewski, Tadeusz Borowski. Translated by Alicia Nitecki. *We Were in Auschwitz.* New York: Welcome Rain Publishers, 1946.

Tulkoff, Alec S. *Counterfeiting The Holocaust.* Atglen, Pennsylvania: Schiffer Publishing Ltd, 2000. Pages 67-70.

Waldvogel, Merikay. "Mountain Mist Patterns," *Uncoverings*, 1995, ed. Virginia Gunn. San Francisco, California: American Quilt Study Group, 1992. pp. 93-138.

Weinraub, Anita Zaleski and The Georgia Quilt Project. *Georgia Quilts: Piecing Together a History.* Athens, Georgia: The University of Georgia Press, 2006. pp. 139, 207.

Williams, Charlotte Allen. *Florida Quilts.* Gainesville: University Press of Florida, 1992. p. 142.

Woodard, Thomas K. and Blanche Greenstein. *Twentieth Century Quilts: 1900-1950.* New York: E. P. Dutton, 1988. pp. 64, 104, 105.

Wright, Jordan M. *Campaigning for President.* New York: HarperCollins Publishers, 2007

York County Quilt Documentation Project. Quilts: *The Fabrics of Friendship.* Atglen, Pennsylvania: Schiffer Publishing Ltd, 2000. p. 154.

Index

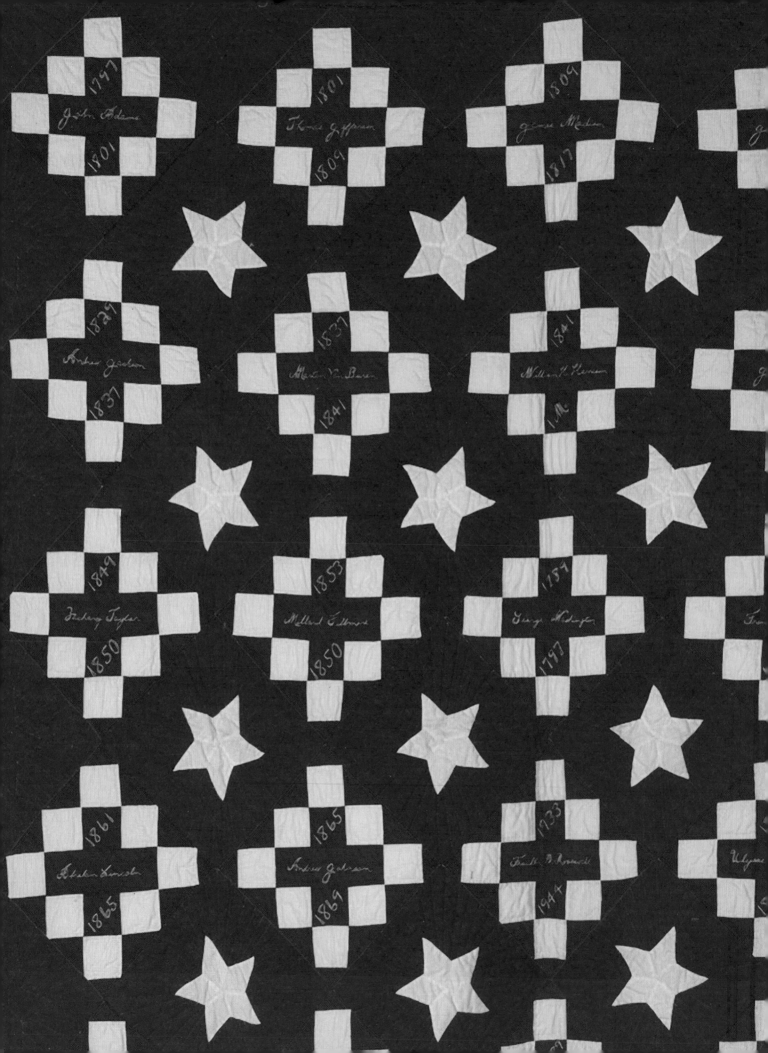